Philip Treacy by Kevin Davies

Φ

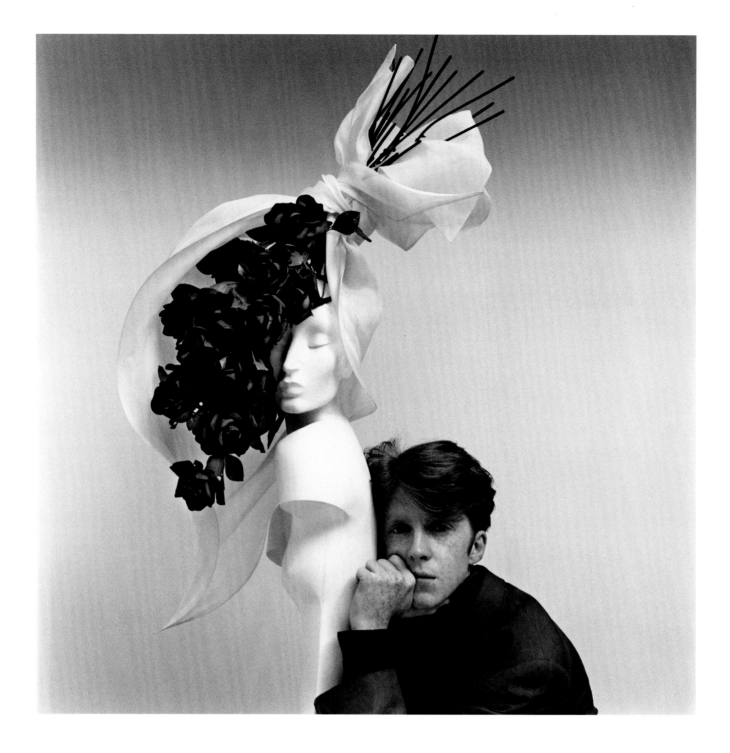

2 Philip Treacy, *Vogue*, 1991

Every hat I have ever made has begun in my mind as a photograph. I can see it on the model, at the right angle, before I even begin. I can see what the girl's going to look like and how it's going to be worn. But it's something that's just for me.

I was introduced to photographers and photography books at fashion school. I was amazed by the images, how they appeared so effortless, but I quickly understood that there's nothing effortless about photography. It's about a highly considered moment in time. To say that a picture is worth a thousand words is an understatement.

Isabella Blow was a great influence on my interest in photography. She loved photographers: looking for them, working with them, helping them and making them famous. At the beginning, there were always photographers at 69 Elizabeth Street and I liked having them around. I understood their passion and their belief in the illusion. Fashion is the same wonderful illusion and it's a thrilling experience – no one sees the tape. There's a shared part of our industries that people wouldn't believe; it's extraordinary what it takes to make an image. Isabella taught me about what was good, what was eclectic and what made photographs fun.

Yet photography, like design, is an obsession: an obsession with the final image. And most photographers, like most designers, are control freaks, because they care so much that it all looks incredible in the end. We believe in it. Whether you're a make-up artist, stylist, designer, architect, photographer, or anyone working in the creative industries, your work is a point of view. It's *your* point of view.

Whenever I've been asked to do the photography for a shoot – and it's always against my will – it's been a nightmare scenario for me. The expectation to deliver something, within a set time and with everyone watching, is daunting. I'm never sure what's going to happen on the day, and it's made me admire photographers even more. Their work is a performance – how they handle people, make the model feel comfortable, placate the client, and, at the end of it all, create an amazing image. Of course, some are more charming than others.

When I first met Kevin, on a shoot for American *Vogue*, he had been briefed to capture a happy, laughing, young designer. And I couldn't do it. Not because I was too grand – I'd just left college – but because when you're first introduced to this world of press, photography and interviews, sometimes you don't have all the answers. Kevin, being diplomatic, talked about what we could do instead. Most photographers – not all, but most – are big on ego, it's part of the furniture, but with Kevin it wasn't like that. When I saw him after the shoot, I asked how it had gone down. 'They weren't happy,' he replied.

Philip Treacy

69 Elizabeth Street
1990–1999

I knew very little about Philip Treacy before I took my first photograph of him (p. 2). The shoot was set up at the house of Isabella Blow, the style editor for *Tatler* and long-time friend of Philip's. I can still remember the beautiful daylight that flooded the space. Issy and Philip were sharing the house and I believe Philip was working from there, but I never saw further than the room I was shooting in. I had been commissioned by American *Vogue* to do a portrait of him, and at the time I mainly shot portraits in a studio. Even if it was on location, I still preferred to make it look like a studio environment.

Philip was warm and friendly but seemed shy. He asked me a lot of questions and was very interested in the photography; he asked what I would like to do and I explained the brief I'd been given by *Vogue*. Now, more than 20 years later, we still argue about what exactly the brief was, but we both agree that we knew it didn't quite work. So we did what we felt was right.

After that shoot we stayed in touch. A year or so later, I asked for Philip's advice in choosing a hat: my first present to my future wife. On the flight to Dublin I sat with a very large hat box on my lap. I'm embarrassed to admit now that I wasn't sure if it would suit her, but of course it did.

A few years later, I was experimenting with colour rayograms, a form of cameraless photography that uses objects placed on the surface of light-sensitive material to create a variety of negative shadow images. The idea for the rayograms came from wanting to approach still-life photography from a different perspective. Some of Philip's hats had dramatic, skeletal shapes that were perfect for the technique. I just called Philip, explained the idea and asked for some hats. Philip came along to the darkroom and offered his own ideas: he wanted to hang his hats from wires across the darkroom and we shone a torchlight on the reflective surfaces of the sequinned hats. Philip, Brian Dowling (my printer), Philip's Jack Russell terrier Mr Pig and me all squeezed in the darkroom together, peering at the colourful hats suspended above the paper.

Having spent a lot of time on studio portraits, I wanted to work on photographing people in the more intimate surroundings of where they lived or worked, showing their physical environments, where I hoped they could feel more relaxed and just be themselves. I went back to shooting for *i-D* magazine, as they rarely had a specific brief and would just provide a subject, time and place. One of the subjects I photographed for them was the painter Jenny Saville. I spent a couple of hours in her studio, taking photos while she worked on a self-portrait. When I announced that I had finished she looked up from her work and seemed surprised I was still there. I thought if someone was that focused, that lost in their creative world, it would be an interesting way to make a portrait. Besides, I had never been an 'in-your-face' kind of photographer.

It was this way of working that I took with me to 69 Elizabeth Street when I began capturing Philip in his studio. Soon, I was also photographing backstage at shoots and fashion shows, and I was certain from the beginning that I wanted to capture the flip side of the events. I knew there would be hundreds of photographers out to capture it all with amazing catwalk images of the hats and models but I was interested in something different: the preparation, the atmosphere, the attention to detail.

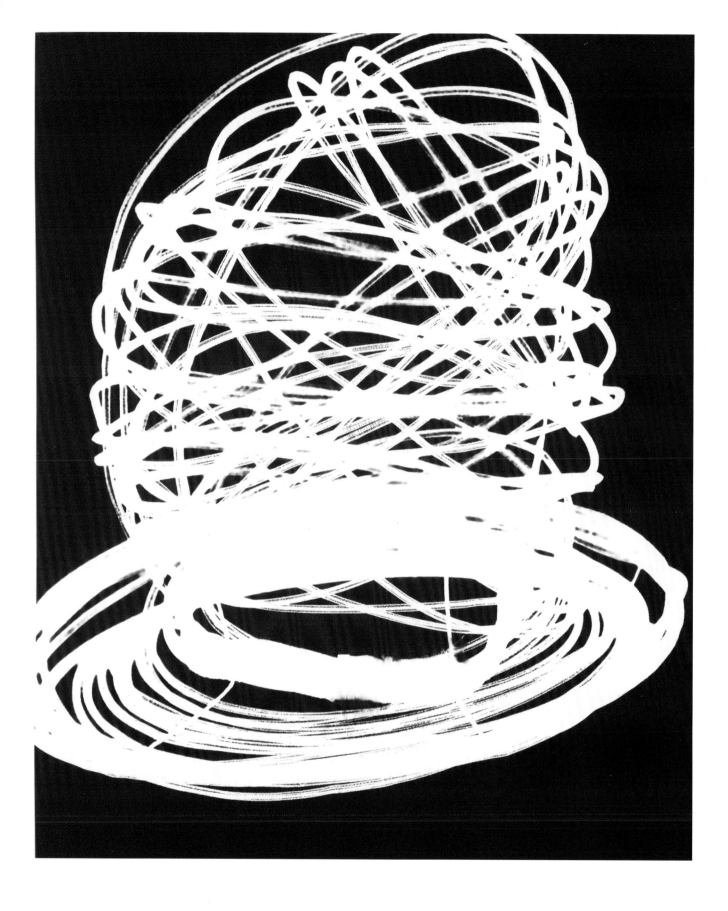

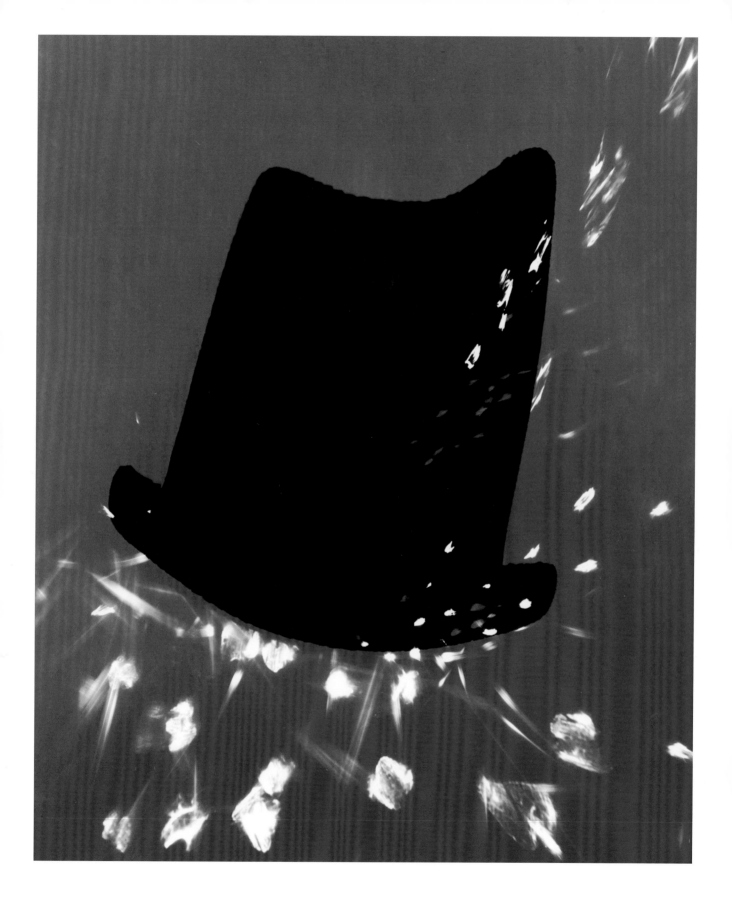

Rayograms

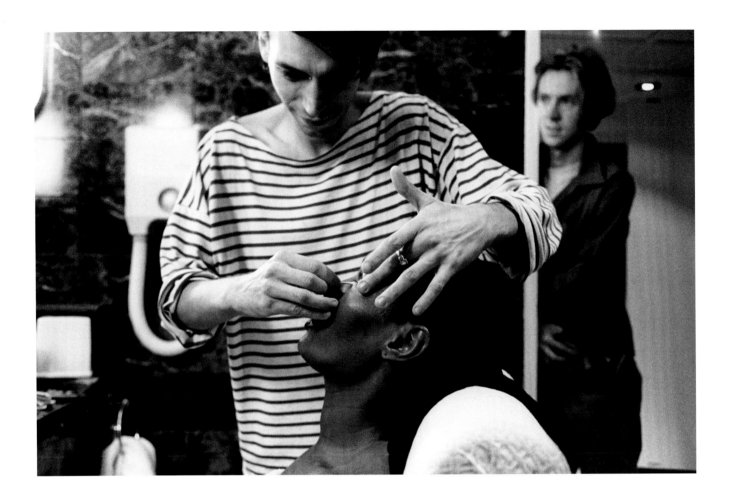

Kevin: In 1998, years after our rayogram experiment, Philip phoned to say that Grace Jones was in town and to ask if I'd photograph her in some of his hats. We did the shoot in the entrance to her hotel suite; Grace is famous for never doing mornings, so we got started late in the evening. French make-up artist Topolino and videographer Nick Scott were there, both of whom Philip had worked with before. Nick collaborated with Philip on all his video work. Between all of them, as with so many of these shoots, preparation took a long time, so I began taking pictures of the process. Though it took some courage to get over the initial feeling that I was intruding. Grace ordered room service at around 2.00 a.m., and everybody perked up. I guess that was the start of my behind-the-scenes shooting.

Philip: These photos are from the early days of my long association with Grace Jones, one of the most unusual and interesting people I've ever met. We'd been introduced a few days before and I asked her if we could take some photos. Grace loves wearing hats and I love making them, so it was the beginning of a marriage made in heaven.

Kevin thought it would begin at 8.00 p.m., but we didn't get started until 1.00 a.m., which was the perfect time for Grace. She's a vampire, a legend, a classic Hollywood star; a delicious nightmare and sharp as razor blades. Grace is a force of nature.

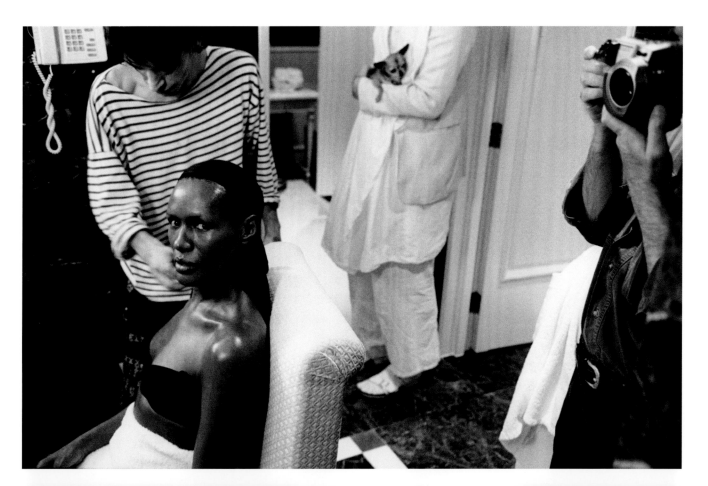

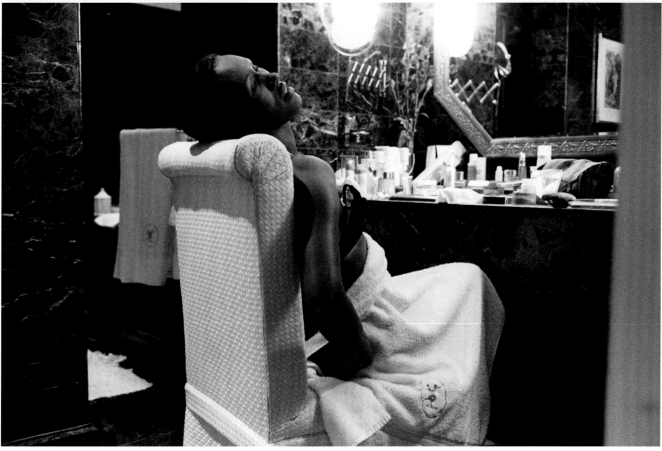

Grace Jones, London

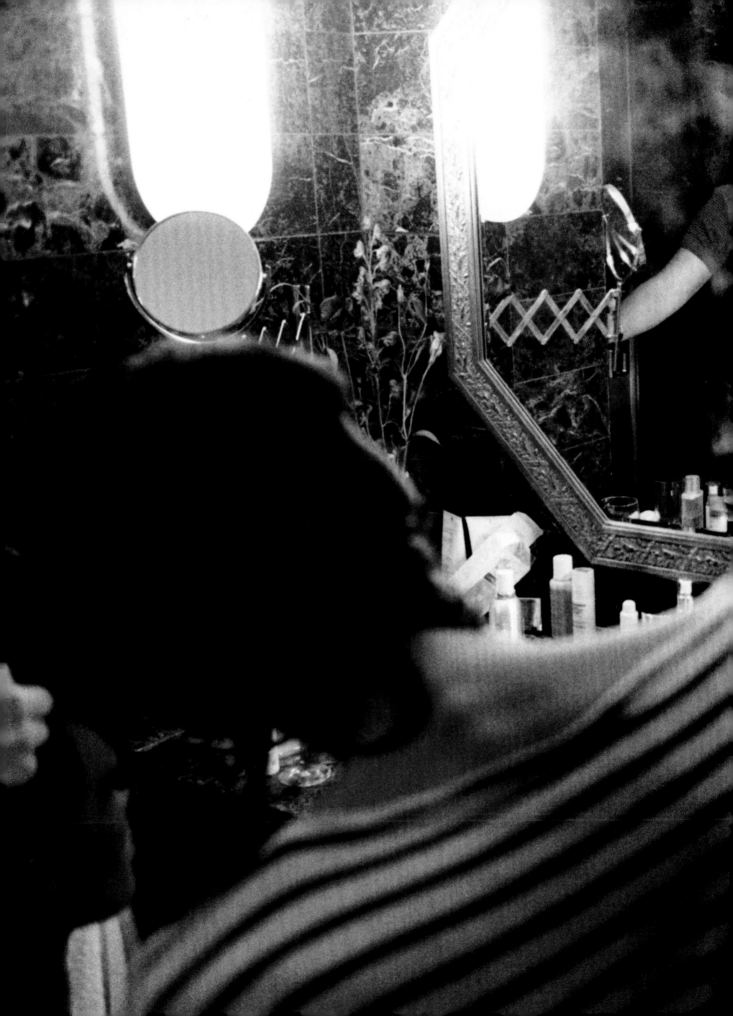

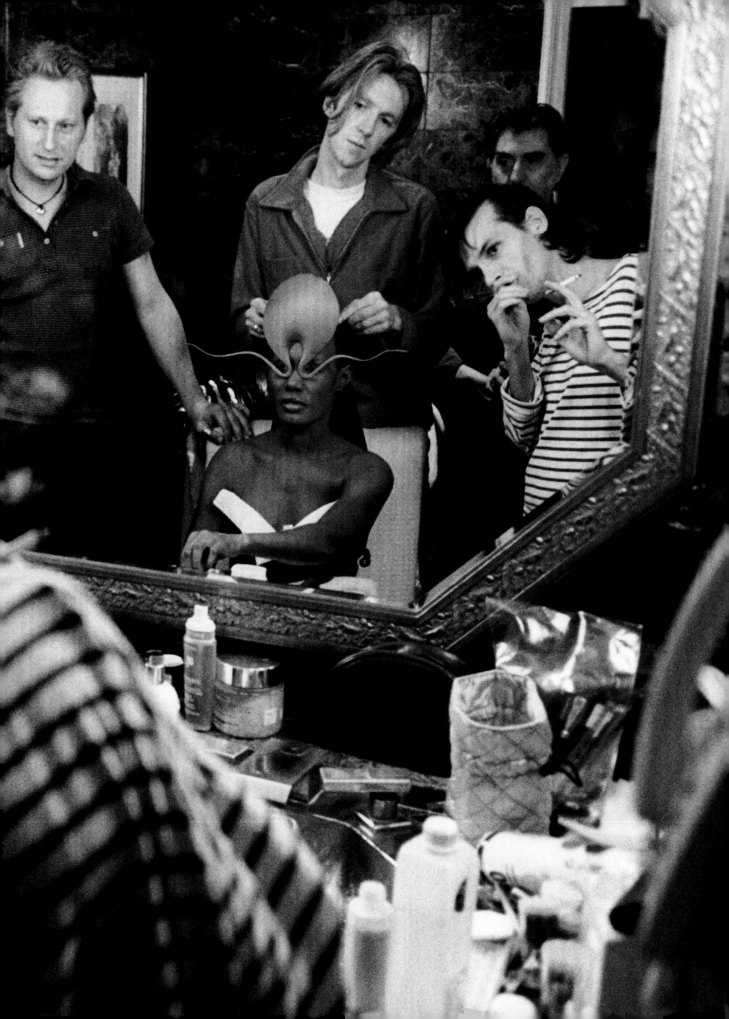

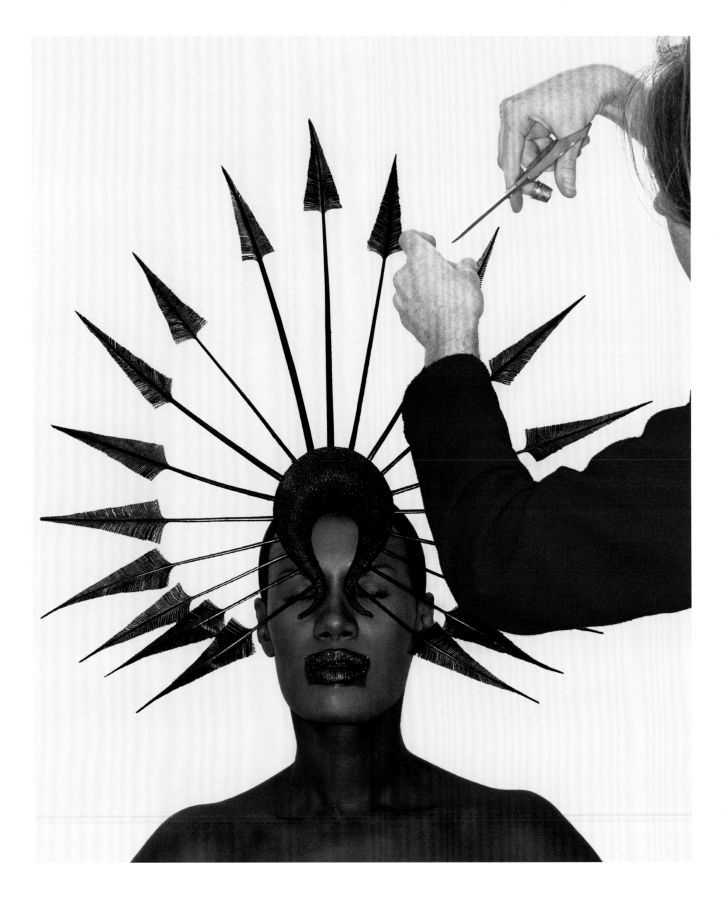

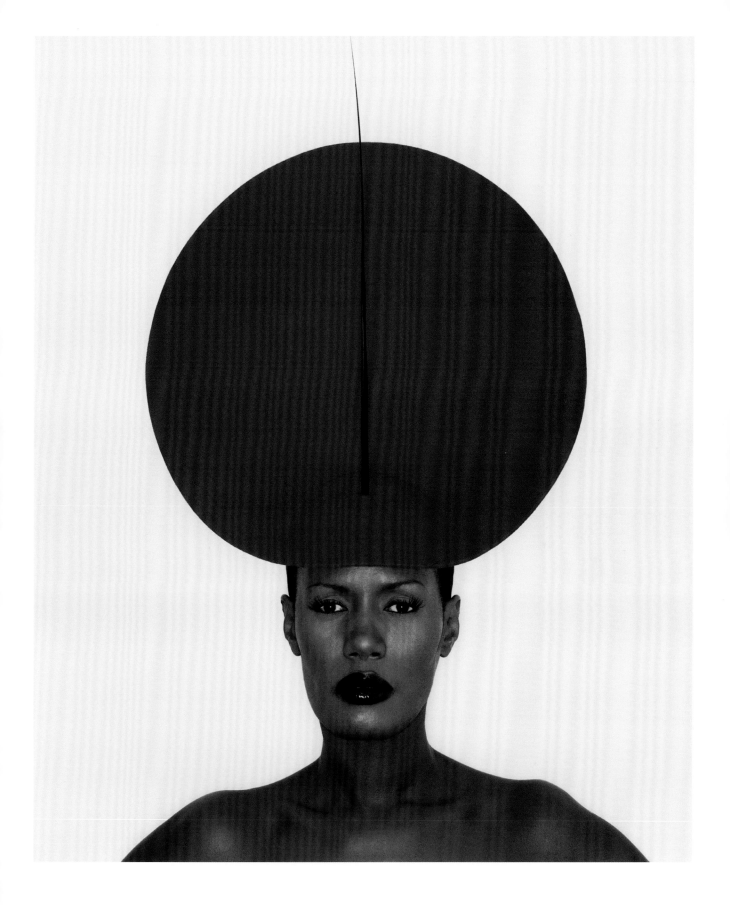

Grace Jones, London

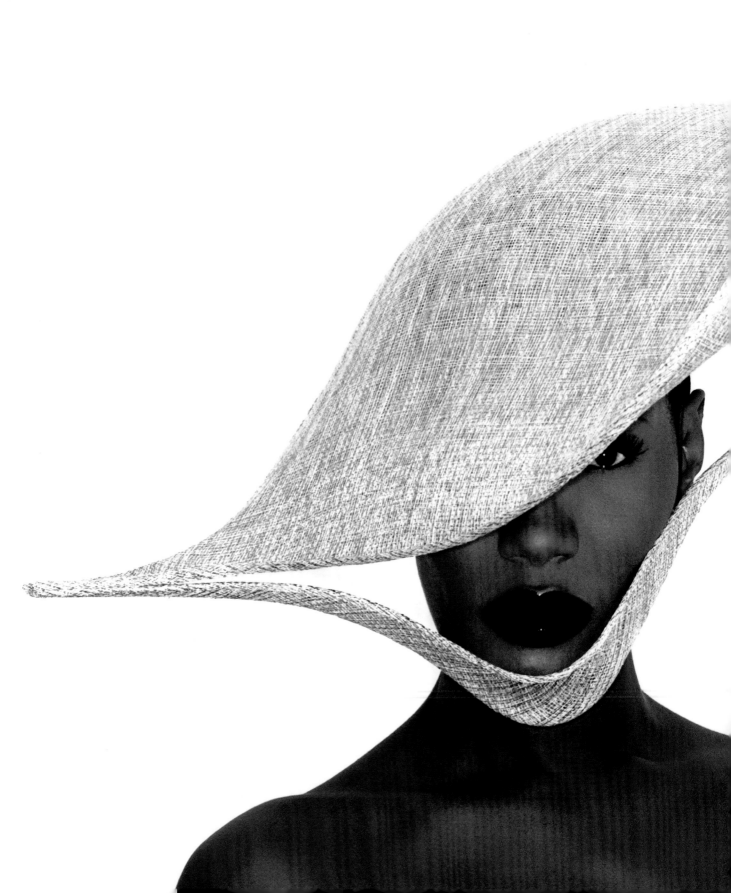

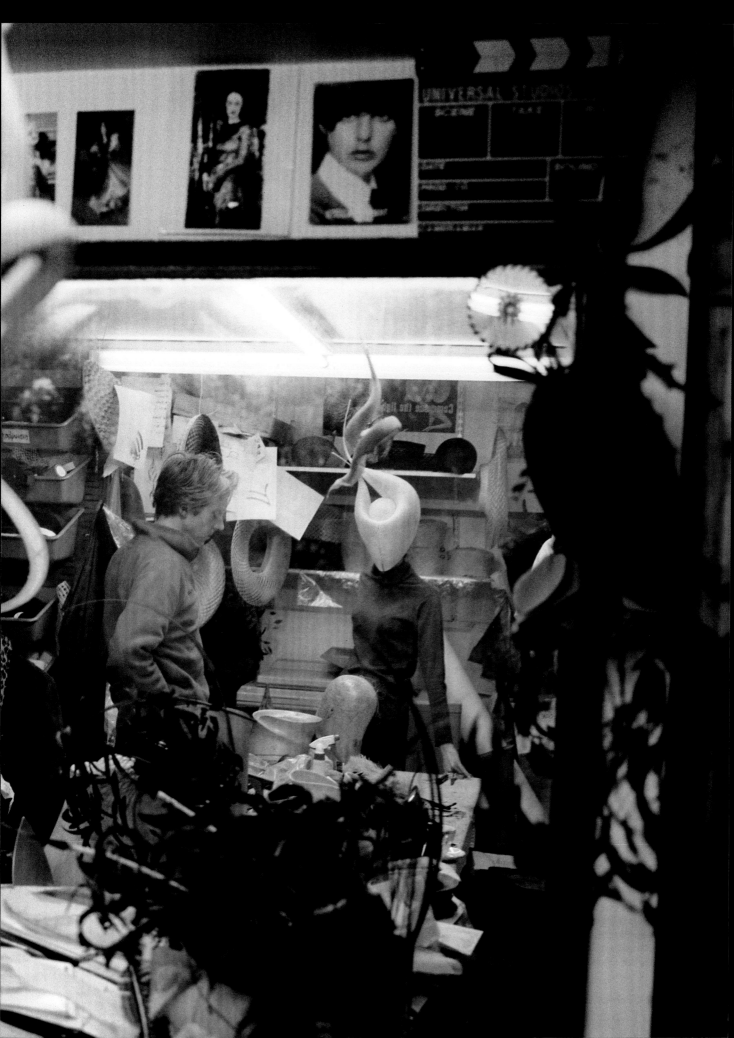

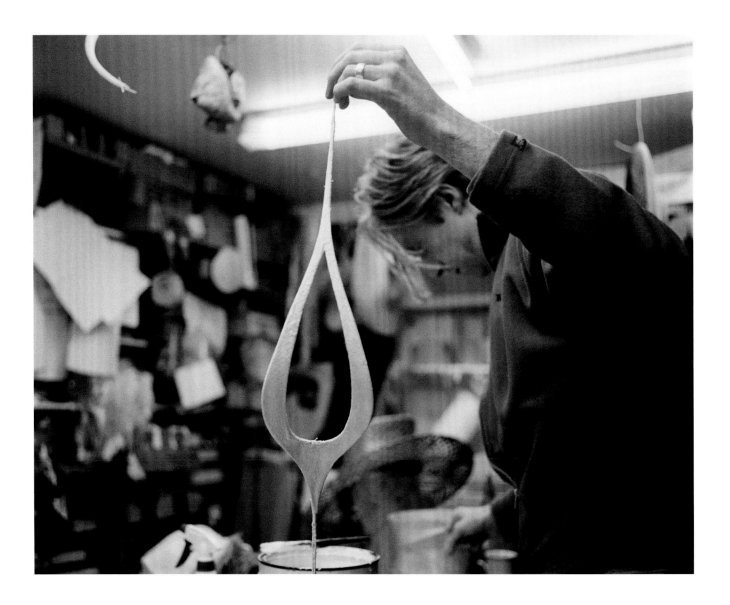

Kevin: After the Grace Jones shoot, Philip invited me to see a show, and it was just four months later that I took the plunge and asked if I could take pictures of him at work in the studio. I imagined Philip would be the perfect person to photograph at work – he was extremely creative but also friendly and genuine – but I had no idea of what went into making a hat. I knew I wanted to take pictures that were more about the reality of making than a glossy, posed image. I never asked Philip to repeat anything he was doing. As far as I'm aware, he only ever adjusted his position to accommodate me once.

Philip: I've always worked in the mirror; it never lies. When I'm working out the proportion and shape of a hat, I can see where anything is wrong much more easily than I can when looking at it directly. The shapes here are all handmade; they're too complex and fine to be carved in wood. They are being strengthened and stiffened with a liquid solvent that hardens when it dries.

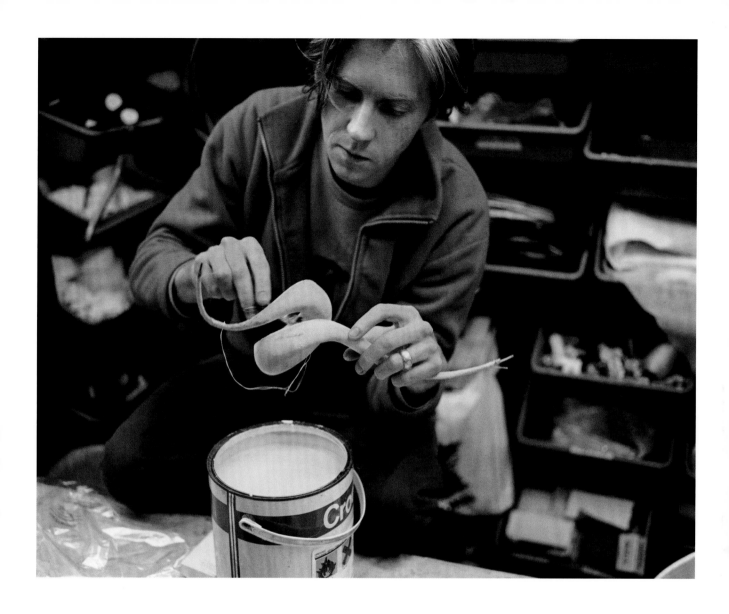

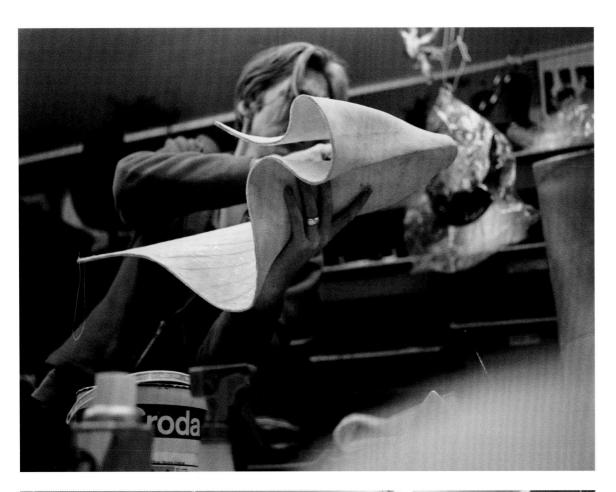

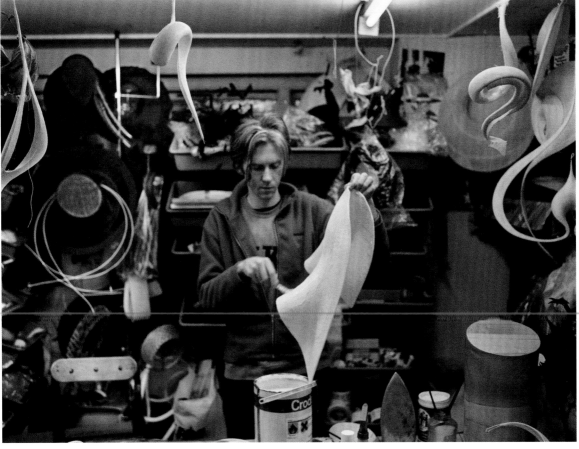

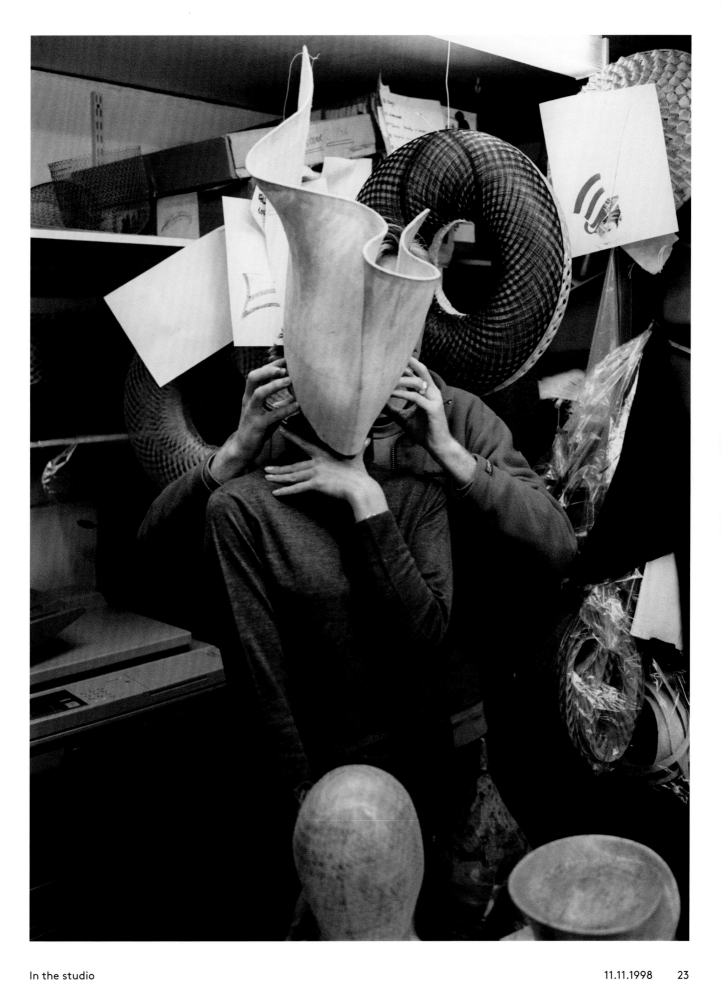

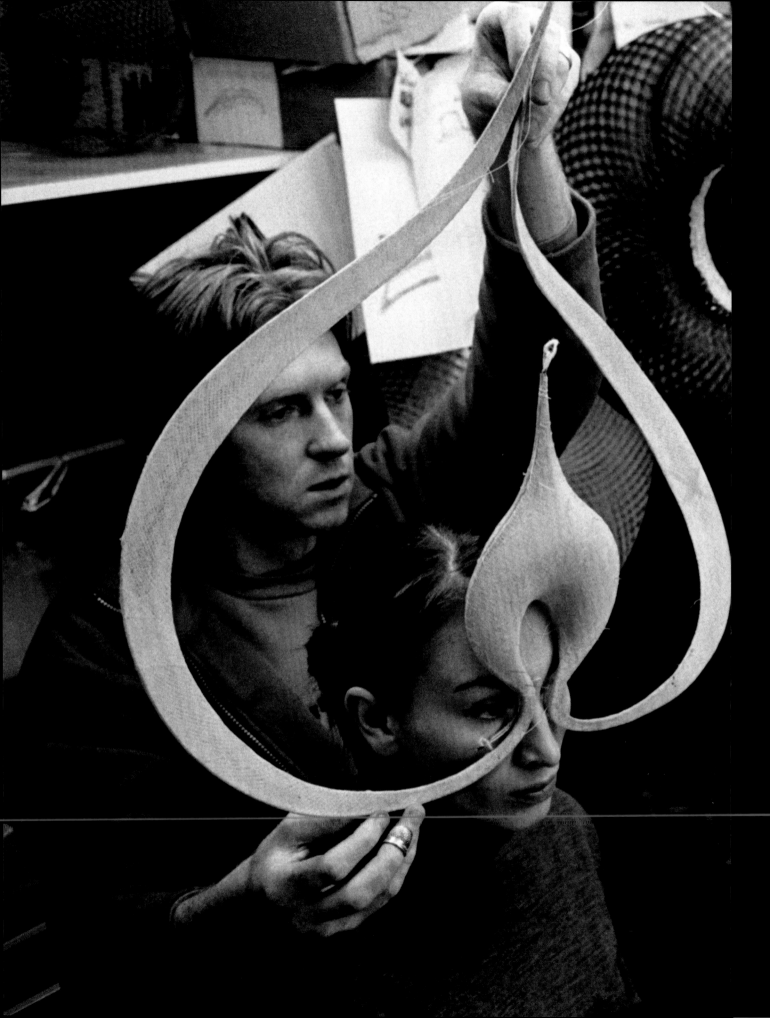

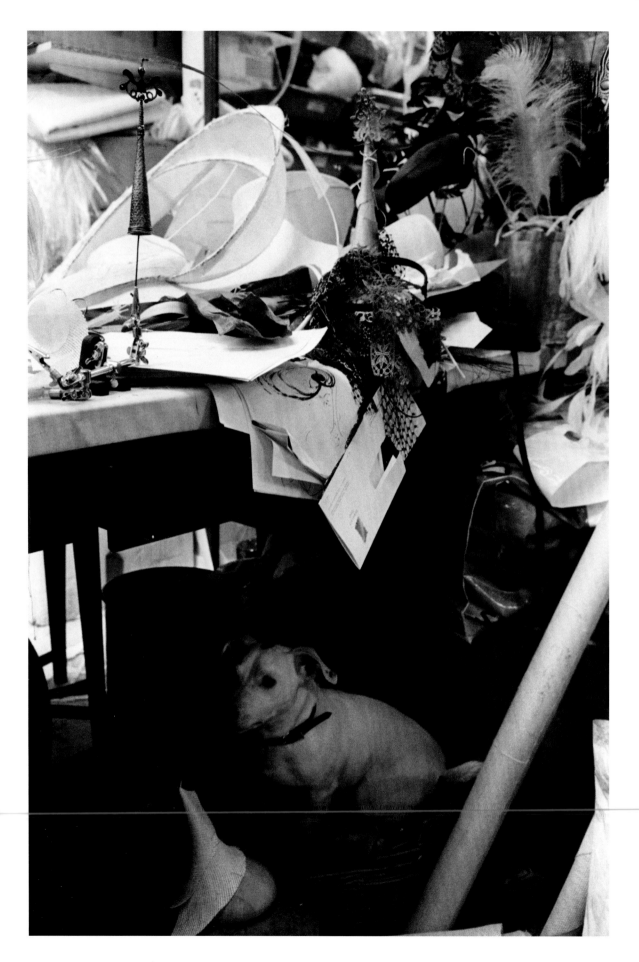

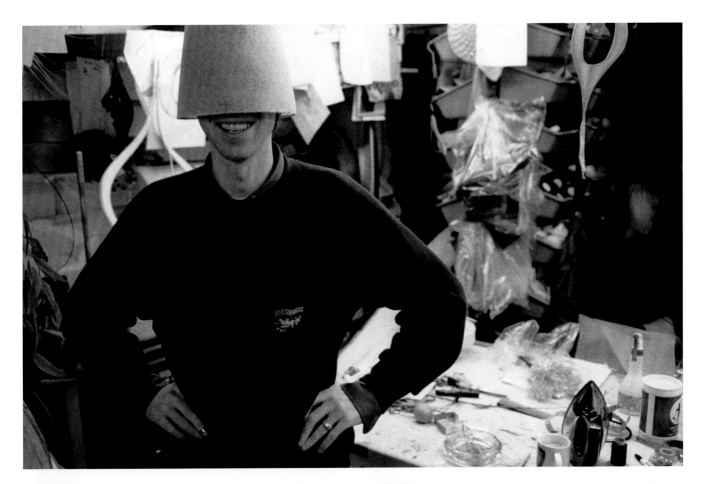

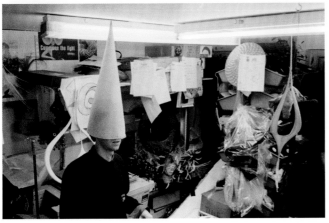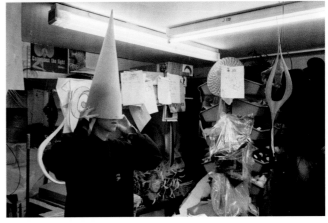

Philip: Mr Pig (left) had spent so much time around the studios watching the craziness that he knew more about hat design than all of us put together. At that moment, he was my best friend.

Kevin: I started taking pictures at Philip's first studio in 1998 – back then it was a space in the basement below his shop in Belgravia. The studio was the size of two rooms of a small house. At first sight it looked almost like a sweatshop, and the smell was a pungent mixture of glue and paint; much later, Philip would refer to that place as 'Bangladesh'. Despite the small space and endless objects I never felt in the way. Philip just let me just get on with it. He was always chatting with me or the couple of assistants he had working there at the time – there was always a buzz about the place.

Mr Pig was always on guard – except when he was snoozing under one of the tables – and patrolled the studio floor. Sometimes, if I was close to a chair that just happened to have Philip's jacket on it, he would growl menacingly. Among the apparent chaos, there were other surprising constants in that studio: cups of tea, loud techno music, Alla (Philip's 'house' model) and a steady stream of people just dropping in. The studio was always a surprising environment to anyone from the outside world.

To me, the atelier was an Aladdin's cave, full to the brim with interesting and wonderful things. I could point the camera in any direction and there would be an interesting backdrop. It was great to have complete freedom and no particular subject. The project felt open-ended and Philip didn't seem to mind or notice me. He was focused on working and appeared completely comfortable. Somehow it all seemed very normal, despite the incredible objects he was making. But then Philip made it seem normal; it was just what he did.

We seemed to work well together and it was a very creative environment. At the time, I had been looking for something more satisfying and wanted to take images without having to think about format, cover lines, double-page spreads or the spectre of editorial deadlines.

It made sense to me to work alone, with no assistant – it just wouldn't have been practical. I would load three cameras, all with different formats, shoot them all and then re-load myself. Working with assistants was something I'd become accustomed to with studio photography, but it wasn't how I had started out. It felt natural to return to a more personal working method. In some ways, not having someone else there freed me up to change and adapt much more quickly.

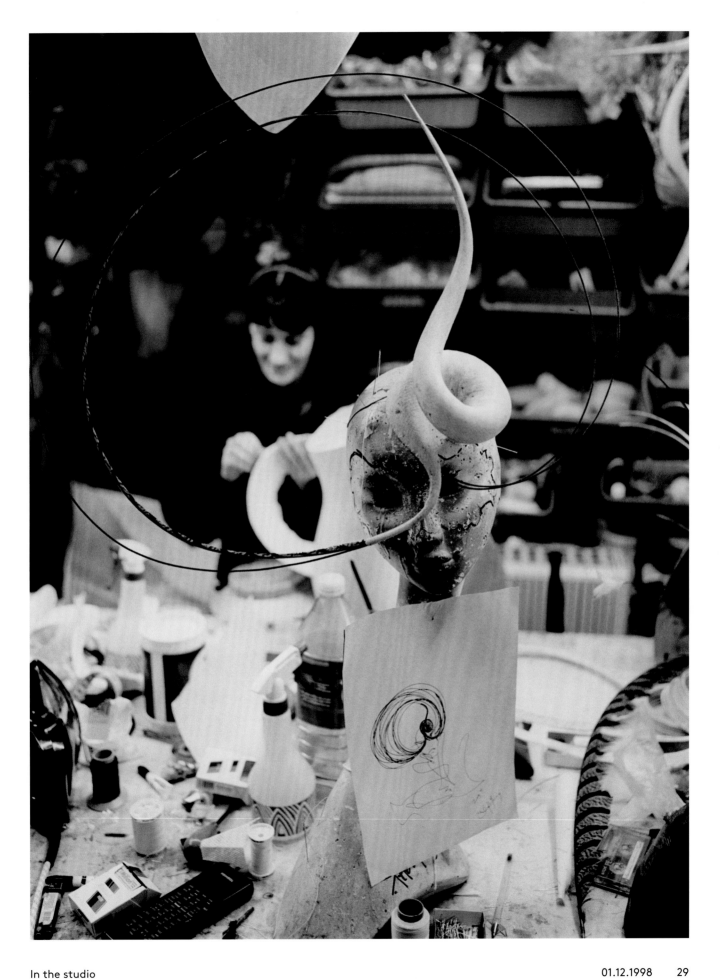

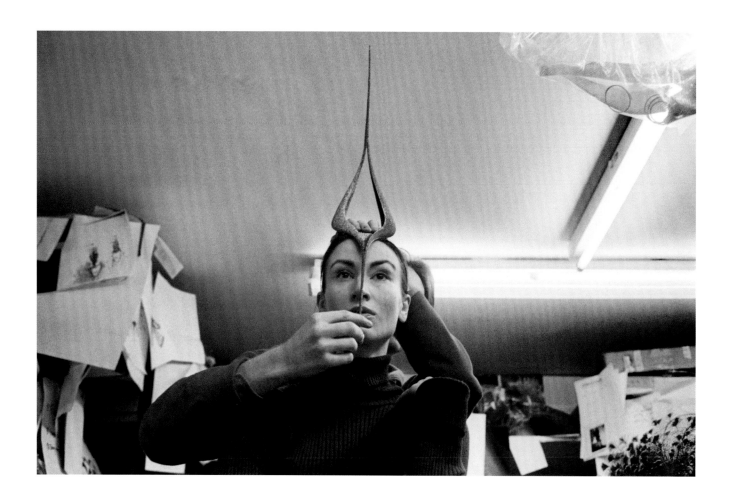

Kevin: For a photographer, it was very poor-quality light in the studio, just office-type fluorescent strip lighting; in many respects not very flattering, and certainly not ideal conditions. But I really didn't want to light the room artificially, or even add to it a little. I knew it would interfere with the natural atmosphere of the place. In a space that small, it was also just not practical. I knew that the work would have to be done in the darkroom, printing. I was getting excited about the photographs as they developed, but at this point I didn't show many of the images to Philip.

Philip: The studio was a little bit like a clown's car. There were more things in there than you could ever believe would fit in such a tiny room. We often had about ten people in that basement and we were all together in the smallest space making the biggest hats. Sometimes people assume I have 50 assistants doing all the work, and that I casually hand over sketches and wait for the results. But that's never been the case, and still isn't today. If anything, someone hands me the sketch and I make the hat.

Kevin would arrive and photograph in an unobtrusive way, and it meant I didn't have to stop working. It was as if he wasn't even there.

This hat (above right) is the first one I ever made for Alexander McQueen. It was for his show in New York in 1999.

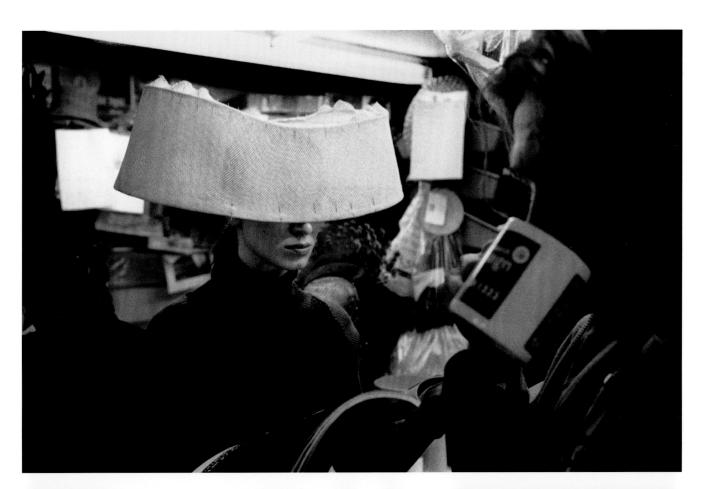

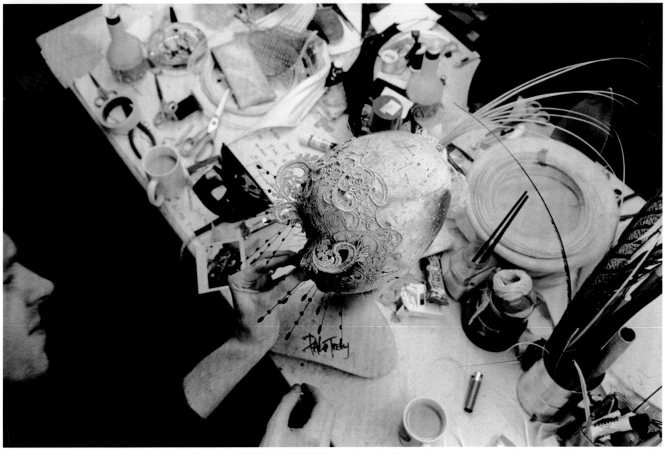

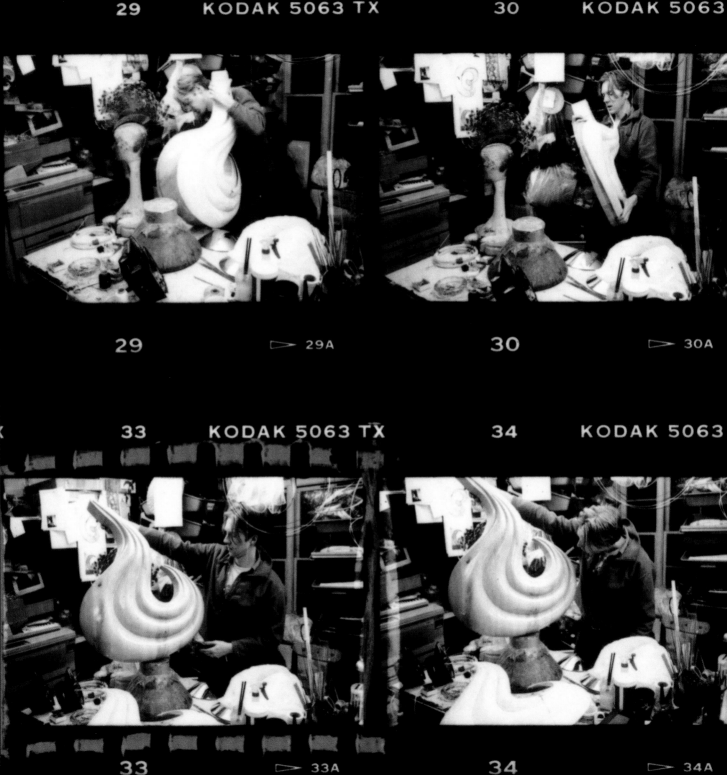

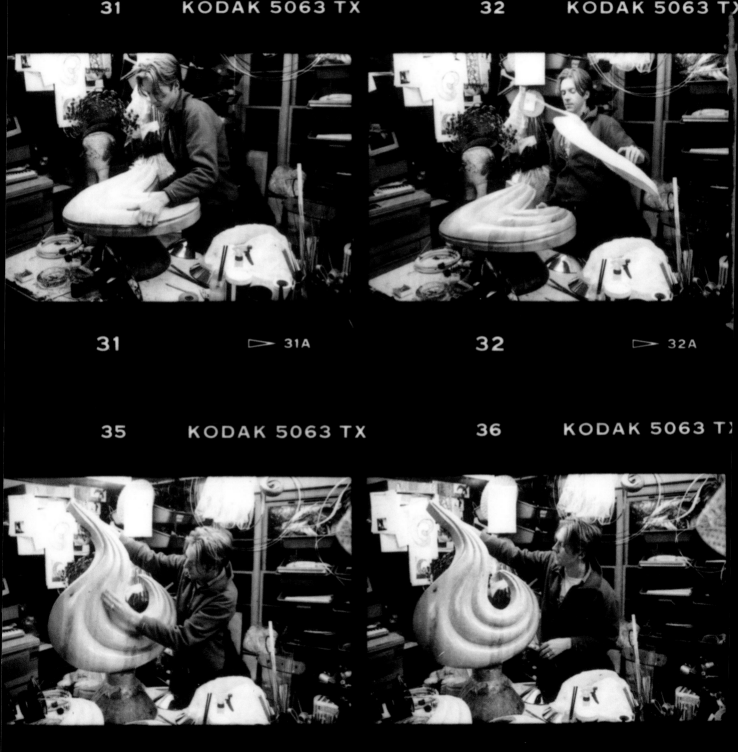

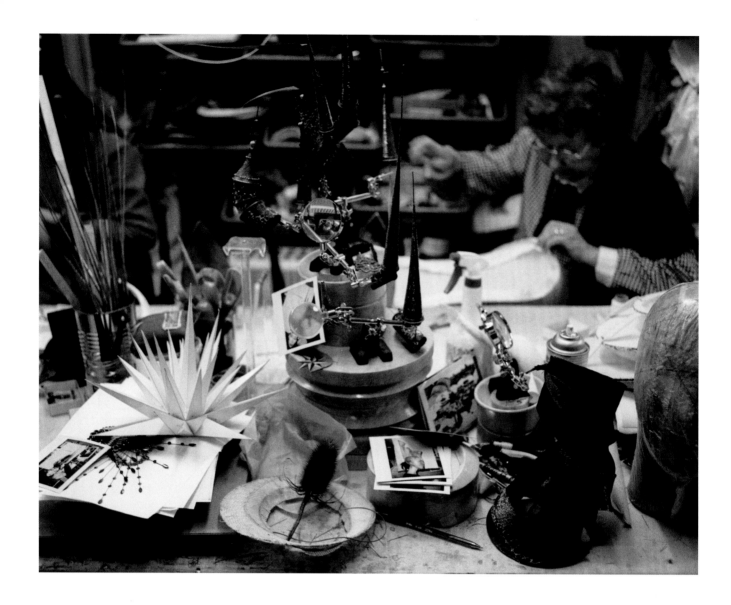

Philip: Micheline Zacharov (above) worked with me, in the studio, for ten years and I learnt so much from her; she enhanced my expression immeasurably. She taught me how to make shapes.

I was young and wanted to make shows. I'd give her a sketch of something insane and she'd tell me how we could make it. I'd start and she'd say, 'Great, OK – you're slow, but it's OK.' Micheline was unique and quite particular – an old-school hat designer – and her love for the craft touched me deeply. I could handle her and she could handle me.

Both Micheline and Shirley Hex, who taught me at the Royal College of Art, are the unsung heroes of hat design.

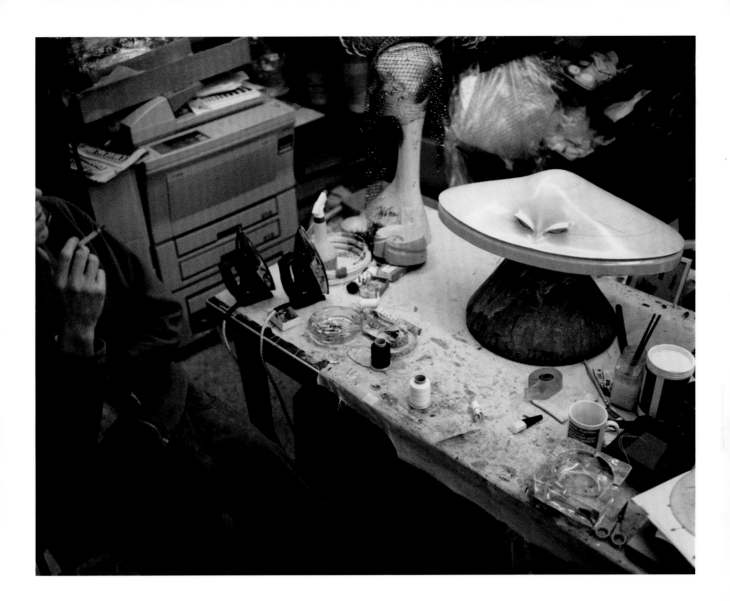

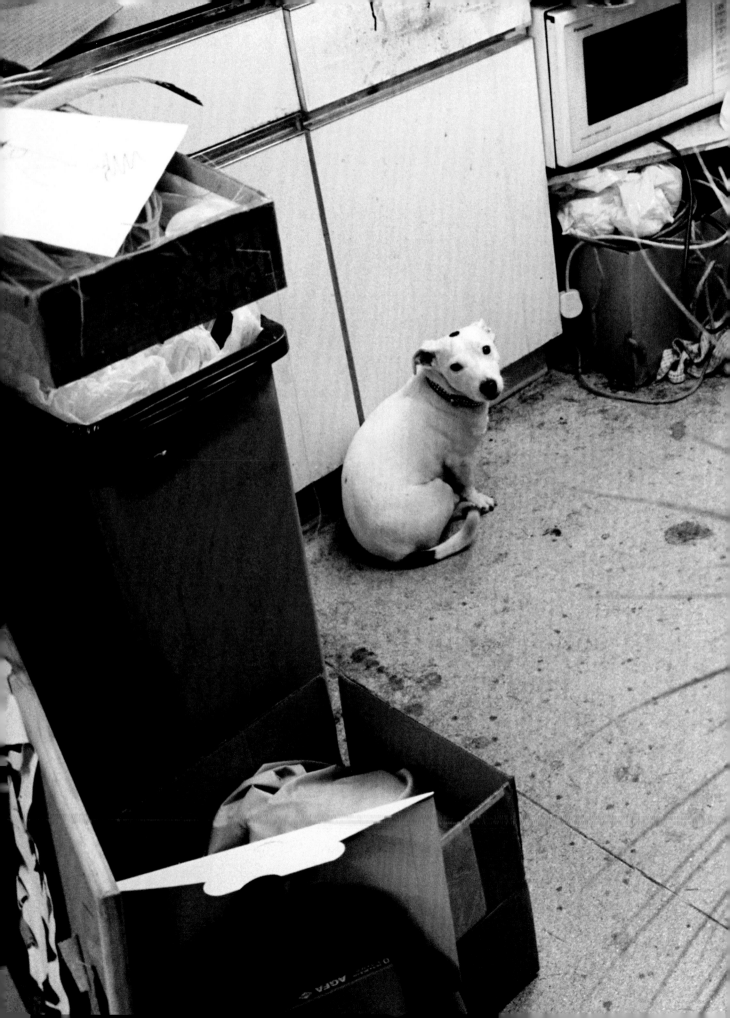

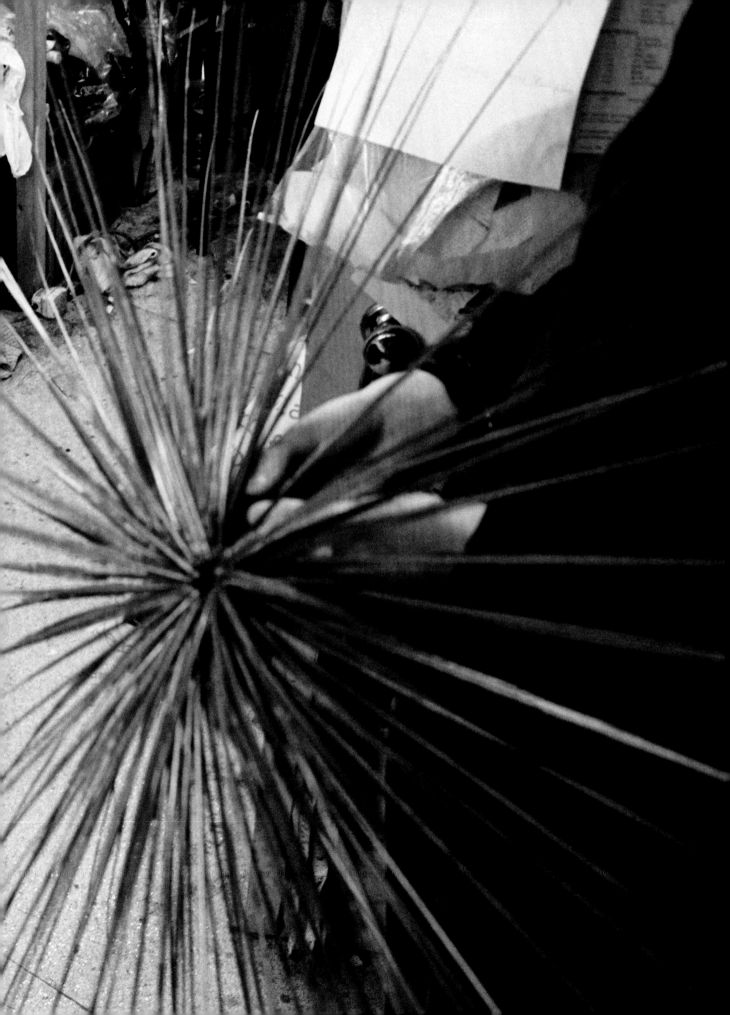

Kevin: While working in Philip's studio, I made a conscious decision to photograph everything in the same way, whether it was Philip, Alla, the maquettes he was working on or the finished hats.

I liked the feel and tone of the pictures in black and white: the hats, the room, the lighting, it all reminded me of surrealist imagery from the 1940s. I also loved printing my own pictures in the darkroom, and this was much more accessible with black-and-white film. Somehow it created a more direct translation of what I was seeing in the studio, although much of the material I was shooting was never actually printed at the time. But since there was so much going on visually, I wanted to try the same approach in colour photography, to see if it could work in the same way – and it did. I had always worked in colour, with a printer, so I knew it would follow through.

These photographs (p.39–47) were taken during the preparation for a show Philip was having in London. He was constantly taking Polaroids of models, people and friends wearing the hats. This period before a show was the busiest and the most productive, and there was definitely a sense of serious urgency about the place.

Sometimes I would shoot entire rolls of film of the same thing; I would shoot quickly, remaining static but capturing Philip as he worked away on a particular hat. Looking at the resulting contact sheets (p. 44–5) was a great way to see the whole process, with all its tiny adjustments and the minute attention to detail. Working as a series, the images on the contact sheets began to visually explain Philip's working method.

Philip: Alla (right) was my house model, and every hat was made on her during this period. She would arrive every day and spend all her time trying on hats, making magnificent shapes and poses with her body. Alla had endless patience and the most fantastic face for hats; she seemed to enjoy the energy of the studio.

It was incredibly busy place, and full of so many things that I would hang a white screen to create a clean background so I could actually see the hats properly. It enabled me to make out exactly what was happening on the head in the mirror. If something is off, I need to be able to see it, and then I can spot millimetres from miles away. I can see if it's crooked and it needs to be perfect – that's what it's all about. I believe in that millimetre.

It's a case of judging and judgement. Every shape I make takes hours and hours and hours of work to perfect. Hat making is supposed to look effortless; if the hats look laboured or forced, they won't look good. But when it comes to how they are made, the opposite is true.

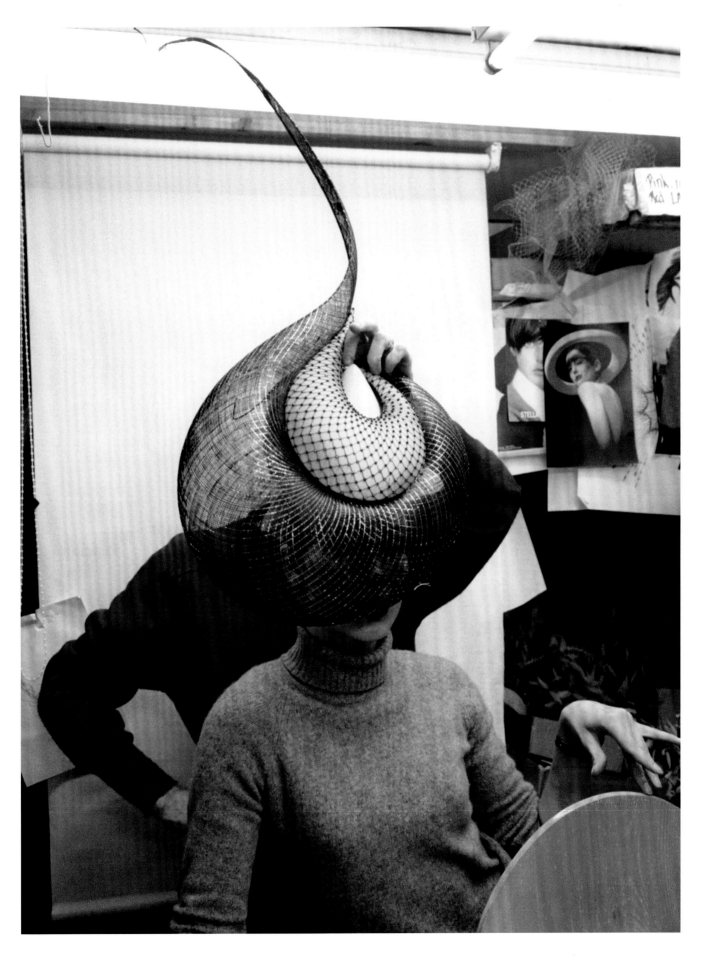

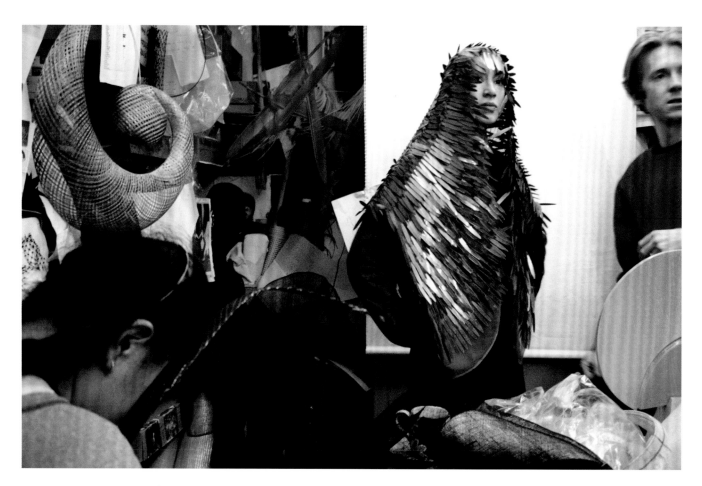

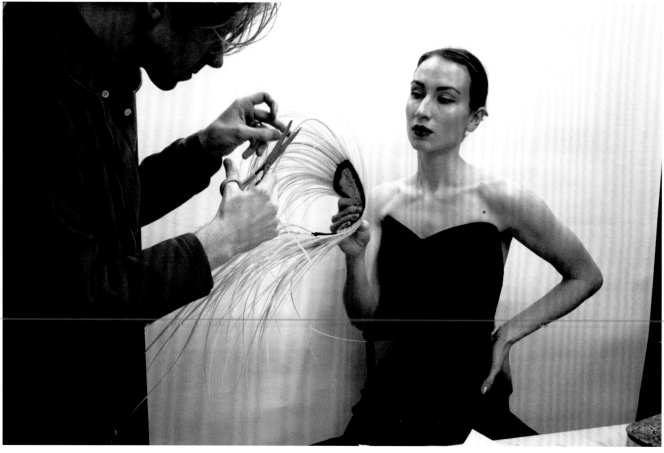

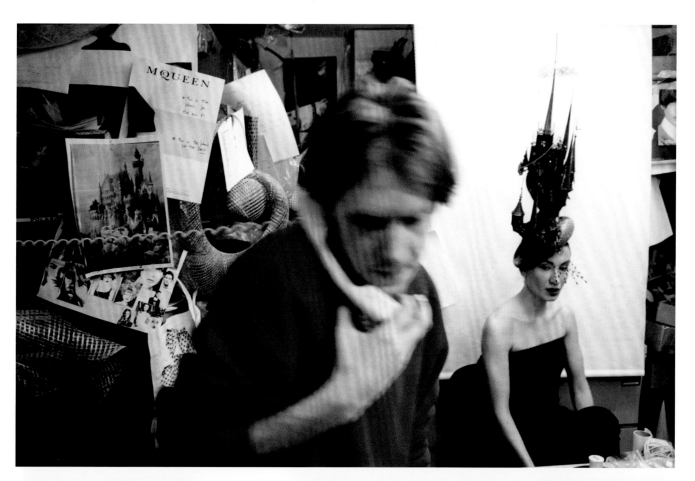

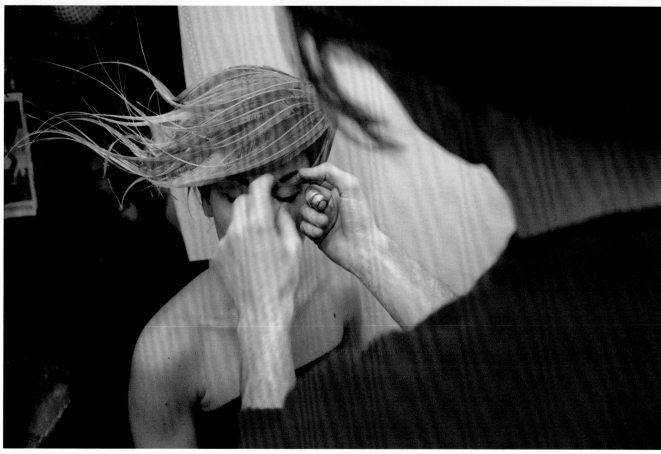

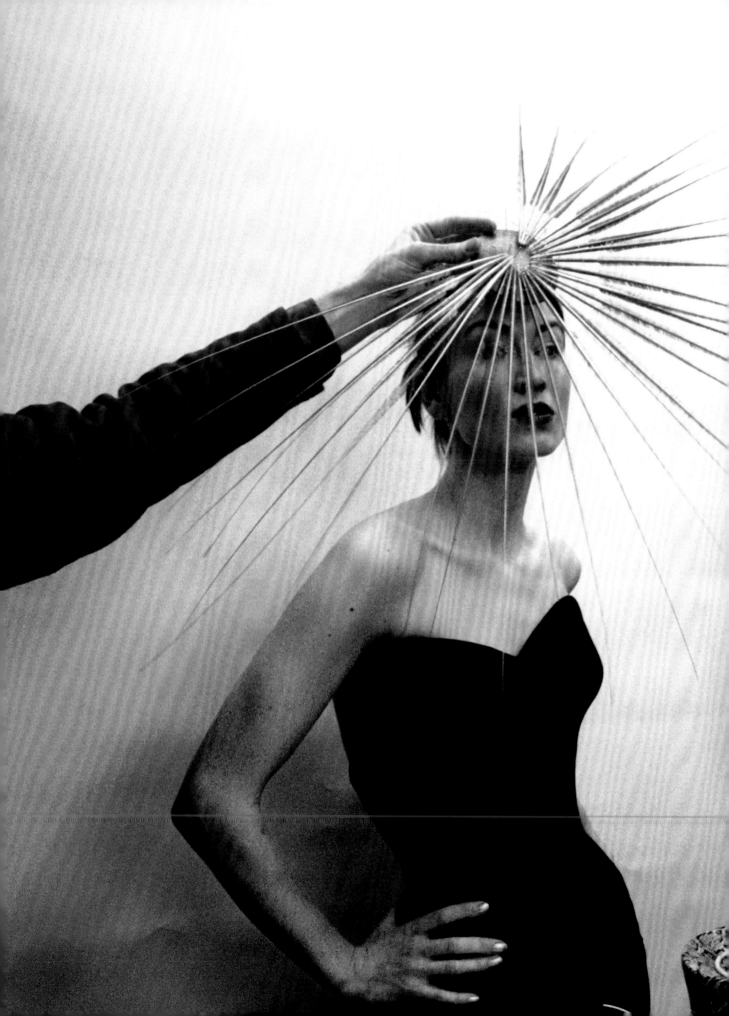

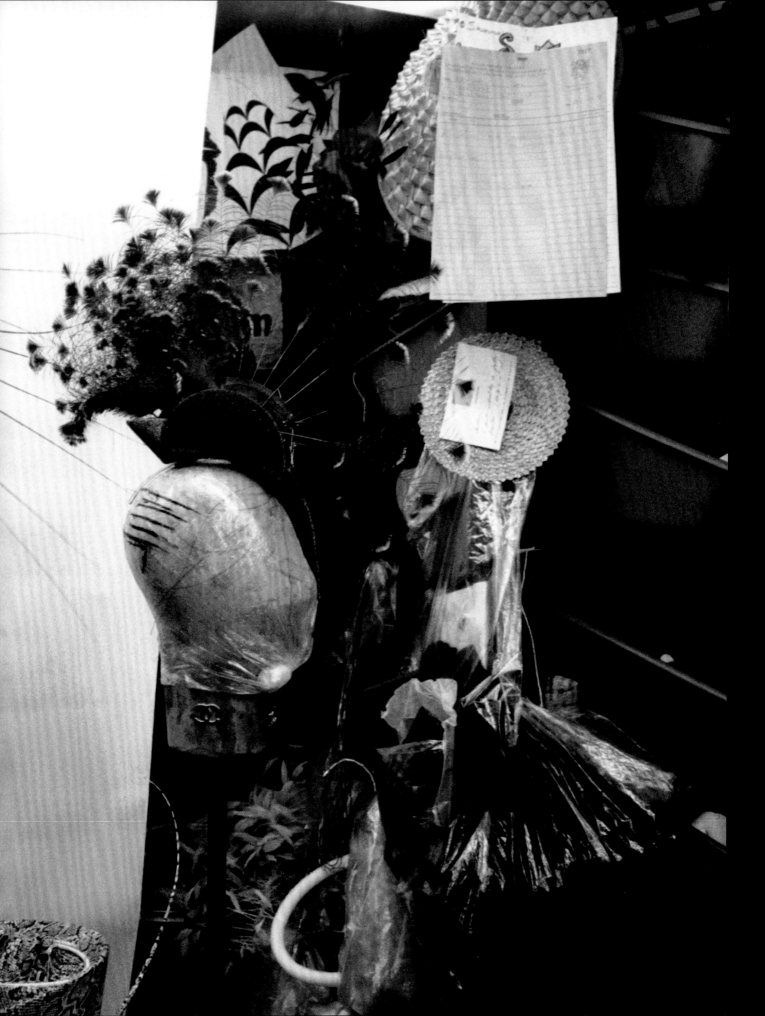

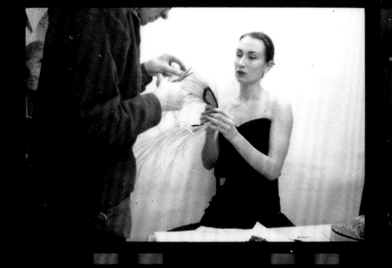
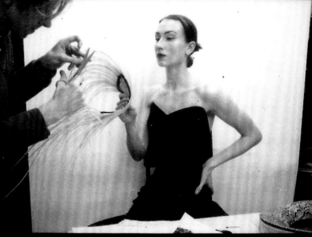

12 NPH400 12A

13 NPH400 13A

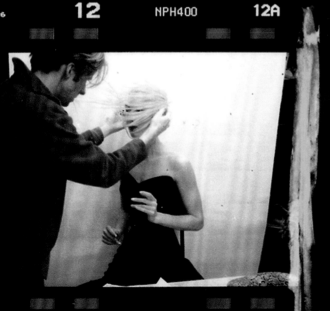
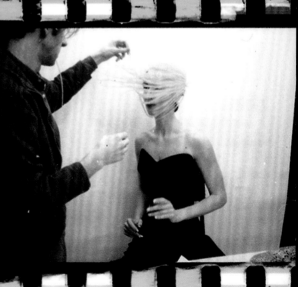

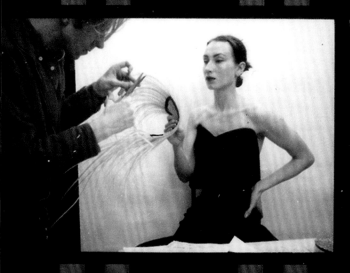 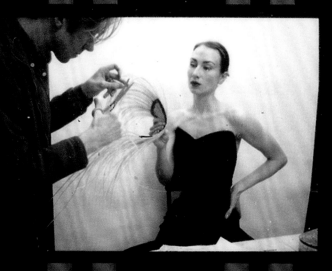

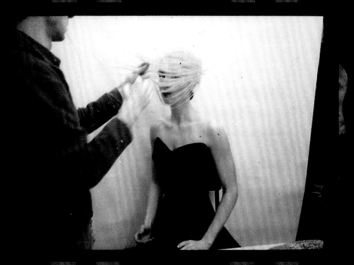 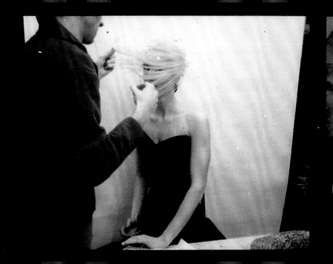

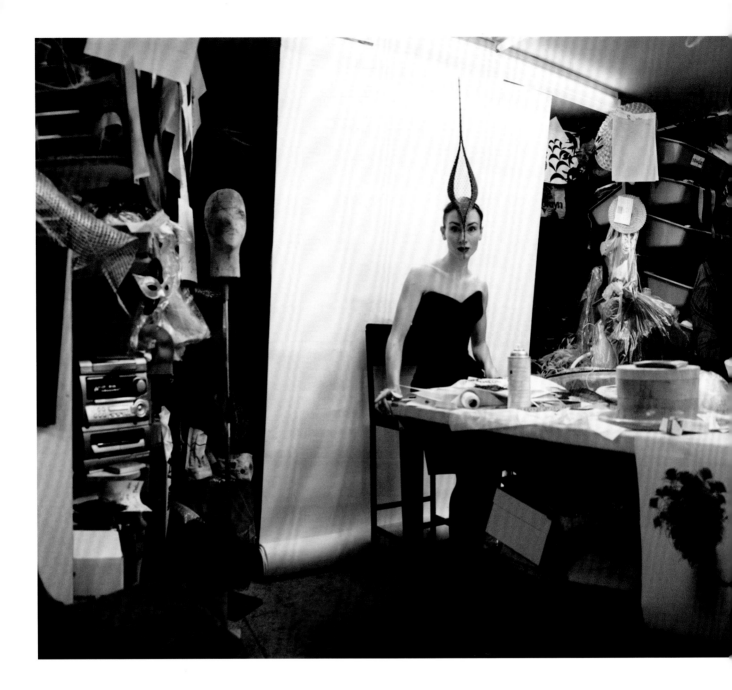

Kevin: The studio could often be a subject
in itself and as it was such a small space, I
thought a panoramic camera would describe
it well and help to take in as much visual
information as possible in one shot. One of
these panoramic images caught a glimpse of
Alla looking into the camera. Almost always
I would discount these frames; it felt as
though they gave away my presence in the
studio. But looking back, that seems a bit
silly now.

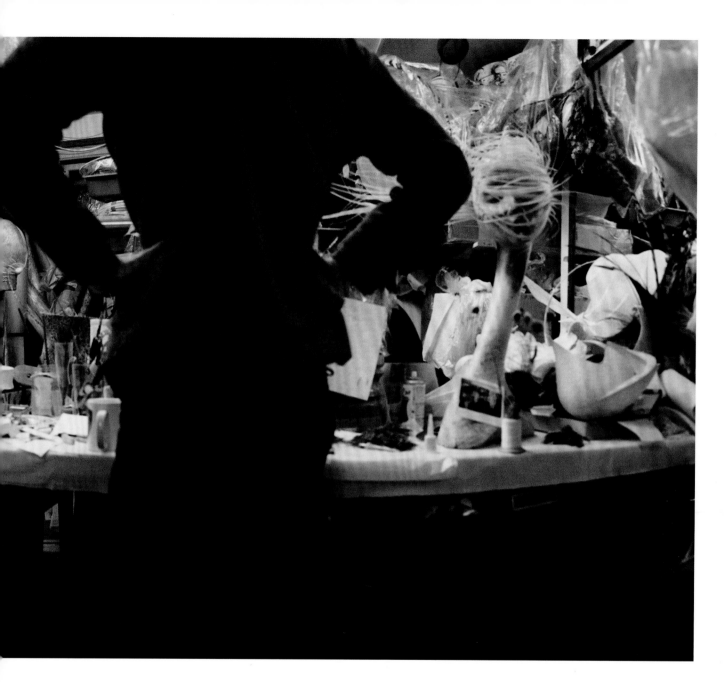

In the studio

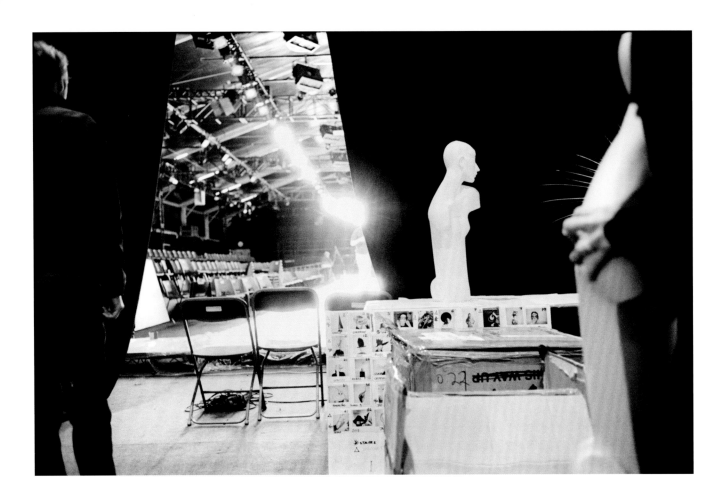

Kevin: This was my first time working back-stage at a fashion show and, despite the low light, I didn't want to use a flash. I wanted my photographs to look more real and less about the fashion. I soon realized that I wouldn't have the luxury of time: everything seemed to happen so fast. Moving out of the safety of Philip's studio felt natural, though. The shows are such a big part of what Philip does, it seemed obvious to photograph them too.

I was particularly caught by the image of Philip looking at the empty catwalk (above). I missed it at first, his figure, peering out across the deserted runway, lost against the black curtain. I like the mannequin, looking in the opposite direction, but now I look back and wonder if would have been a better image if it had been wearing a hat.

After the show, Philip and I spent a long time with the contact sheets. Finally I asked: 'You don't like them?' He replied, 'No, I don't understand them.'

Philip: I love this image (above right): the show is about to start and I'm furiously polishing Grace Jones's conical hat, with her inside it!

Grace is an exceptional artist and performer. There's an expectation that she'll be all over the place but she's always a professional. In the photograph overleaf, I know that she's checking the monitor to see what's going on out on the runway. One of the most exciting aspects of the job is that I get to make up my own mind about the people we see and read about. And Grace was truly a revelation.

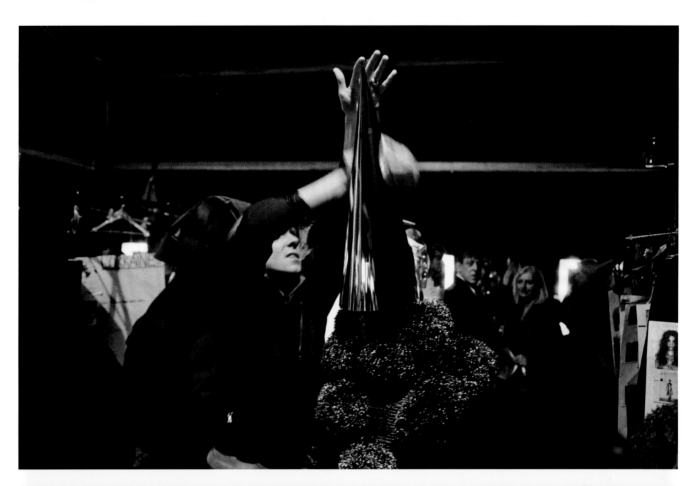

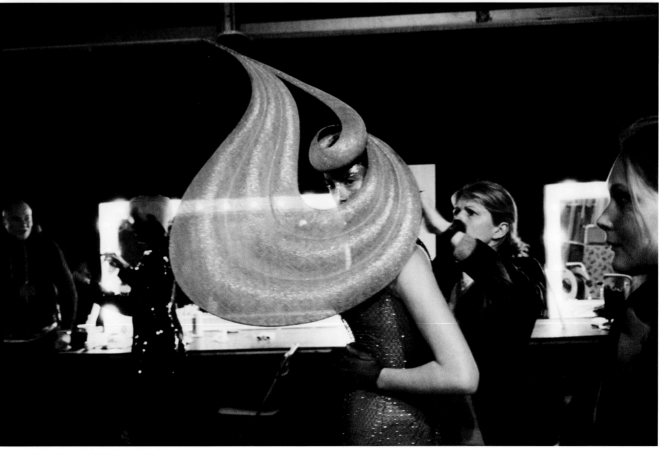

London Fashion Week, Natural History Museum

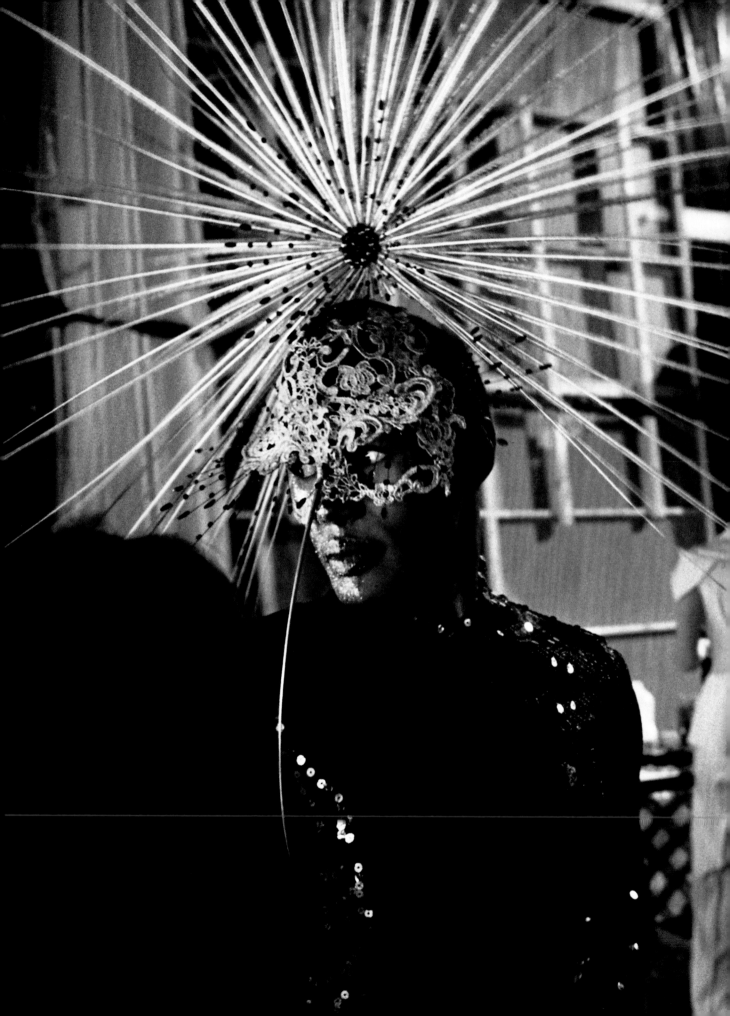

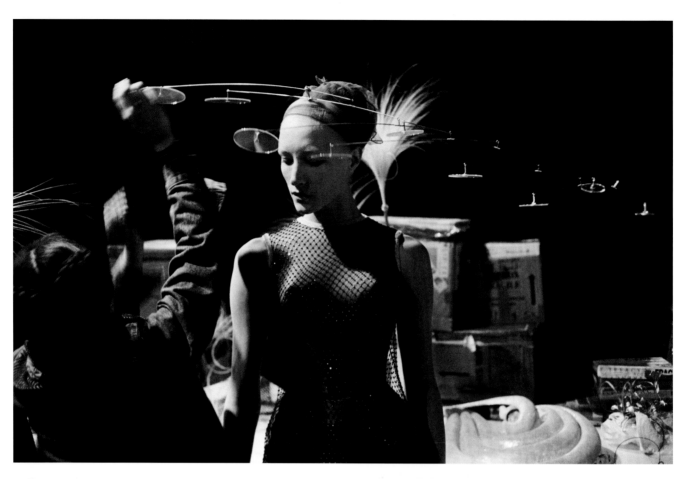

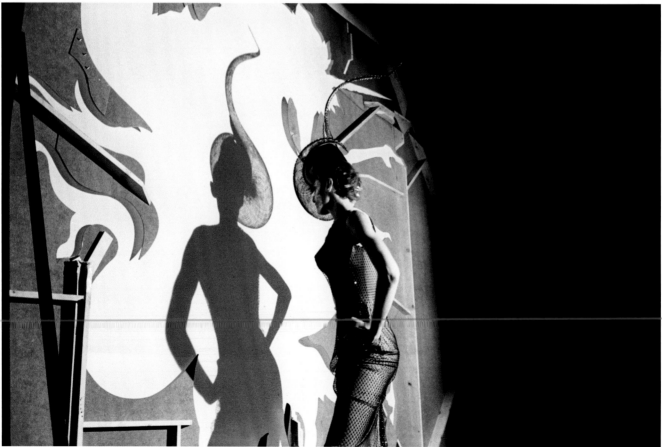

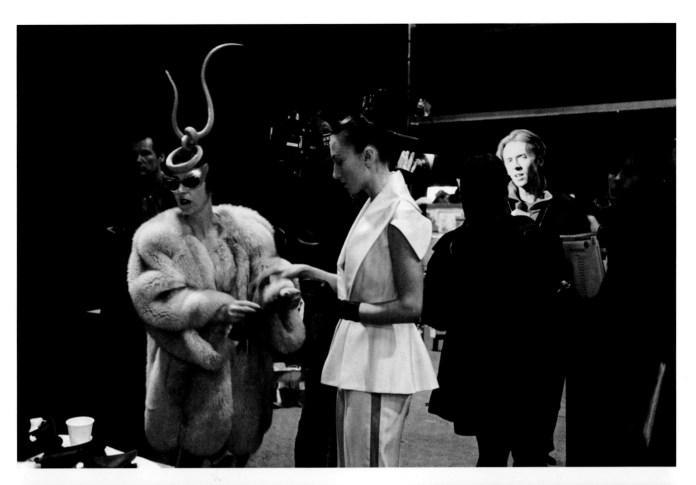

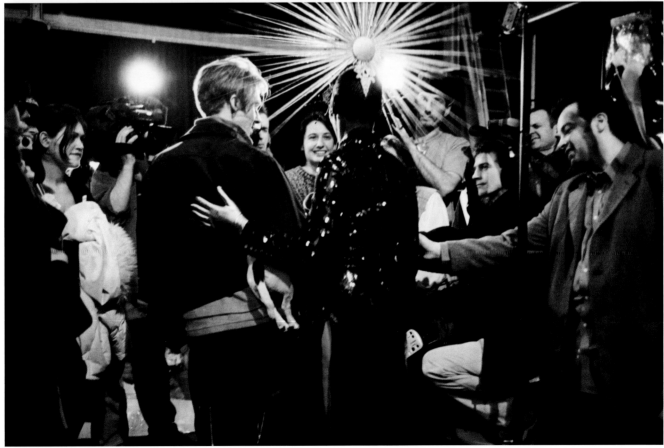

London Fashion Week, Natural History Museum

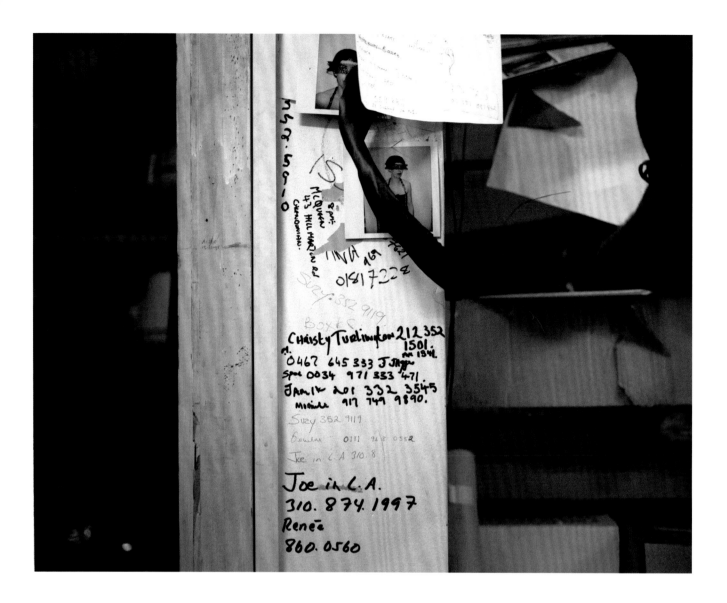

Kevin: I always enjoyed visiting the studio at 69 Elizabeth Street. It was like stepping into another world. Its location, tucked beneath the shop – a showroom designed by Tom Dixon, busy with various women stopping by to buy hats – always reminded me of the aptly named 'underworld' of U2's Zoo TV stage: a messy, chaotic but highly technical control room that remained invisible from the public performance above.

As the final days in the studio approached, I wanted to make a document of the space, empty of people and free from the frenetic hat making. On impulse, it seemed mad not to record the final night. I wanted to capture the abstract beauty of the place, from the colour of the spray paint on the walls (p. 56–7) to the surreal reality that even the bathroom could be like a botanical garden, filled with hats and plants (p. 58), not to mention the boyish appeal of the scrawl of a supermodel's phone number on the studio walls (above).

Philip was moving to a larger studio, and the upheaval was taking place at the same time that my own life was changing, and fatherhood and family life were offering whole new perspectives. Time seemed to be moving faster, and children's birthdays became fleeting markers in the steady progression of our own lives. Suddenly, the luxury of time, which I had taken pleasure in before, seemed to be evaporating. But, in reality, the next stage was only just down the road.

In the studio; last night

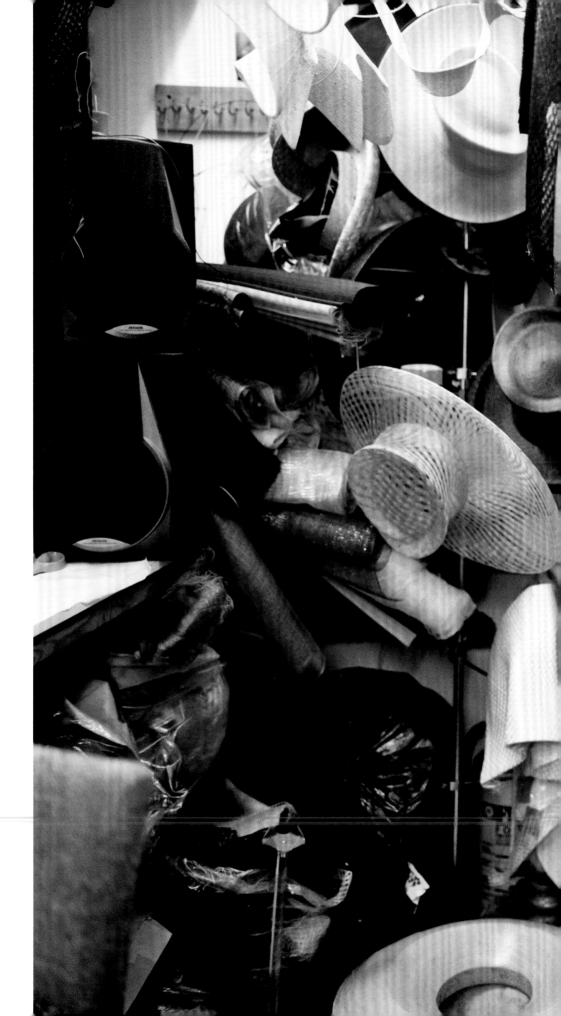

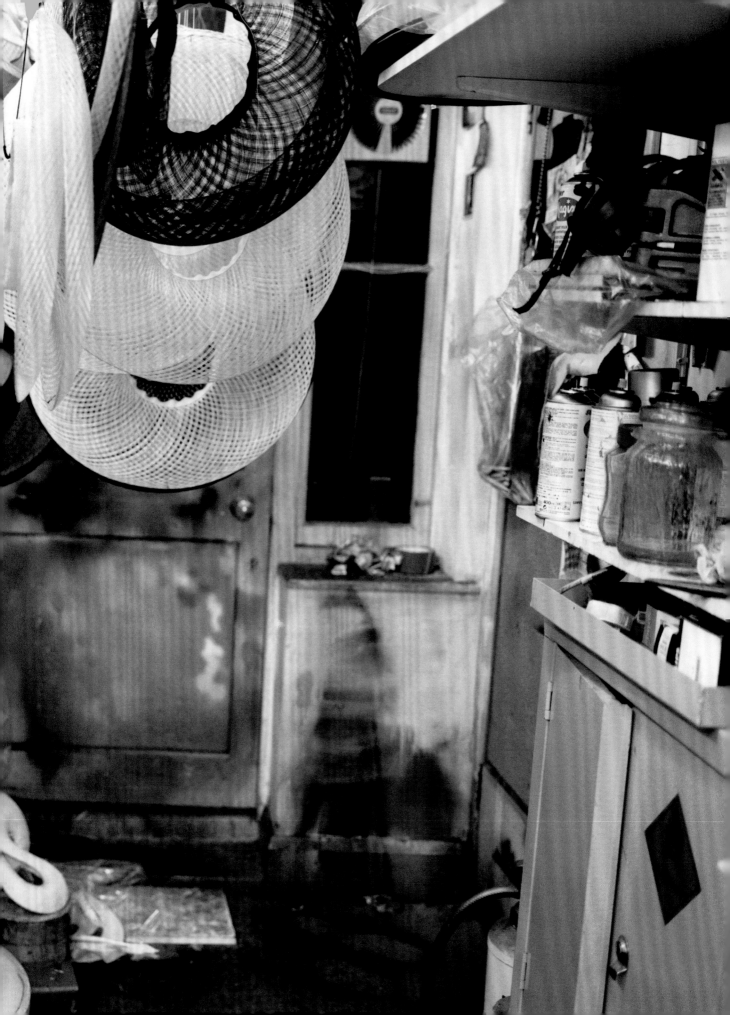

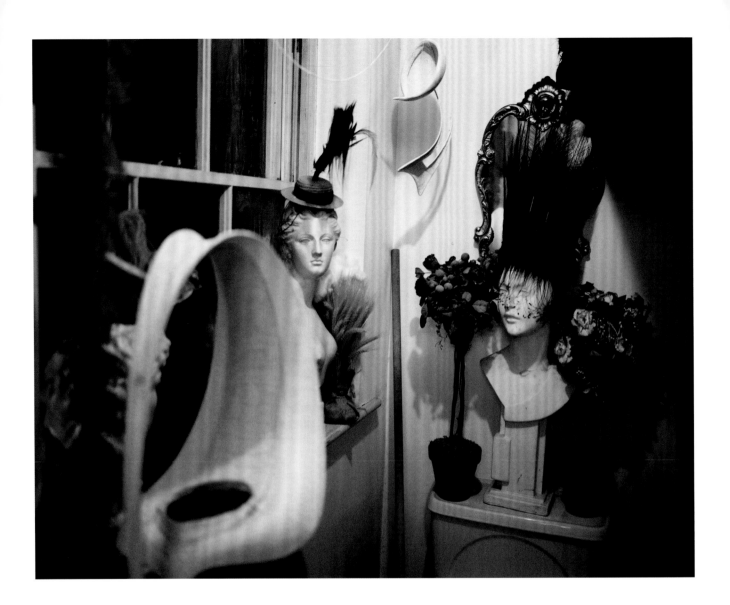

Belgravia Studio
1999—2004

Philip's second studio, which he moved to in 1999, was still in Belgravia, a mere 600 yards further down Elizabeth Street. It took over the whole first floor of the building and had the added luxury of windows to the outside world. The old studio became a fitting room and office.

The new rooms were much larger and included office space and storage. For once, there was plenty of natural daylight flooding the studio from the windows on two sides, although I always seemed to be photographing at night. So it was back to dealing with the strip lights and handling the interesting colour they produced.

For much of the time I was still concentrating on capturing the work in the studio during the build-up to shows. In 2000, Philip was to present his first *couture* show in Paris – the first milliner ever to do so. I wanted to continue the working relationship we had developed. I was encouraged by the kind of freedom I was experiencing at Philip's and the success of the photographs that were emerging, and it allowed me to try and pursue a similar thing with commissions I received for magazines like *The Face* and *i-D*.

It was also around this time that I began to shoot brochures for Philip, focusing on the mainline collections he was now producing. Photographically, the new studio allowed me the space to pull back and shoot wider, bringing in more context. It also meant I was able to follow Philip around the room as he worked on his pieces. In any case, it was certainly less claustrophobic.

I explored shooting Philip at slower speeds, with the camera on a tripod, to try and show how manic it could be. The hat became a still constant in the frame as seemingly tiny adjustments were made and the fast pace of the studio carried on behind.

Although there were now more people working in the studio, loud music still played constantly, and Mr Pig was still always there. It was a mixture of pressure and deadlines with a fun and creative energy. Though I would only be able to come to the studio for a couple of days or nights, the work would be going on at this rate for several weeks.

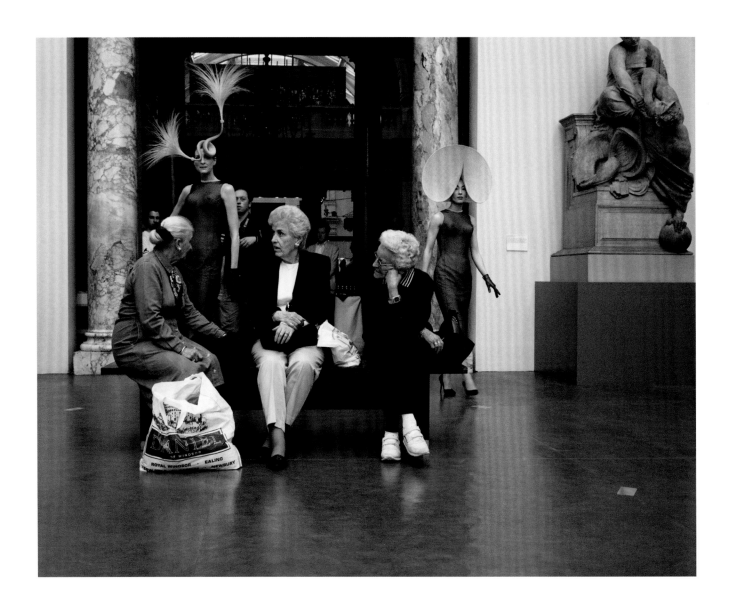

Kevin: Philip was the first designer invited to do Fashion in Motion, a monthly live catwalk event at the Victoria and Albert (V&A) Museum in London. I believe the museum wanted to bring fashion and the exhibits to life, using models walking through the static museum displays, as if in a runway show.

Although the V&A offered to supply their own photographer, Philip asked me if it was something I would like to do. I guess it was a sign that our relationship was developing and that he understood my photographs more.

The Cast Courts are my favourite rooms in the museum, particularly because the daylight there has a wonderful quality. The hats seemed to beautifully complement the backdrop of statues, busts and architecture. Added to this were the incredible Antony Price dresses with moulded breasts and Swarovski crystals, and the occasional visitor, apparently unaware of the fashion show happening around them. These things combined to make the photographs all the more surreal.

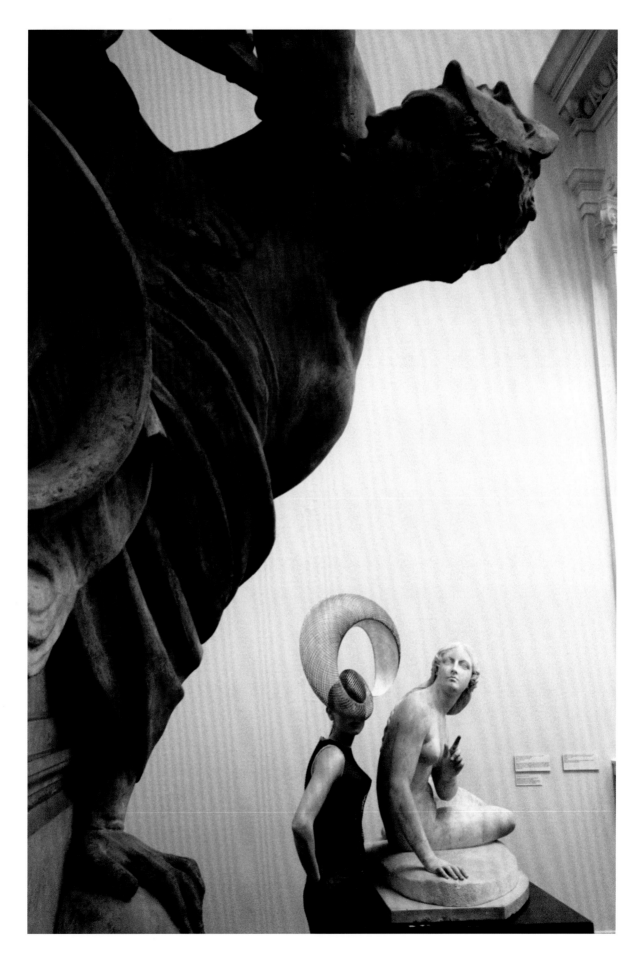

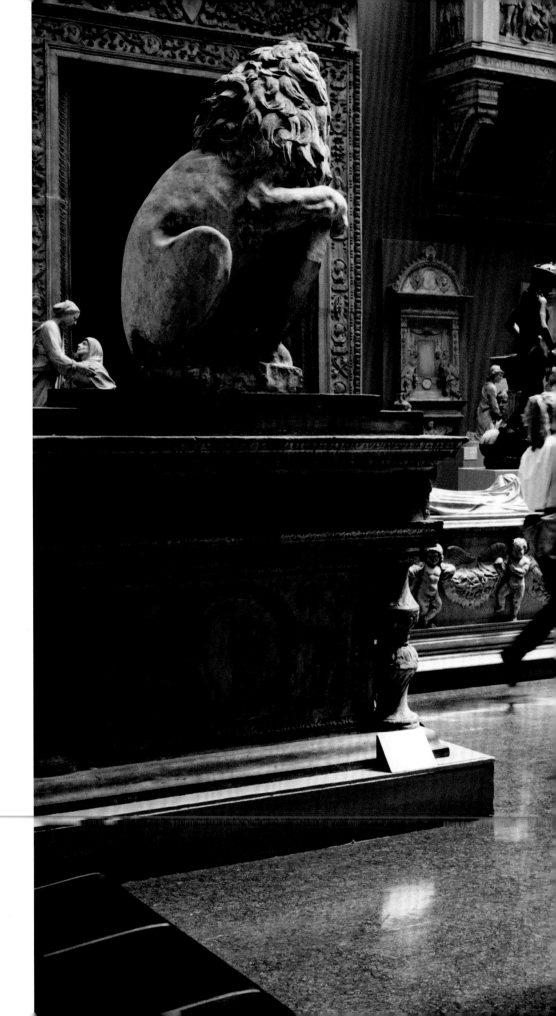

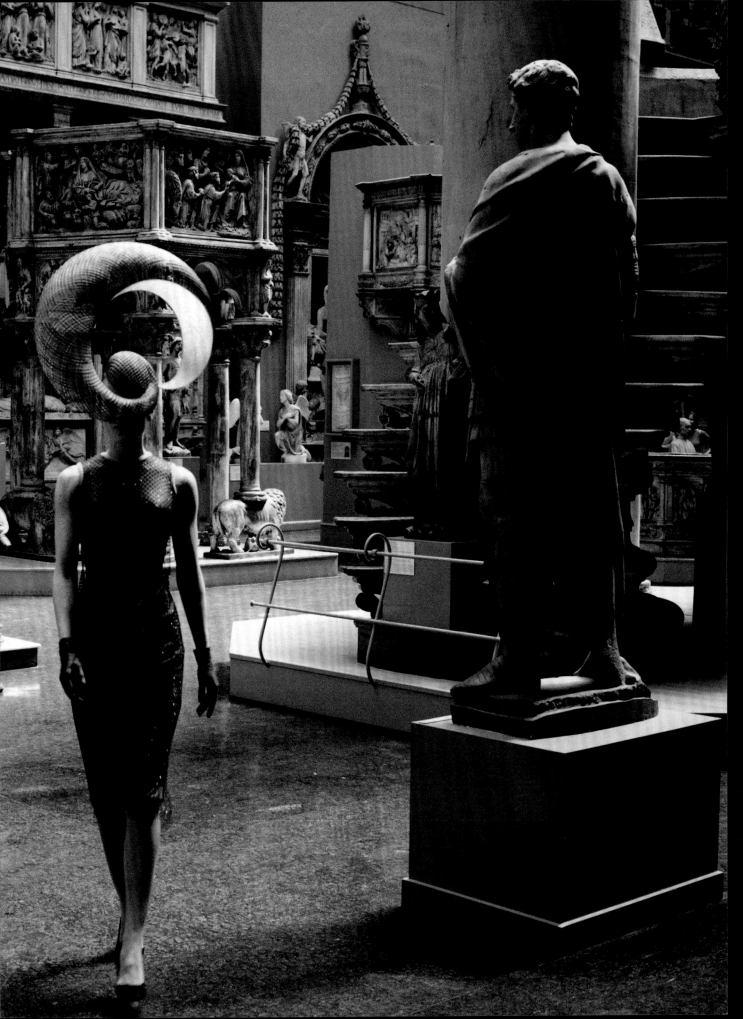

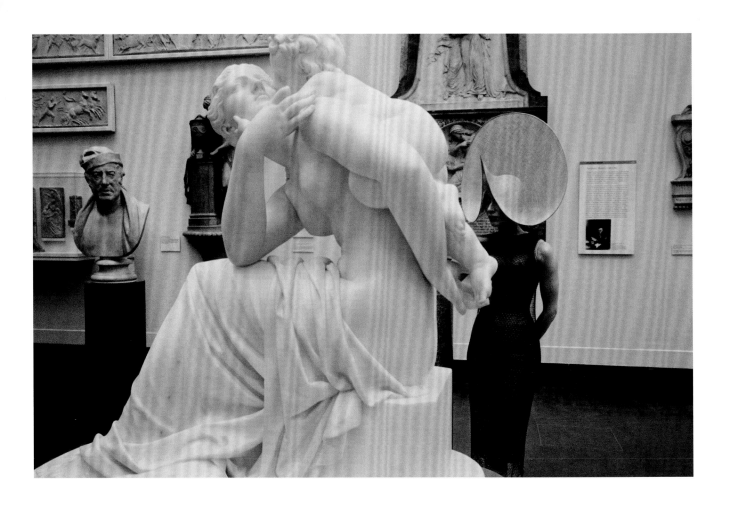

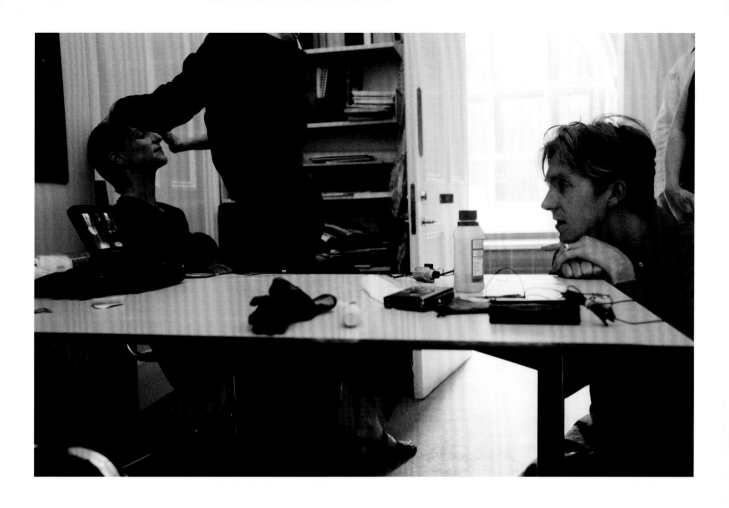

Kevin: The studio is always busy but it is difficult to describe in words just what it was like when Philip was working towards an event, particularly the large collections, and in January 2000 he was preparing for his first major *couture* show.

Of course, there was pressure and stress, long days and late nights, and more people were drafted in to help; it was a very exciting and creative environment. Philip often played rough mixes of the soundtrack that Dan Donovan, his music director, had created. I guess the music is an important part of the mood. Despite the long hours, Philip seemed to have endless energy and was extremely focused, and somehow constantly upbeat.

Philip: My favourite possession in the world is this wooden mannequin head from the 1960s (right). When I was growing up, hairdressers in Ireland had mannequins like this, but covered in hair. I bought this one back when I was in college and every shape and every hat I've ever made has been designed on it. It's elegant and it has attitude.

The time I spend preparing for a show is some of the most difficult of my life. The pressure is intense. Sometimes it can feel like a runaway train, hurtling towards its destination – it's going to arrive and there's nothing you can do to stop it.

We would probably have only about three to four months from the original concept for a show to its final execution. Everything has to come together at the right time, it's like growing a show out of thin air.

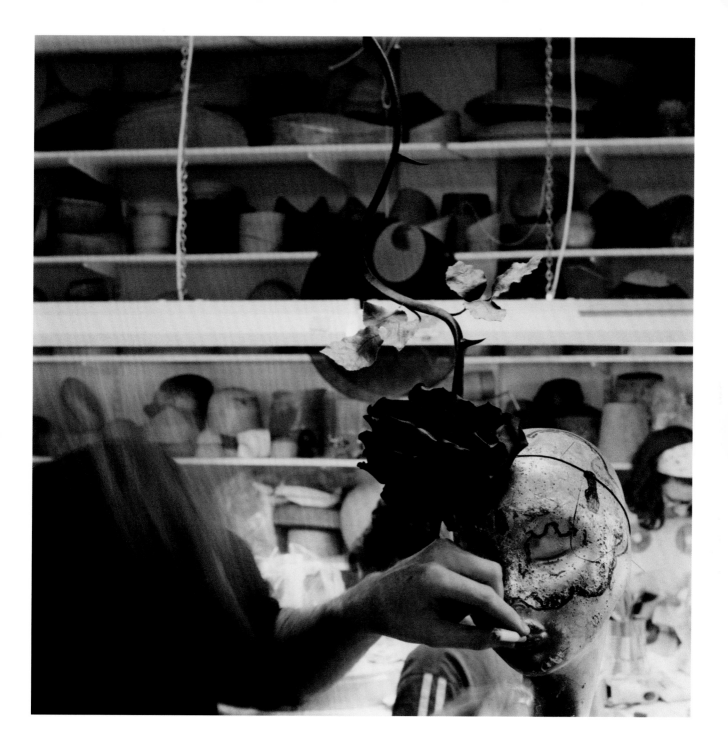

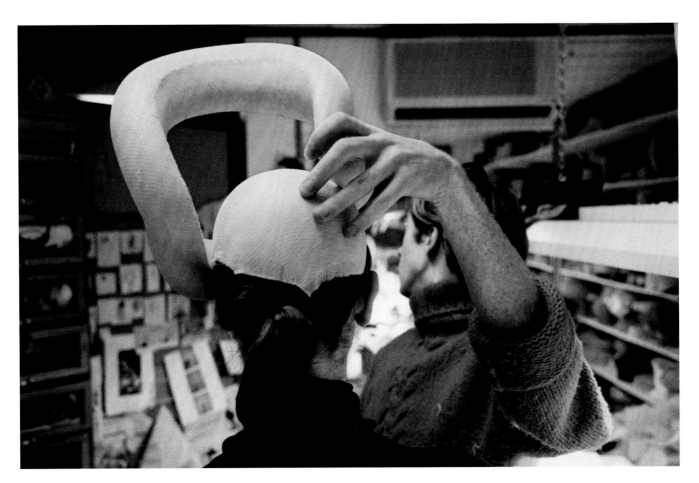

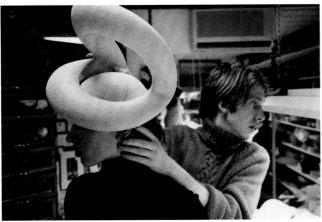

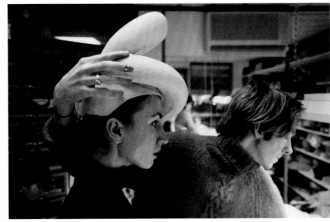

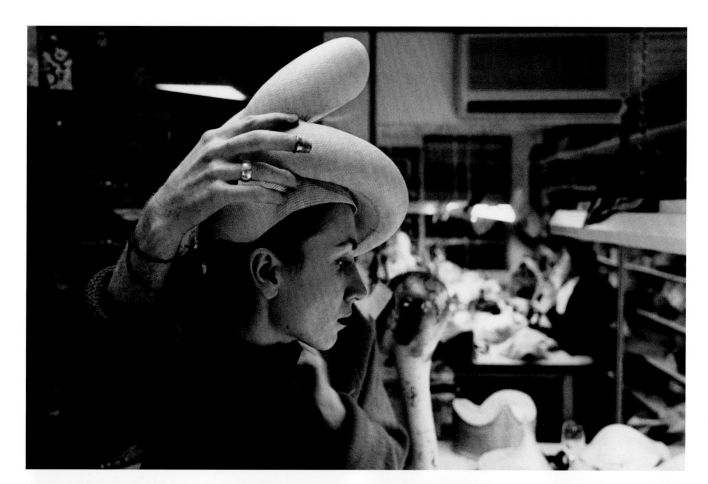

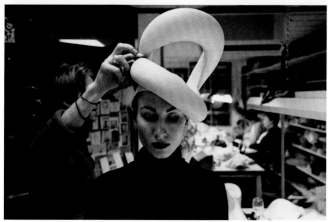
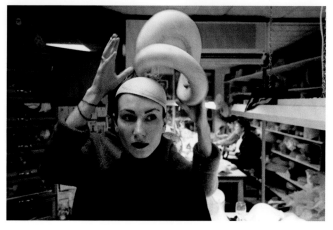

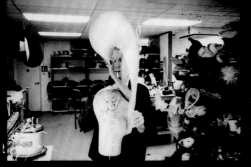 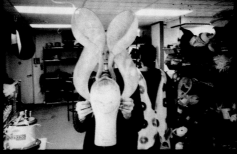 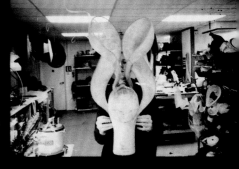

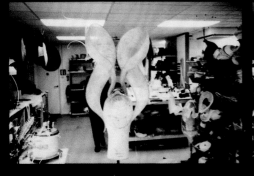 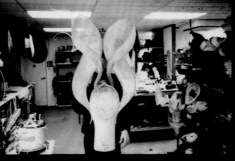 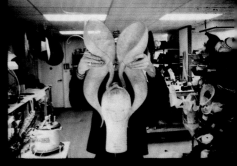

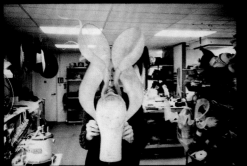 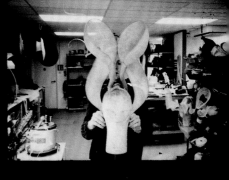

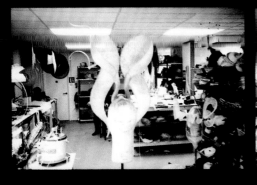 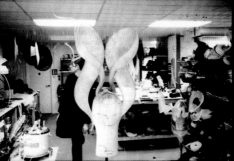 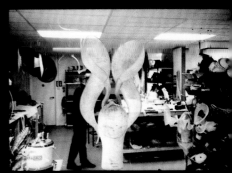

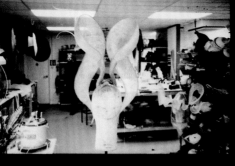
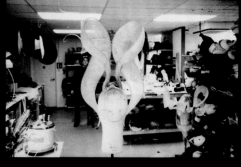

2A 3 ▷ 3A 4 ▷ 4A 5
5063 TX 9 KODAK 5063 TX 10 KODAK 5063 TX 11 KOD

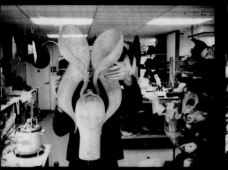
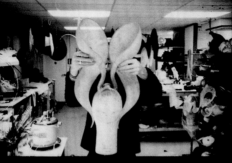
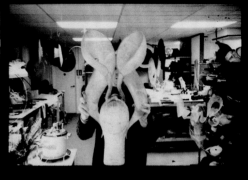

8A 9 ▷ 9A 10 ▷ 10A 11
5063 TX 15 KODAK 5063 TX 16 KODAK 5063 TX 17 KOD

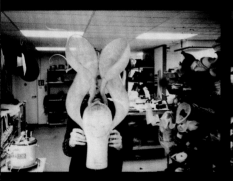
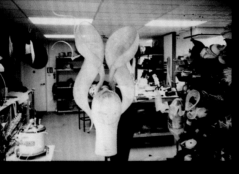
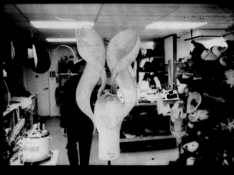

▷ 14A 15 ▷ 15A 16 ▷ 16A 17
20A 21 ▷ 21A 22 ▷ 22A 23

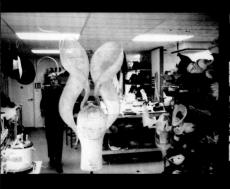
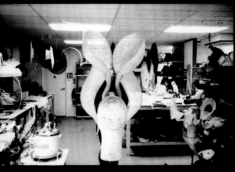
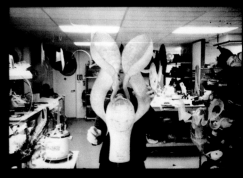

20A 21 ▷ 21A 22 ▷ 22A 23
5063 TX 27 KODAK 5063 TX 28 KODAK 5063 TX 29 KO

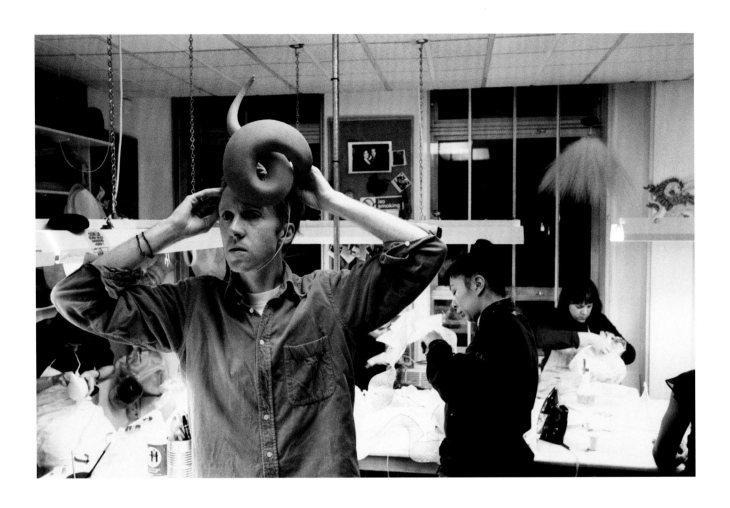

Kevin: I tended to photograph everything that
was happening, without considering its value
or interest. It seemed better to make decisions
later about what worked or didn't. I don't
remember Philip saying, 'please don't take
a picture of this', even when photographing
something like him getting his hair caught
in a headband. At that time there was no
grand plan for the pictures and our friendship
continued, along with our trust.

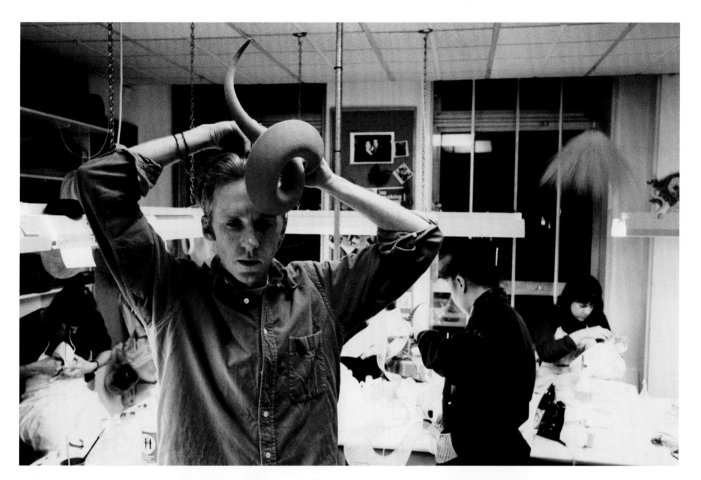

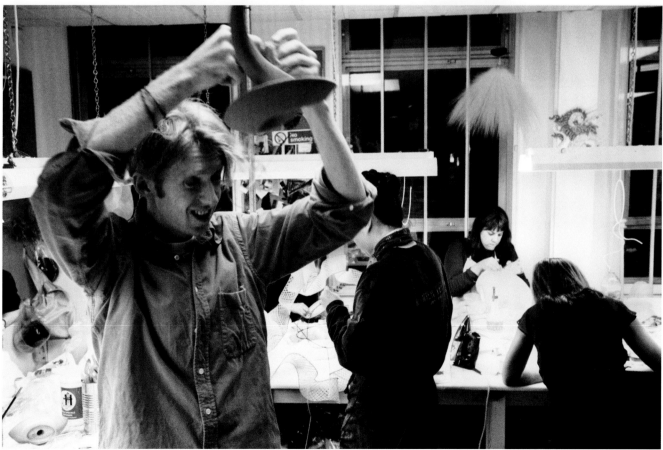

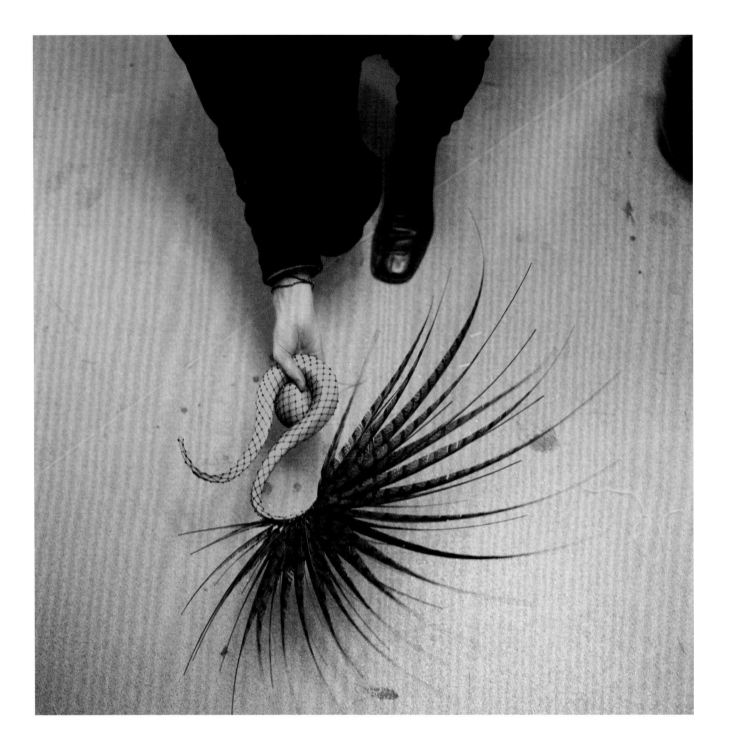

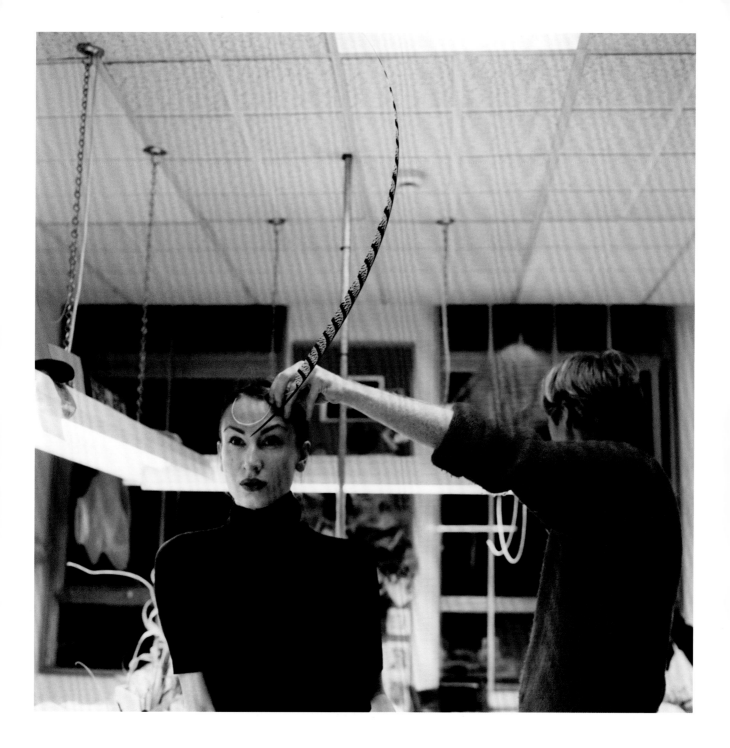

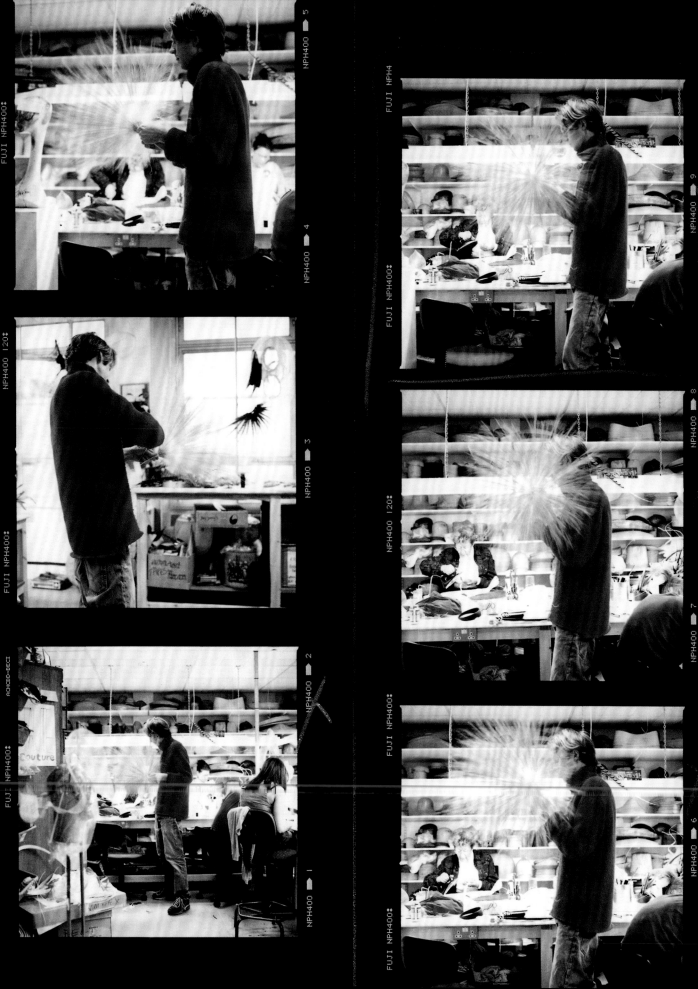

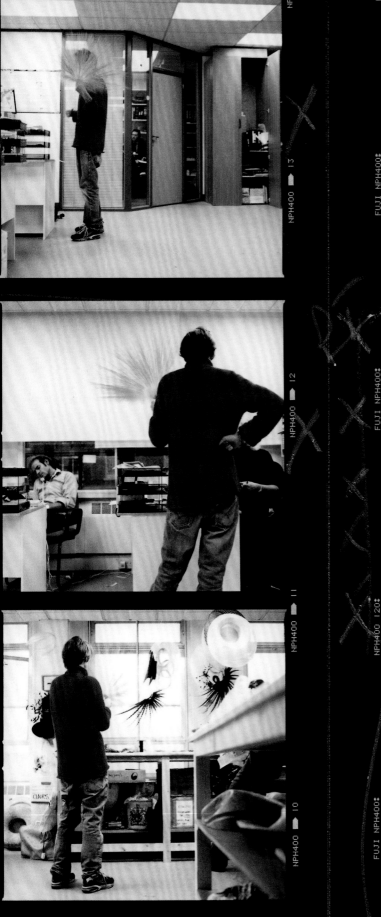
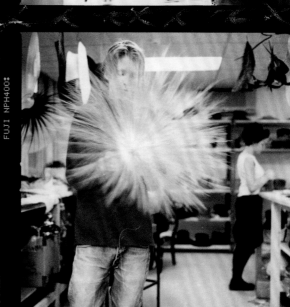

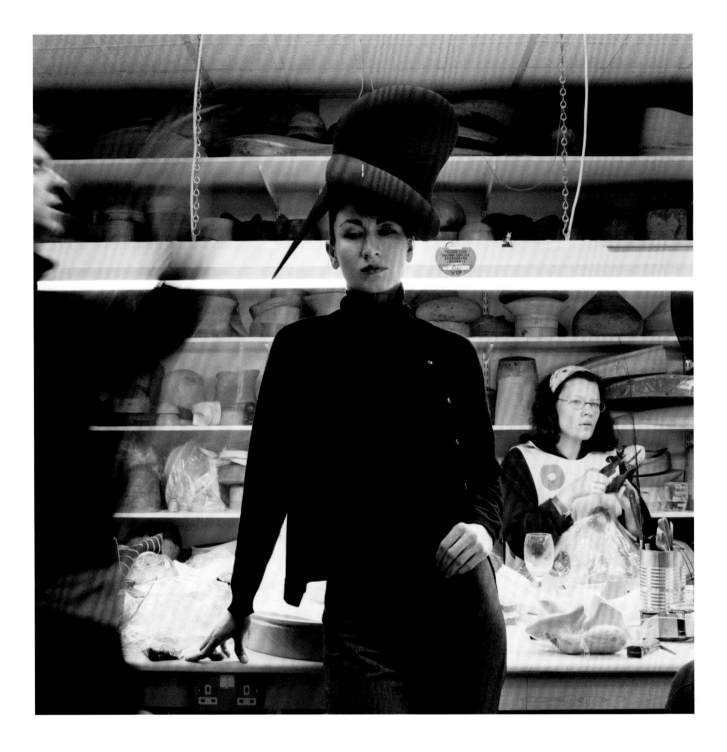

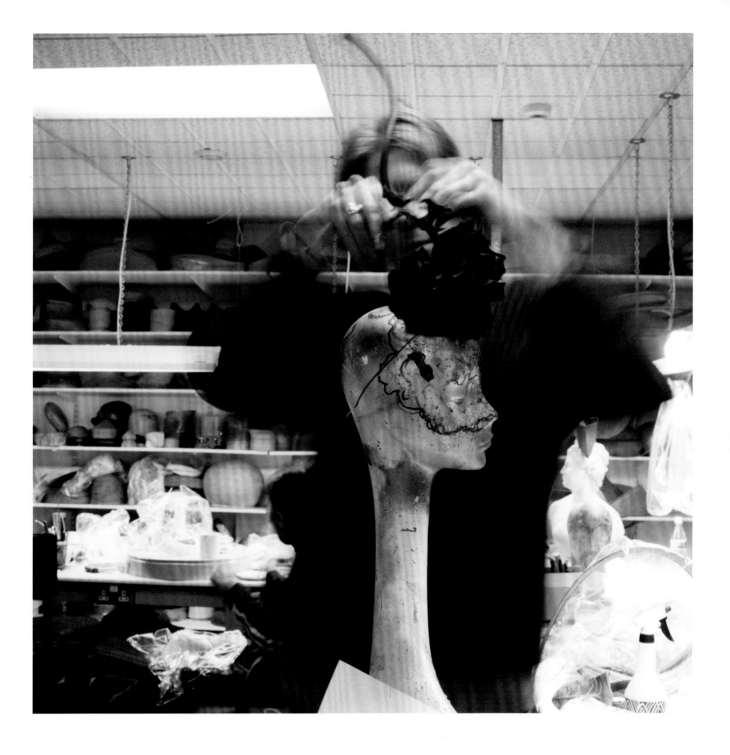

Kevin: In January 2000, Philip presented his Orchid Collection during Paris Fashion Week, at the invitation of the Chambre Syndicale de la Haute Couture. The venue for the show was the Hotel George V in Paris. It was a hugely important event, as Philip was the first milliner to be invited to show *couture* at Paris Fashion Week, and everything was on a much bigger scale. But I knew more about what to expect now. By this point, I had assumed that Philip liked having me around; I am low maintenance, and not having a flash and stepping back helps with not getting in the way.

The workroom was quite a surprising environment, but great visually. The French opulence of the rooms contrasted with the rather raw practicality of running a show: multiple workstations and boxes of materials were spread out behind screens and matted power cables would disappear beneath the ornate patterned carpet.

When I saw the boxes it struck me that people might not consider just how awkward it is to transport such fragile objects. The hats are incredibly delicate and they looked particularly beautiful in their packing cases, like museum artefacts, cushioned and framed by bright white tissue paper. It seemed logical to capture them in this environment, before the pressure of the show began.

Philip: This was our workroom at the Hotel George V, Paris (right), and we were working on the hats right up to the last minute.

All of the travel boxes would be specially made before the show. After spending so long working on them, it's incredibly important to keep the hats safe.

In any fashion show, it's the models that bring the clothes to life, and it's just the same with hats. Without the models they're just inanimate objects. It's the combination of hat and wearer that creates the personality.

I've always been incredibly lucky to have the most beautiful girls working with me on our shows. Models are amazing women; they live their life on the road, travelling and staying in hotels – it can be a lonely lifestyle – but they're giving up everything for beauty and elegance.

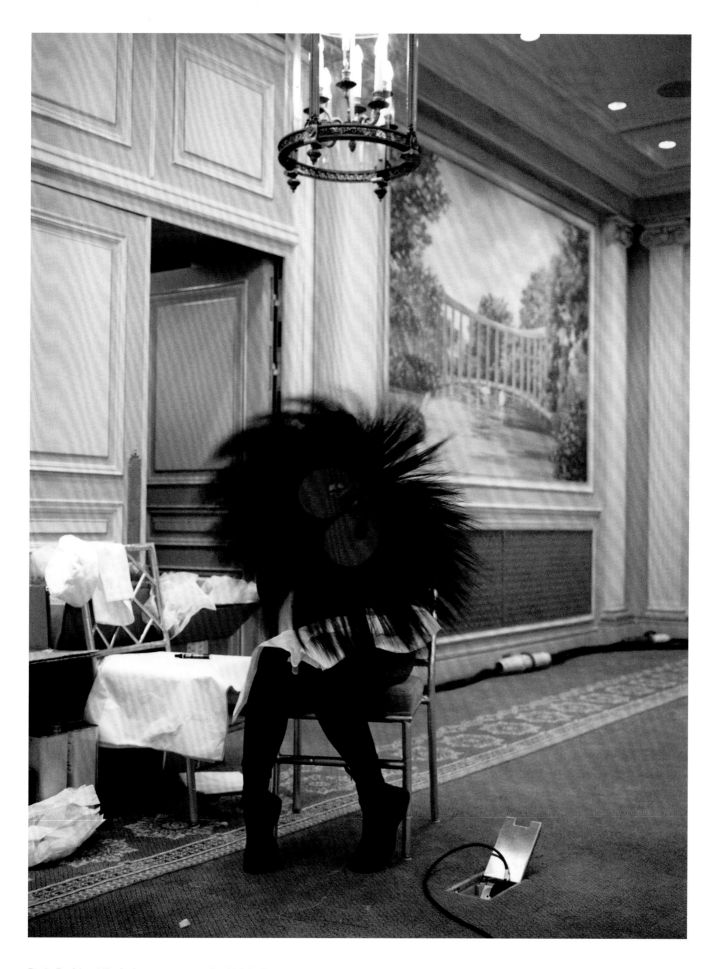

Paris Fashion Week; *haute couture* Orchid Collection

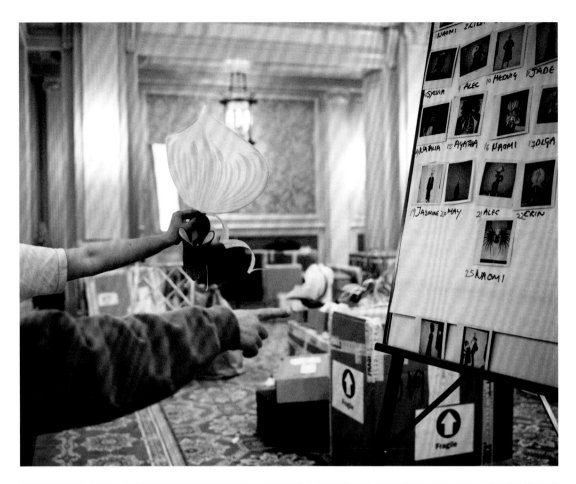

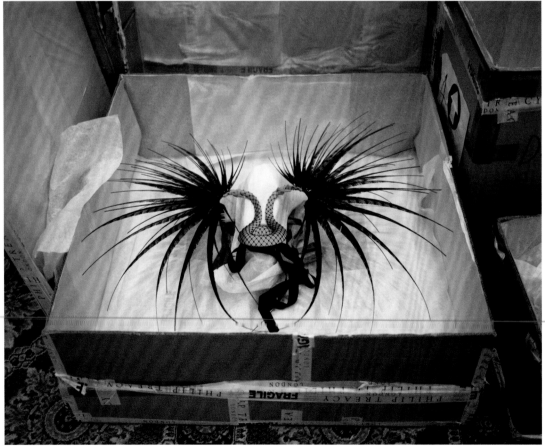

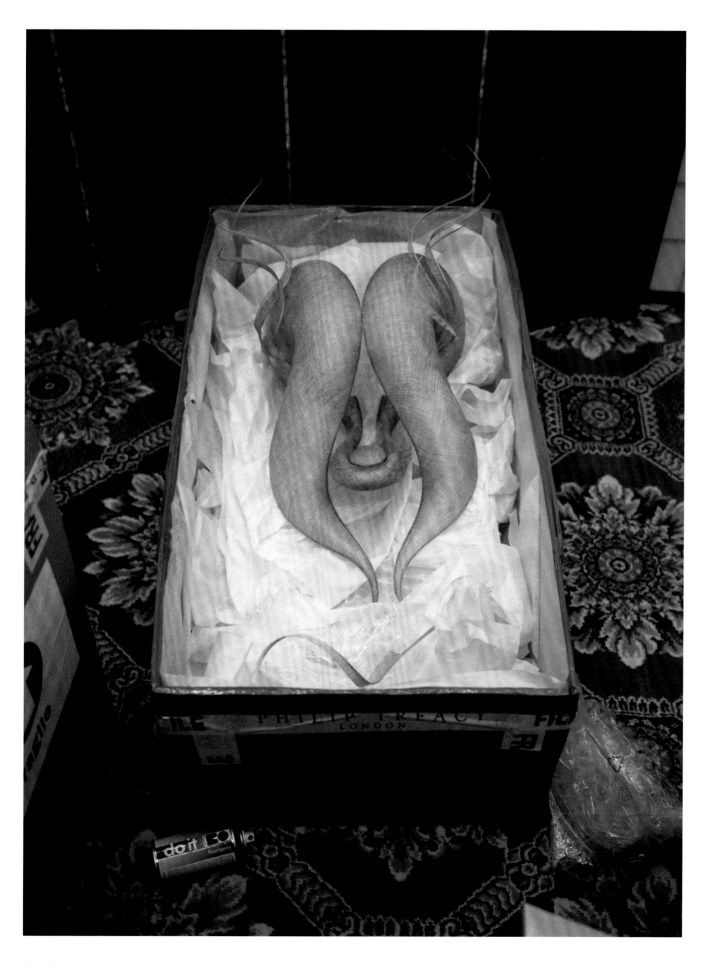

Paris Fashion Week; *haute couture* Orchid Collection

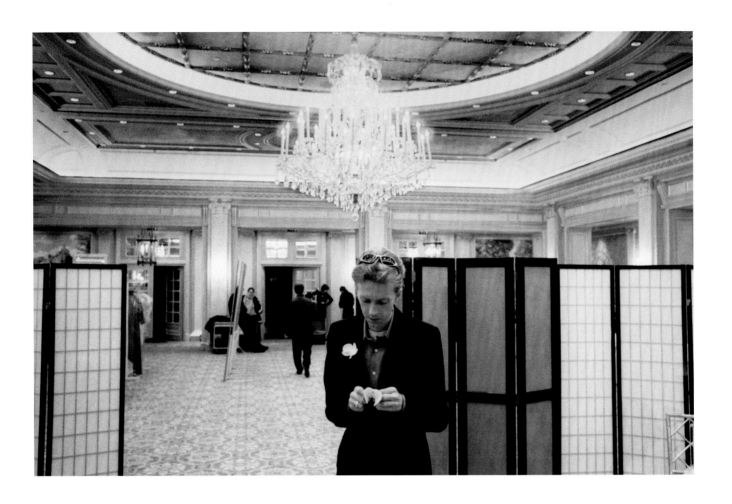

Kevin: Some of the hats were still being finished or even created at the venue. Philip asked me to stand beside him so that I had the best view of the models as he made his final checks before they were sent down the catwalk. It was thrilling.

Philip: The moments just before a show, as the models prepare to go on, are always the most exciting and chaotic. There's an energy and you have no control over it. I like to let the models do whatever they feel like out on the runway. They take their energy from the hats and it's always surprising. Hats are such an empowering force.

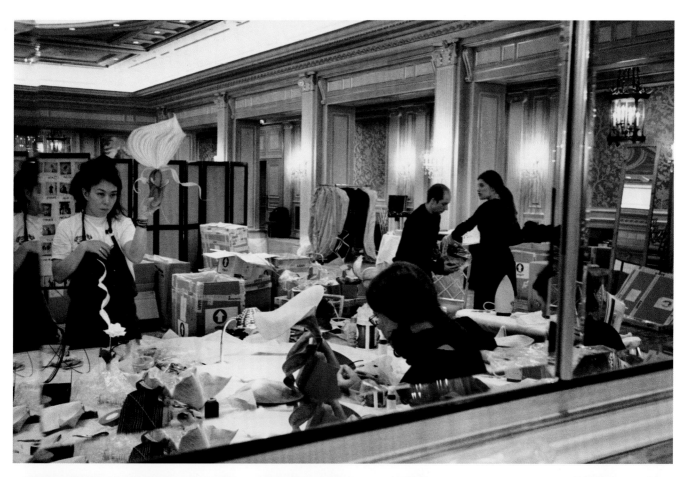

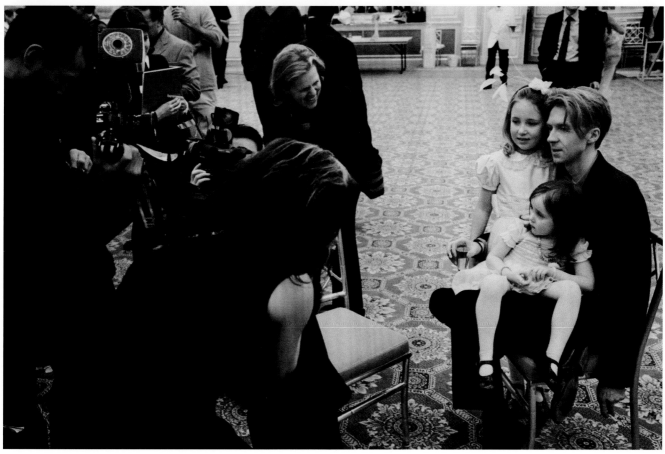

Paris Fashion Week; *haute couture* Orchid Collection

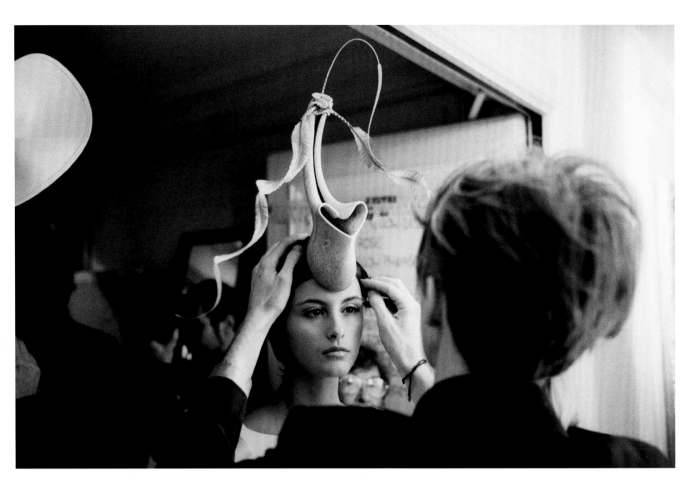

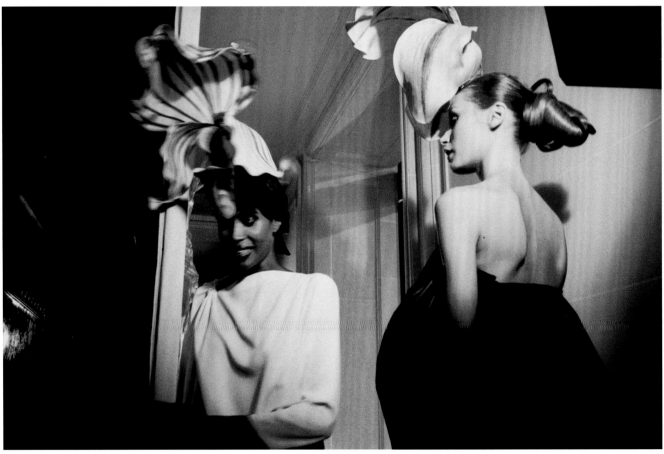

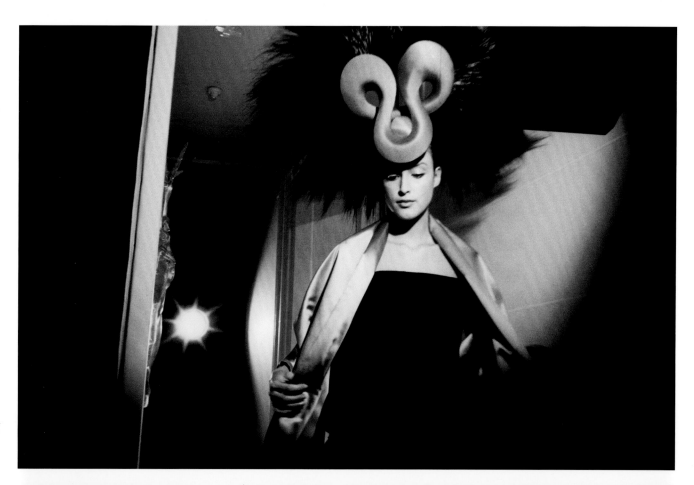

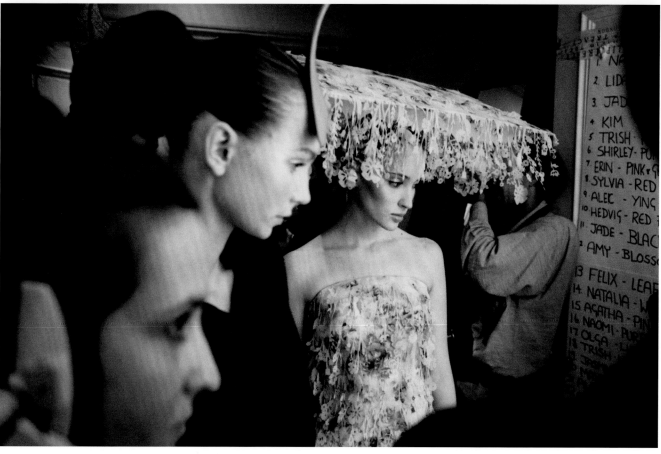

Paris Fashion Week; *haute couture* Orchid Collection

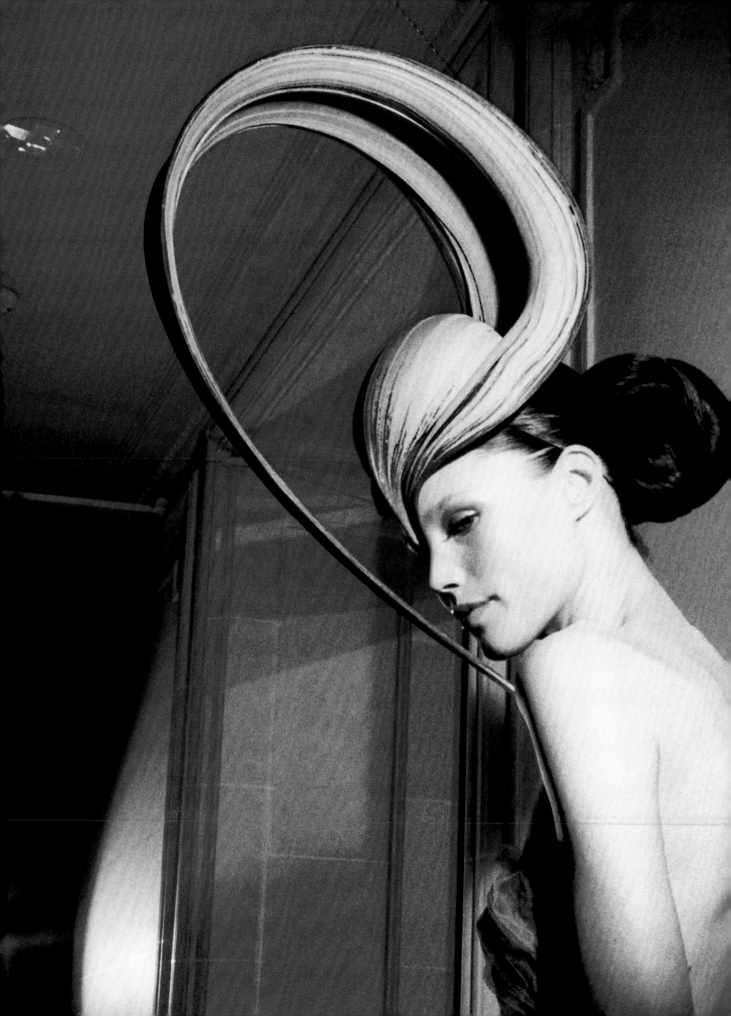

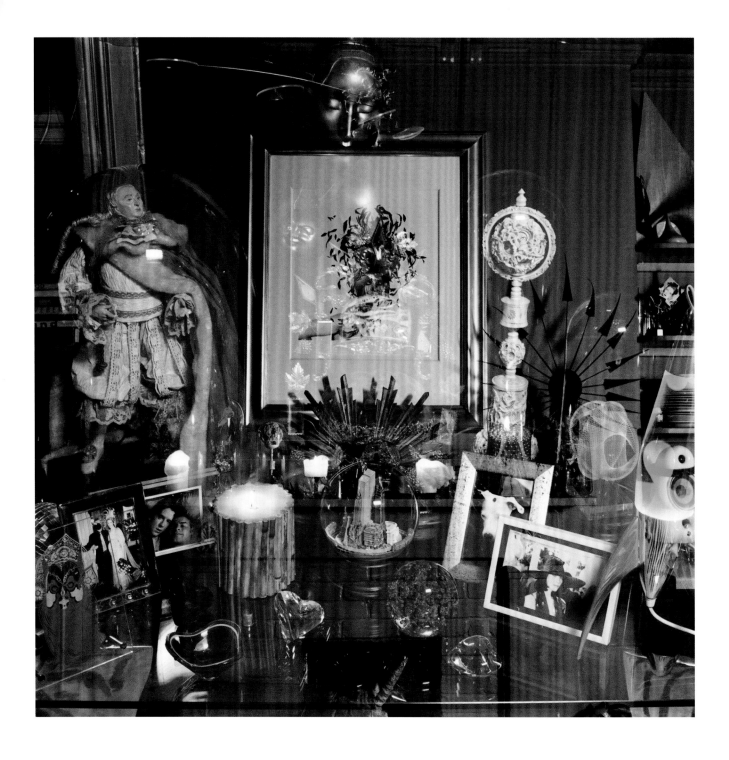

Kevin: I was commissioned to photograph Philip in his home, and a happy accident led to this double exposure. Less happy was the fact that the light stand accidentally fell over, crashing through the glass dome on the table. To this day, Philip has never mentioned it.

Philip: This hat (right) was made for Yasmin Le Bon. It was worn in my very first catwalk show, which featured all black hats, held at Harvey Nichols department store as part of London Fashion Week in 1993.

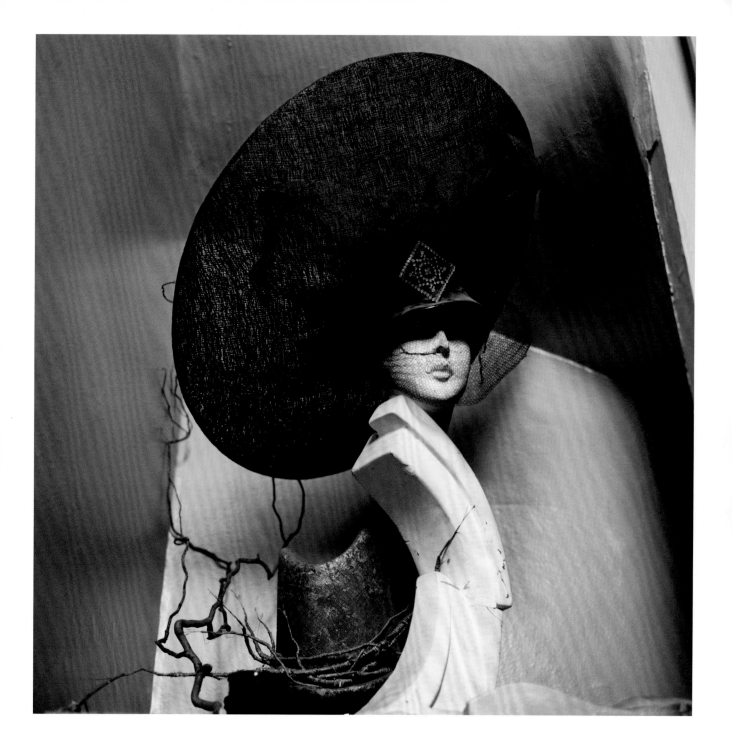

Kevin: Philip asked me to join him for the preparations for Naomi Campbell's outfit at Ascot in 2002. I had met Naomi a few times before, and this was her first visit to Ascot. Philip wanted a record of the hat for himself, something other than a commercial image or a paparazzi shot. He convinced me it would only take a couple of hours. Of course it took quite a lot longer than that.

The whole day was quite surreal. Naomi was not at the hotel she was supposed to be in, and the place where she actually was felt as though it should have been perched on the side of a Swiss mountain. Although we were now just a short helicopter ride away from the event, inevitably we seemed to be running late. It was just the four of us in that room: Philip, his partner Stefan, Naomi and myself. There was no hairstylist or make-up artist; Philip did all the styling himself.

Helped by the bright, sunny weather and the Disney-esque location, the day's events had a sort of fairy-tale ending. It wasn't until I looked at the film a few days later that I realized that the images played out like a mini photostory: in the final photographs it appears as though Naomi is being whisked away to a wedding.

Philip: I'm a great fan of Naomi. She treats the world like it's such a small place – Tokyo one morning, Rio in the afternoon – and I love that about her.

On this day, she had just flown in from who-knows-where, and she was getting ready to go to the races. It was her first visit to Ascot, and she was excited about it.

When she was available, Naomi would always model for me in my shows, and never for a fee. She hadn't demanded that I come to Ascot, but I felt it was the least I could do. When I arrived I saw that her dress needed ironing, so I simply offered to help. She had called with maybe a week's warning. I must have known her outfit was going to be all white so I just winged it and created her a hat that I knew would make her look amazing. To make a stunningly beautiful woman like Naomi look even more so is a thrilling experience.

She was supposed to travel by helicopter to Ascot, but by the time she was ready to go, we were running so late that a no-fly zone had been set up around the venue. An open-top Bentley was quickly found as a replacement. I will always remember the young waitresses at the hotel coming out to see her. She's so beautiful in the flesh that you can't just look – you stare.

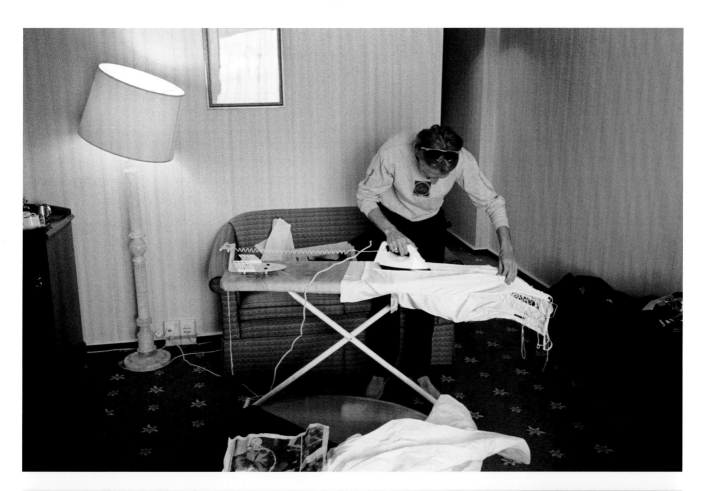

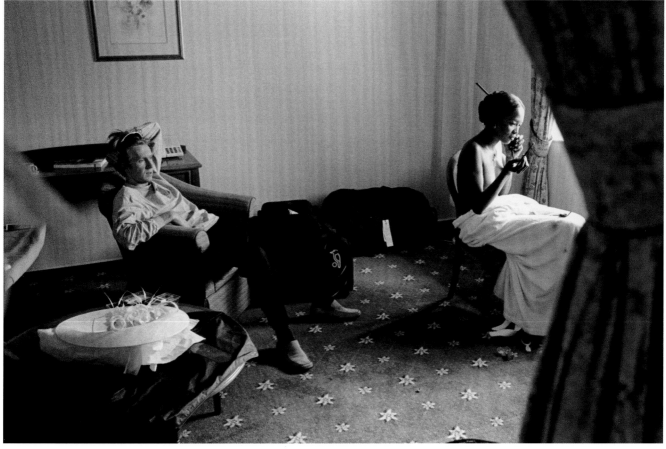

Naomi Campbell, Royal Ascot

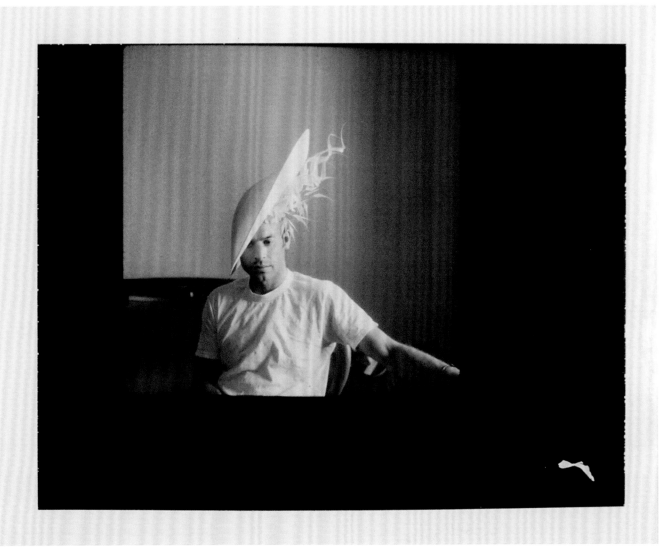

Kevin: I often take a Polaroid attachment for my camera with me on shoots, to make sure the camera is working properly and to check the exposure. I asked Stefan to sit for the Polaroid and he didn't object. It looks quiet and reflective, and felt like an opportunity that was not likely to be repeated.

The final image of Naomi that we used for the shoot is slightly different from the one I chose here (right). In the other frame, before this moment, she and Philip were side by side and not looking at the camera. Here the focus is on Naomi, making eye contact with the viewer, make-up in hand. It seems natural to me and I like to think of it as more of a portrait than a fashion image.

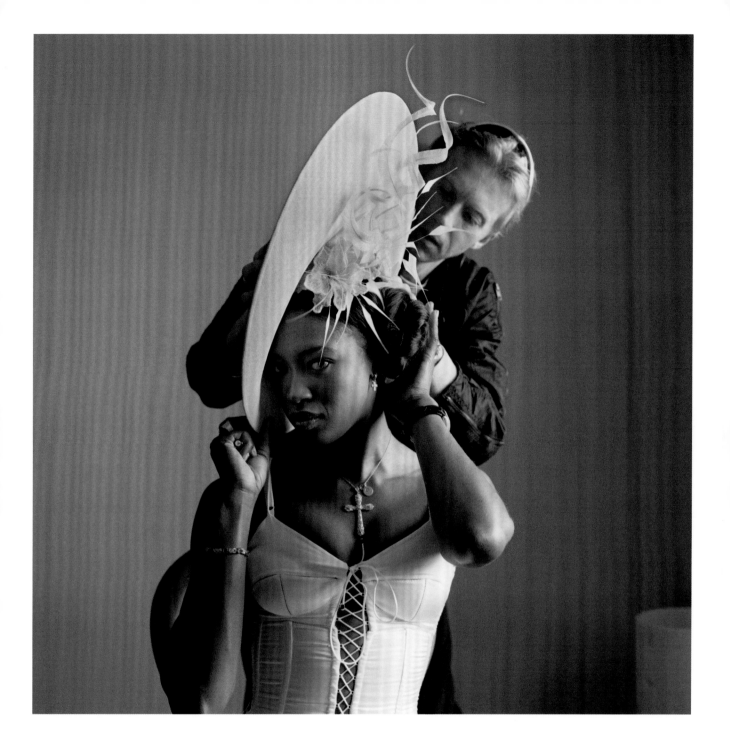

Naomi Campbell, Royal Ascot

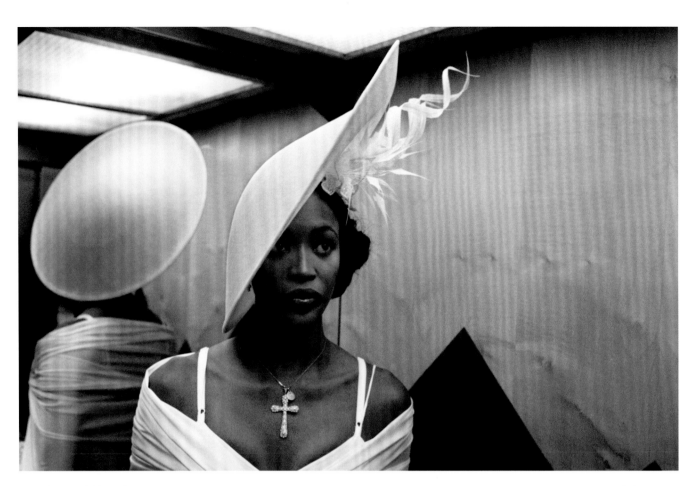

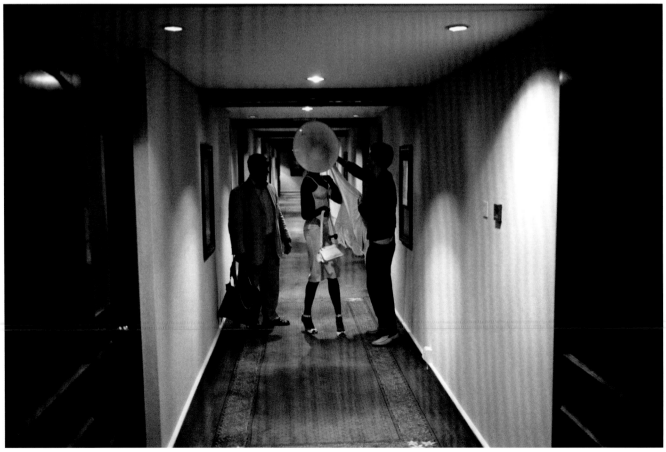

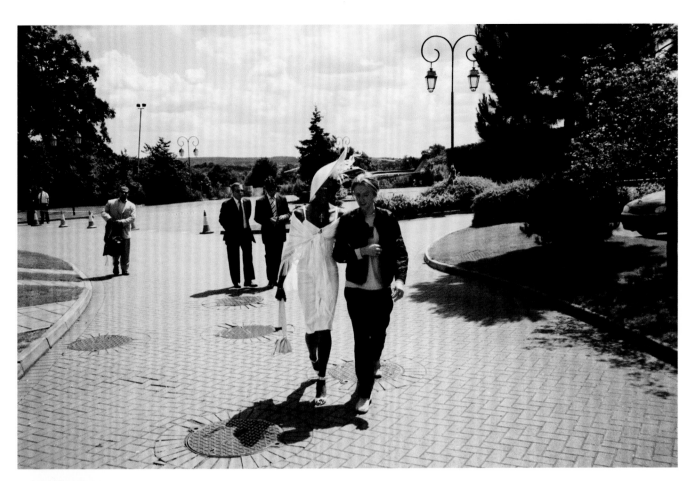

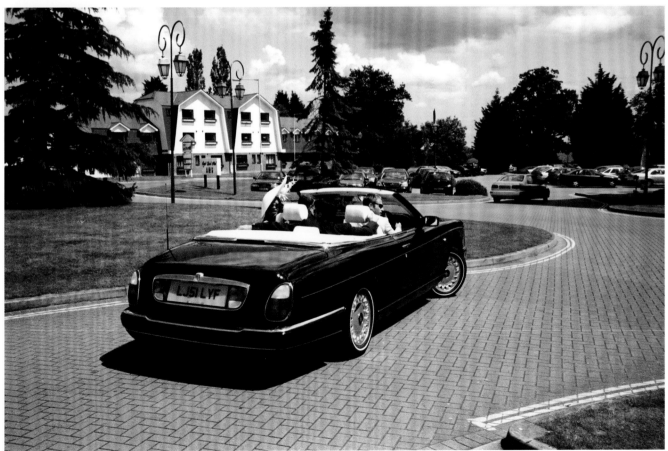

Naomi Campbell, Royal Ascot

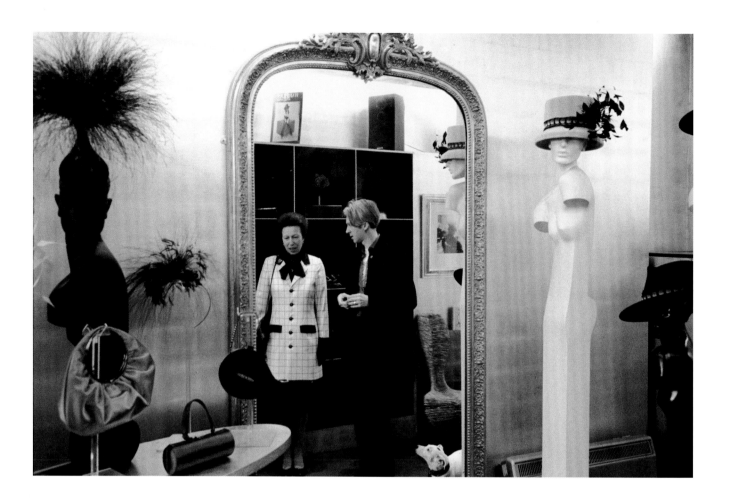

Kevin: Just as with the Fashion In Motion event at the V&A, Philip was offered a photographer to cover the royal visit, but asked me instead.

I was very nervous about photographing such an event, knowing that most of Philip's staff would want a 'good' image of themselves with Princess Anne. At the time, I wasn't really sure what Philip expected, as we rarely discussed such things. I hoped something might happen on the day that would give me a direction to follow.

Luckily for me, Mr Pig saved the day. Firstly, as the subject, sitting on the floor and framed by two very recognizable bodies in front of him (right), and secondly, in the studio kitchen (overleaf), tucked under Philip's arm, creating a very normal image out of a not-so-normal experience.

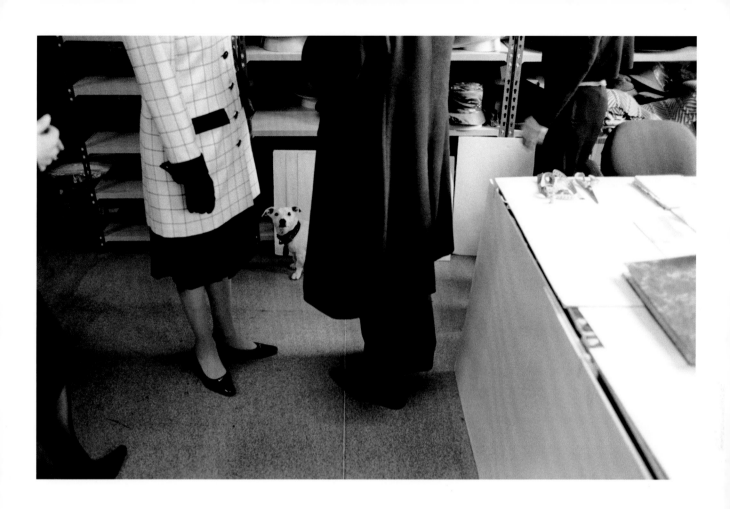

In the studio; Princess Anne

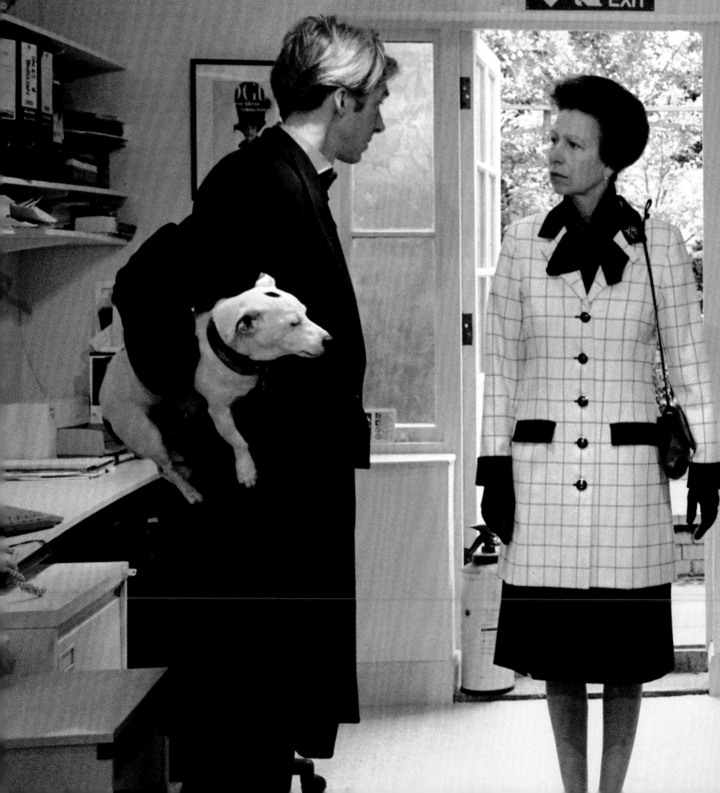

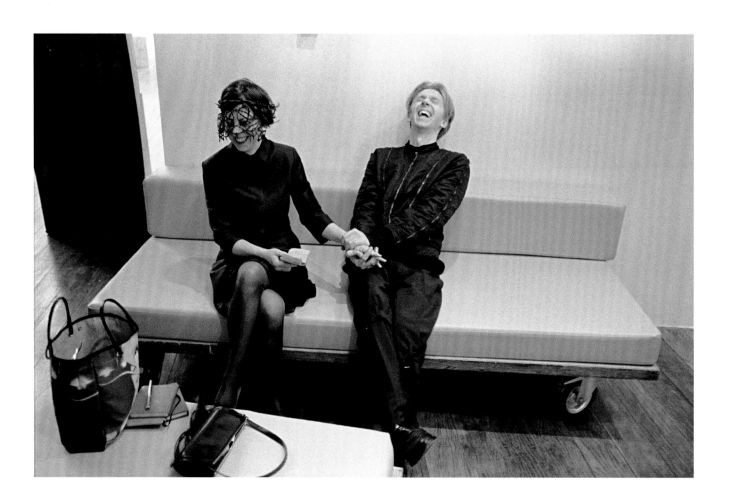

Kevin: Initially I felt uncomfortable about being invited by Philip to another photographer's shoot, and this one was to last for three days. I tried to avoid photographing the set as much as possible and focus on the preparation, which inevitably involved Philip and Issy. They never stopped talking, joking and laughing, sometimes in a conspiratorial way. They were from completely different backgrounds but were on the same wavelength. It was work for them, but they always seemed to be having so much fun.

At the time, I felt the picture of Issy and Philip laughing summed up their relationship best (above). Now I realize that the intimate picture of her helping Philip with his cufflinks shows how close they were (above right); it is exactly what a wife would do for her husband.

Issy was building up to the main event: the last picture on the final day with Daphne Guinness, Amanda Harlech and herself. She must have tried on every outfit that had been called in. Philip gave her the security and confidence she needed that day. Amanda jokingly asked the photographer what was to be their motivation for the shoot. Issy immediately responded with 'how to get that *couture* dress off Daphne.'

On the set I could see Philip standing in the shadows just to the right of the lighting rig. Suddenly, he rushed across the room, followed by Mr Pig, and adjusted the angle of Amanda's hat (p. 110), before Diego, the photographer, took the picture. It might have only moved a fraction, but I'm sure it made all the difference.

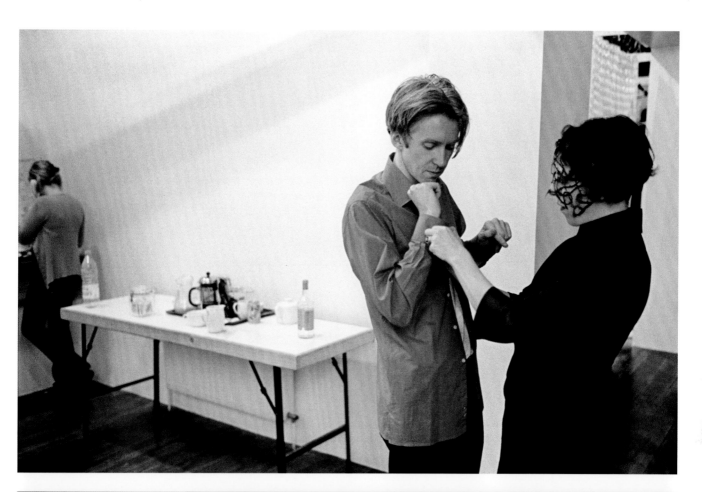

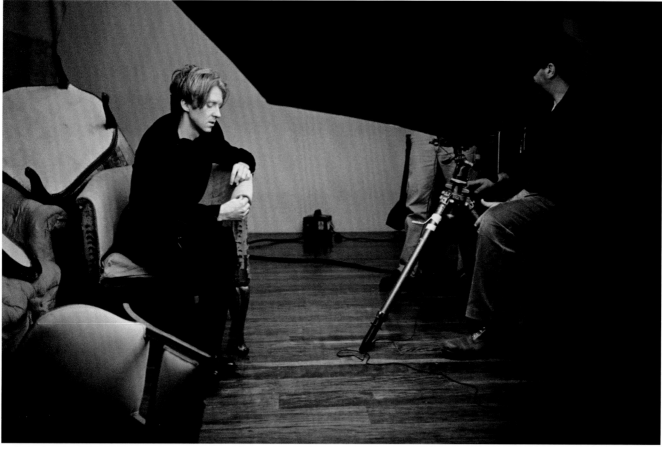

Isabella Blow, *Harper's & Queen*

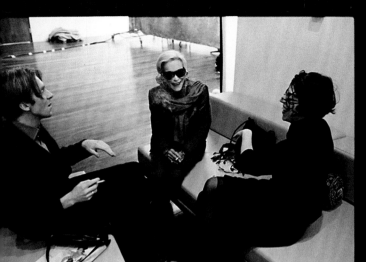
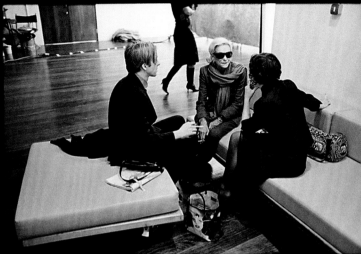

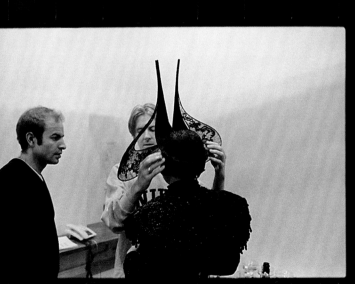
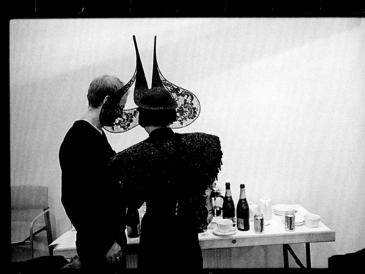

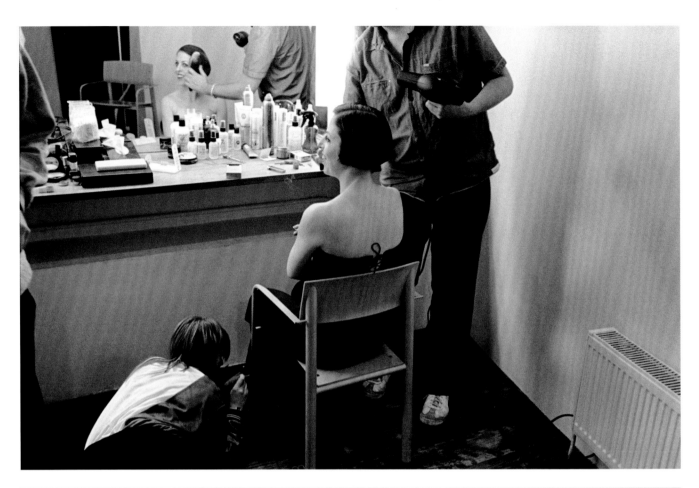

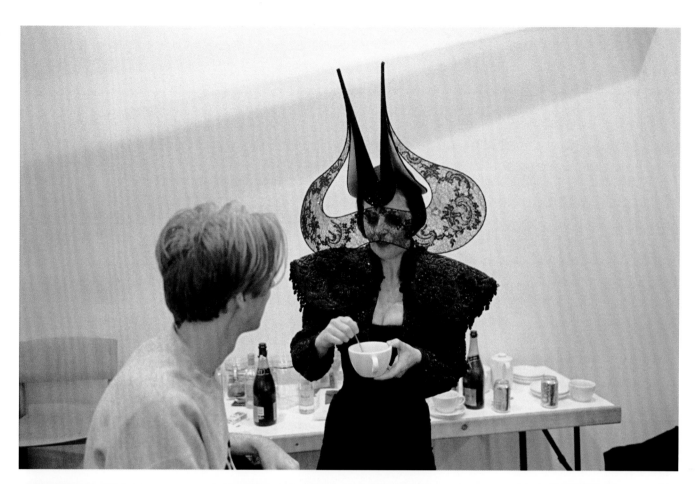

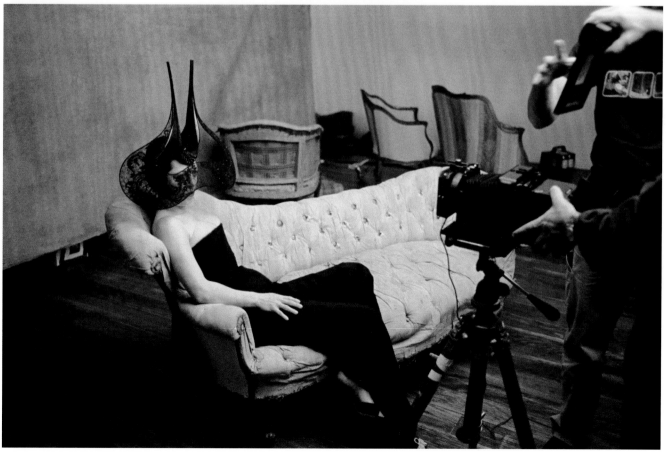

Isabella Blow, *Harper's & Queen*

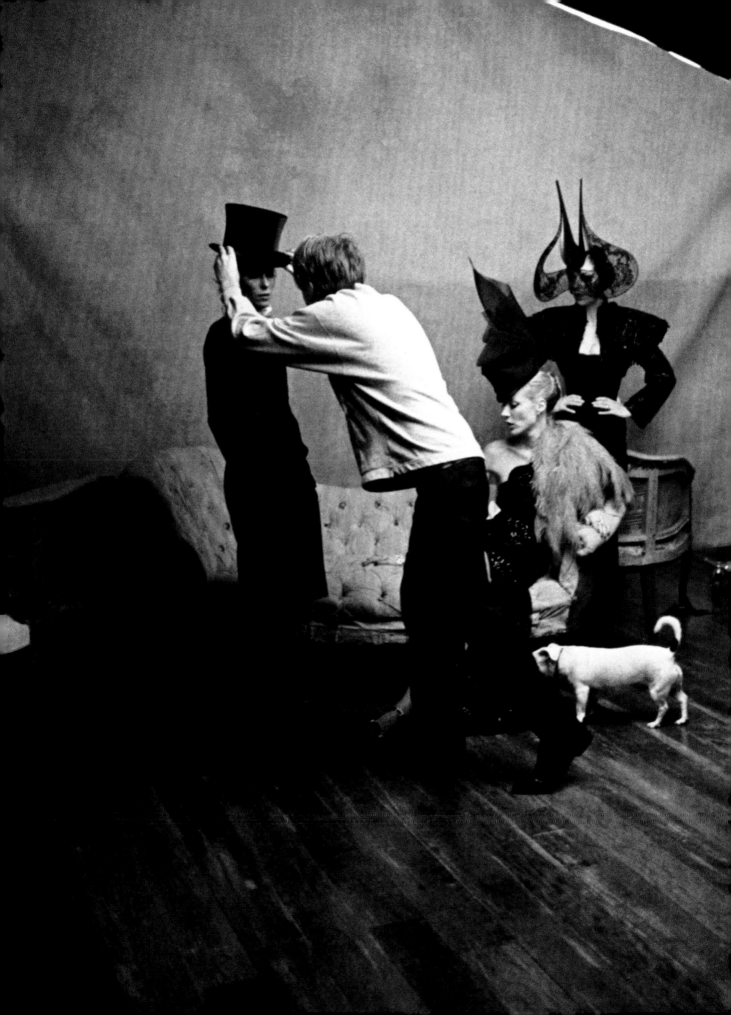

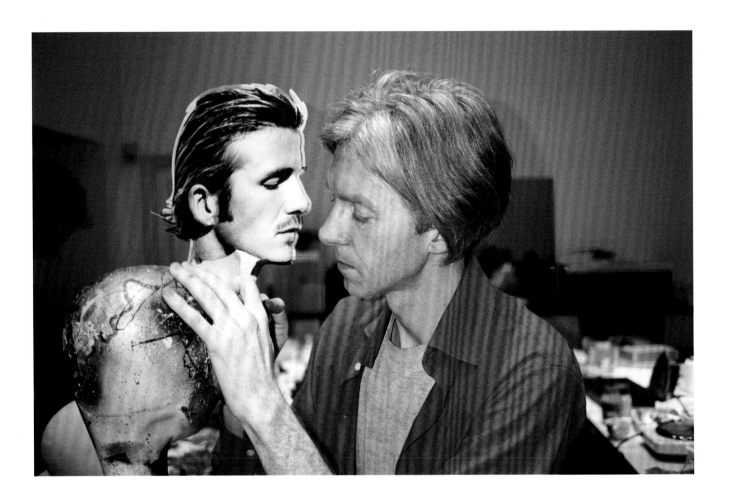

Kevin: Many of the hats for this *couture* show at Paris Fashion Week were based around 2D faces, each sculpted into a 3D relief. Even when they were being created they seemed to have a life of their own. Eyes eerily followed me around the workroom.

I wanted to photograph the headpieces as people, whether they were on a table or someone's head, and the images refer back to the surreal quality of the early studio photographs. And I particularly liked the shocking pink of the leopard-skin carpet.

Philip has never been keen to be photographed wearing a hat – but boy, I have tried! On a trip to New York, though, the great Irving Penn finally persuaded him. Philip apologized to me afterwards, but who could honestly have refused Mr Penn? During the preparations for this show I saw Philip talking to Issy, he was standing behind a clothes rail with a hat perched on top, as if on his head (p. 115, above) … I just had to get my own back.

Philip: This show was held at the Parisian pole-dancing club, Pink Paradise. I found the venue by accident on a night out and it was the most beautiful, surreal place.

Michael Roberts, then fashion director at *The New Yorker*, was helping me with the styling. I had Eva Herzigova wearing David Beckham, complete with a diamond earring (p. 119, above) and Fred Astaire danced on some psychedelic records (p. 114, above). Alek Wek wore a flight of Marilyn Monroe's lips that shimmered and danced around her head (p. 114, below) and Naomi Campbell opened the show with a Campbell Soup can. I thought it would be great to then close with Naomi again, this time wearing Naomi wearing a Campbell Soup can (p. 118, above).

Issy was later invited by Victoria Beckham to watch David play football at Old Trafford, and of course she wore his hat. When they met after the game, she introduced herself and proclaimed, 'David, meet David.'

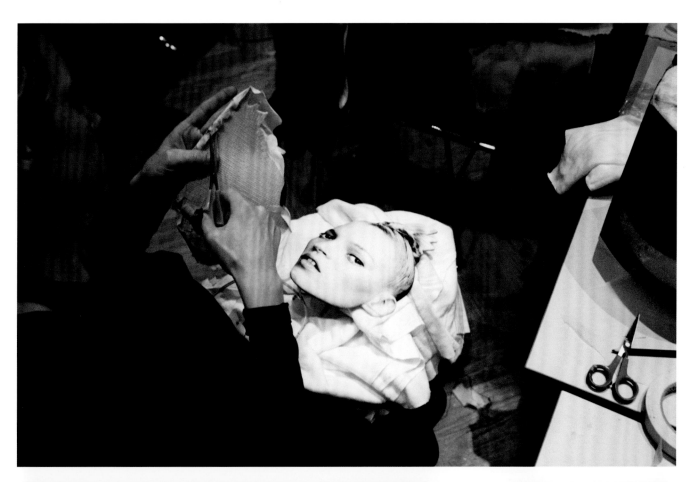

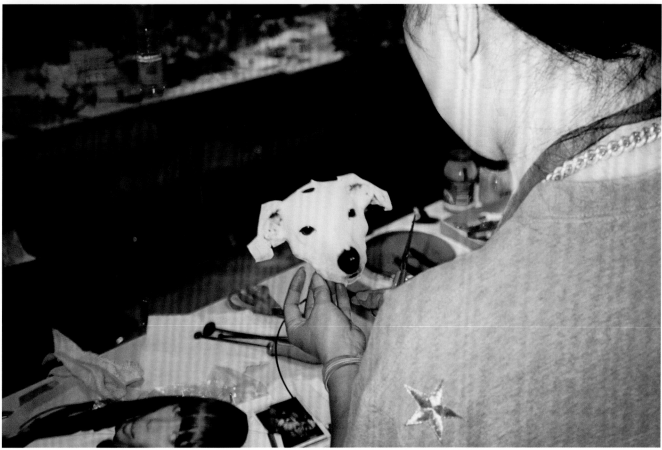

Paris Fashion Week; *haute couture* Andy Warhol Collection

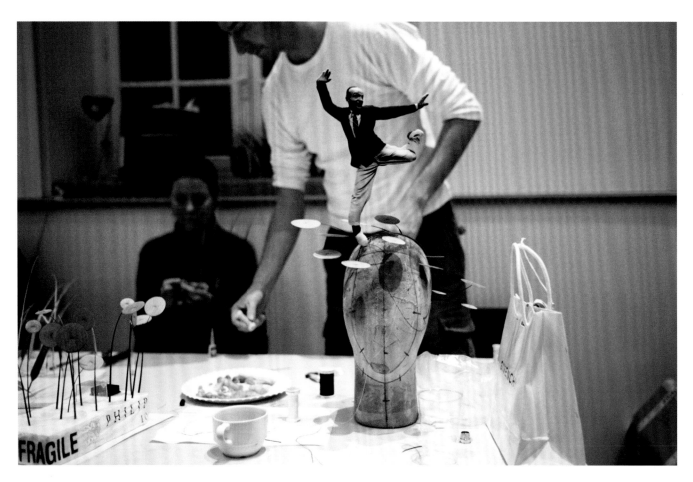

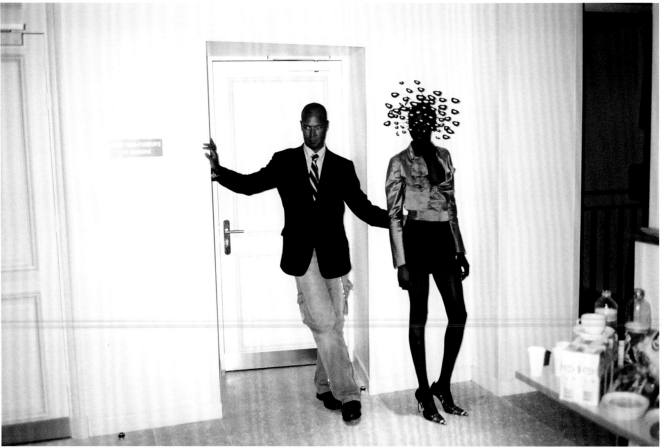

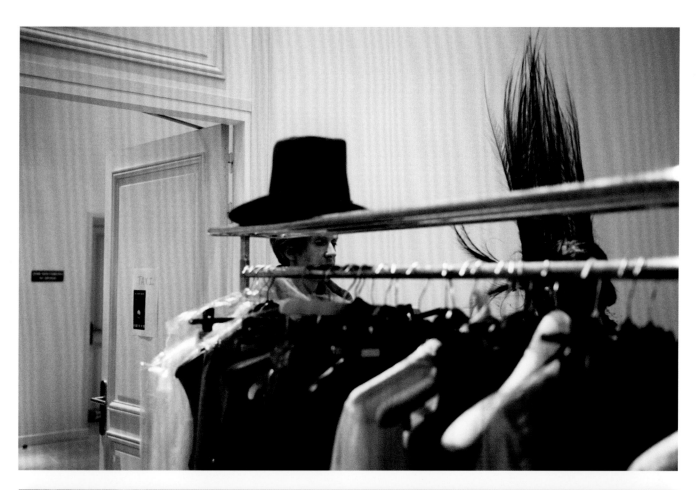

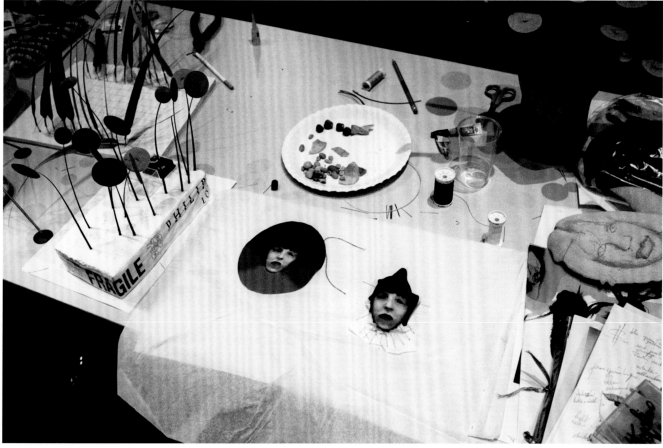

Paris Fashion Week; *haute couture* Andy Warhol Collection

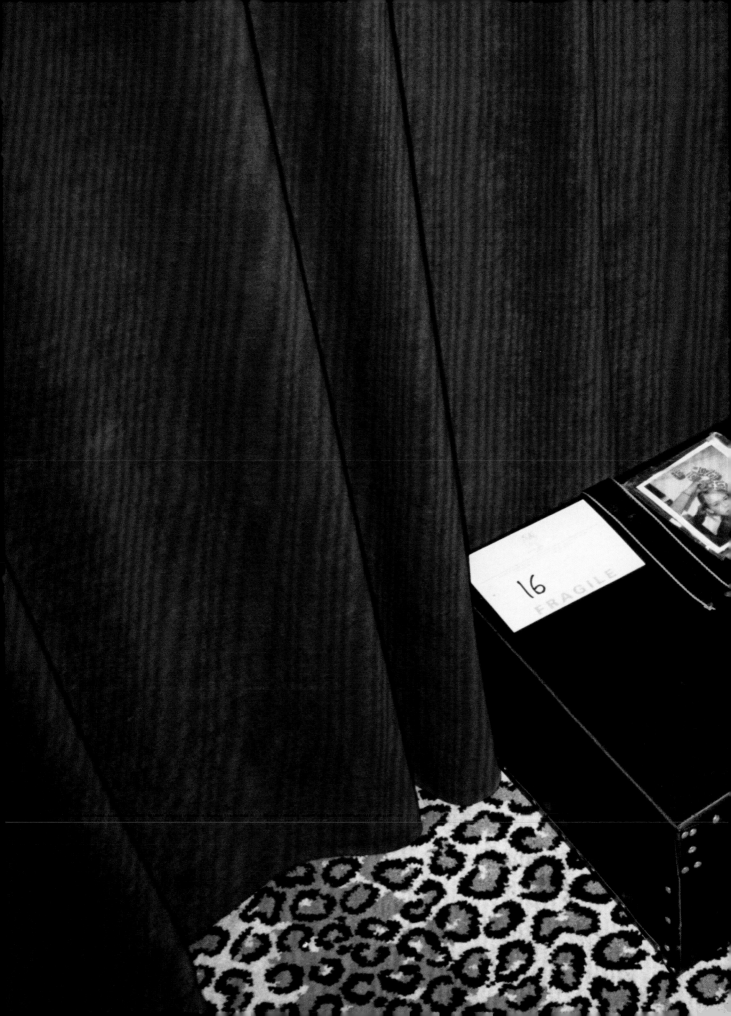

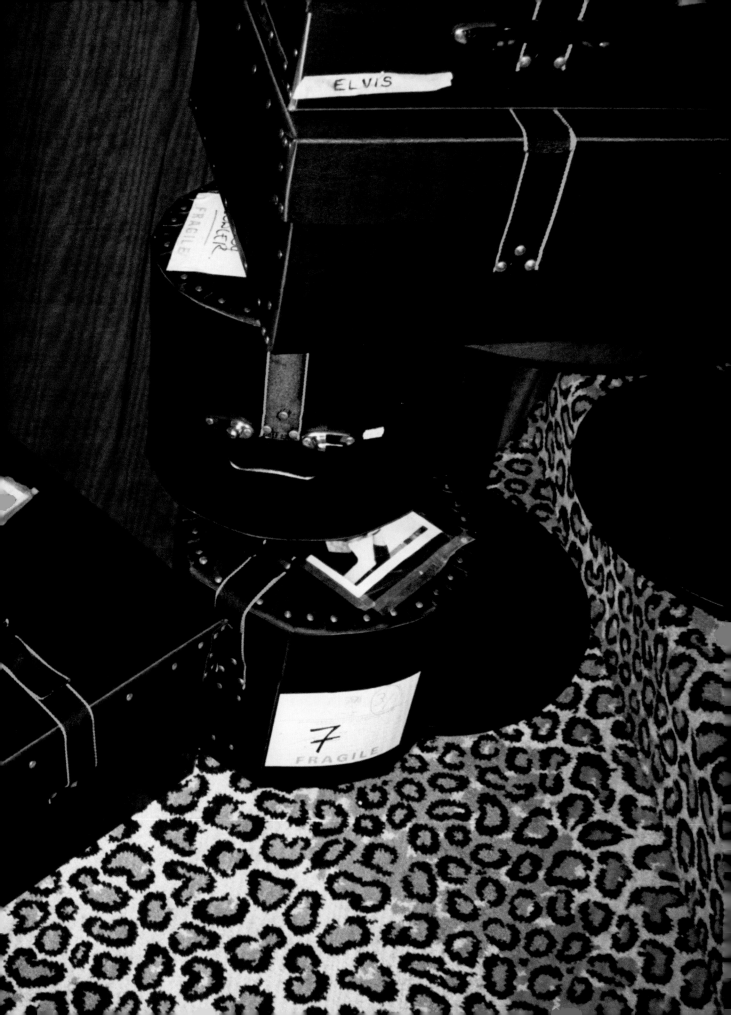

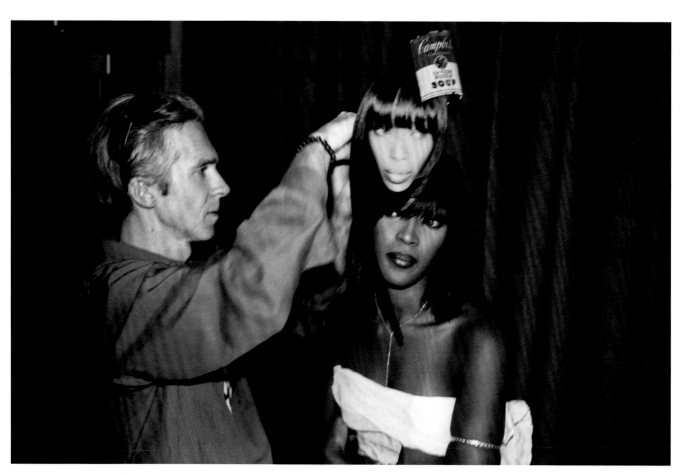

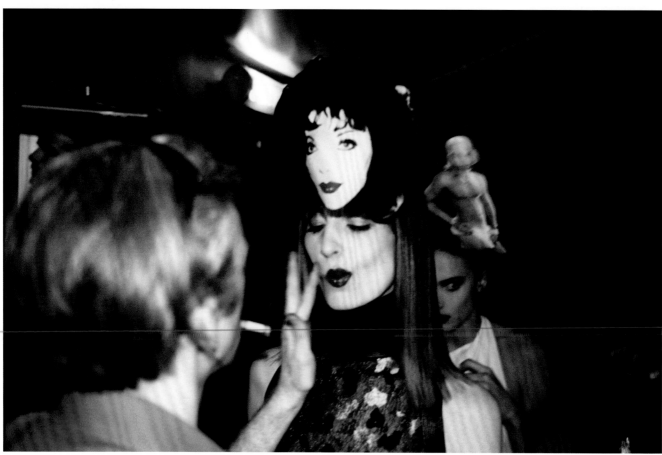

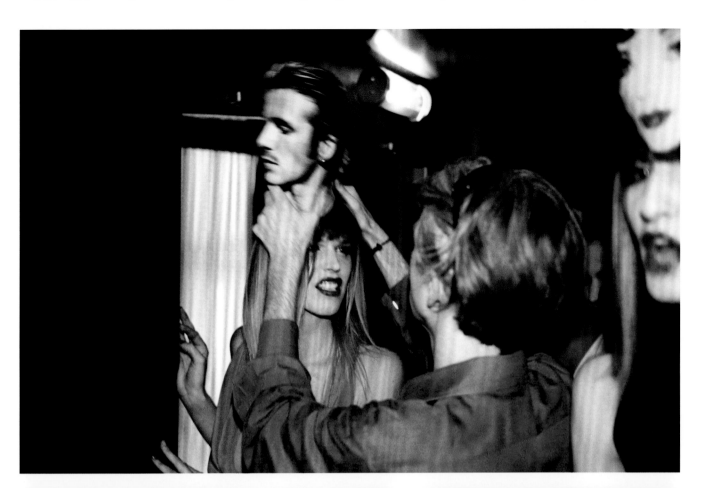

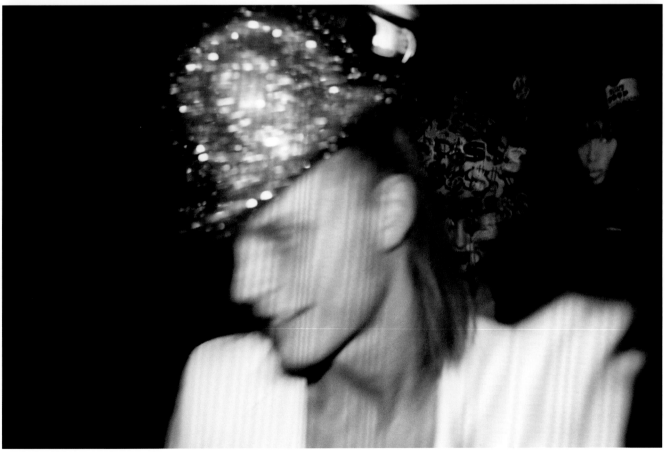

Paris Fashion Week; *haute couture* Andy Warhol Collection

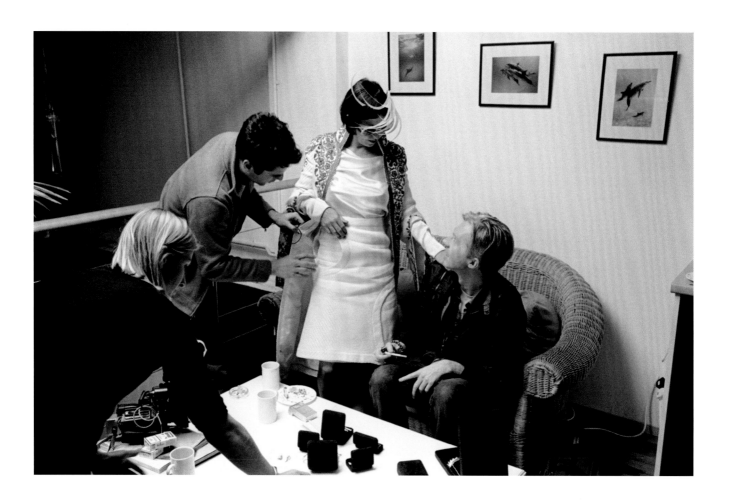

Kevin: Tatler had commissioned Philip to shoot a cover for the magazine with Erin O'Connor. He asked if I could come along and advise on the technical side of the photography. My assistant Damian and I worked on the lighting, and later I helped with the printing of the images.

The whole conceit for the photographs was Philip's vision; it was his idea to use the lettering, which Stefan's father David Bartlett had made in three different sizes. For me, the important part of that shoot was the relationship between Philip and Erin, and I found that interesting to watch. It was an unusual, inventive dynamic between two creative people. Issy was there to style the shoot, while also finding time to use the manicurist. We joked that Philip, for all his creative vision, couldn't find the button to take the photo.

Philip: I love this picture of Issy (right) because it's very deceptive. To anyone who didn't know her, she looks relaxed, enjoying a pedicure. But I know that when that phone was out, she was working on something. Her telephone manner was a revelation. Issy could talk for hours and hours and could work a phone like nobody I've ever met.

The man next to her is a security guard, charged with protecting the millions of pounds' worth of diamonds used for the shoot.

Isabella at a fashion shoot was like a ringleader at a circus, though never in a domineering way; she was always at the centre of everything. She had insisted that I take the photograph for this *Tatler* cover – I didn't want to, I'd never taken anything more than a Polaroid before then – but she wouldn't take no for an answer. So, in search of a quiet life, I relented.

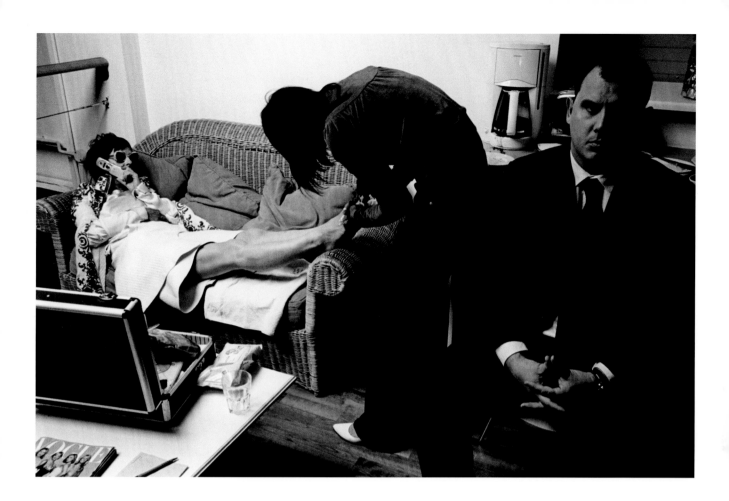

Erin O'Connor, *Tatler*

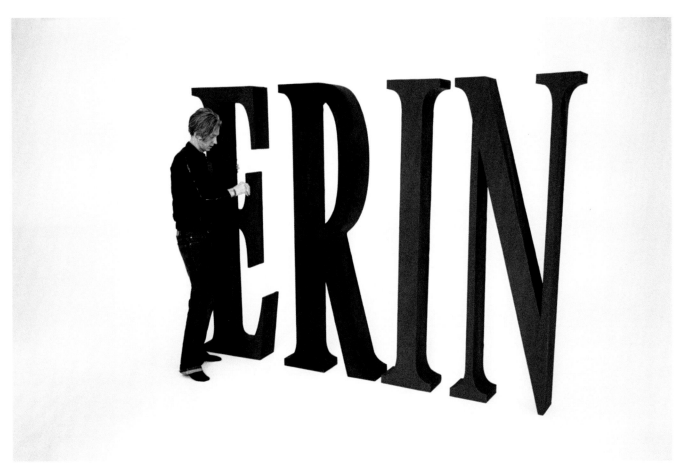

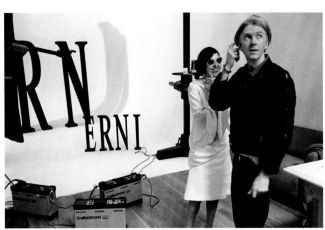
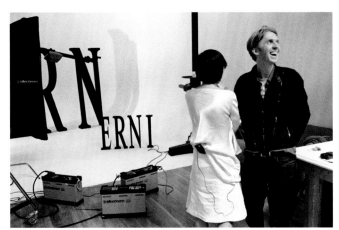

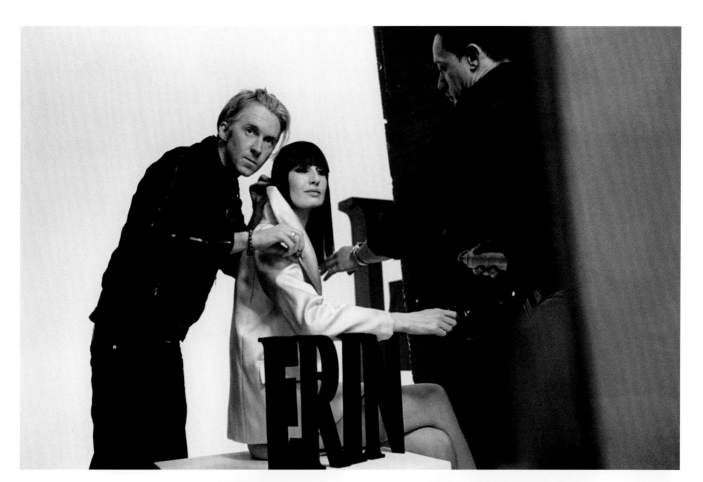

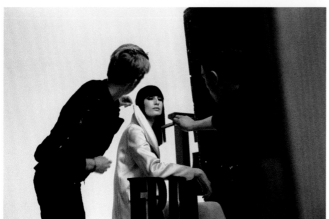
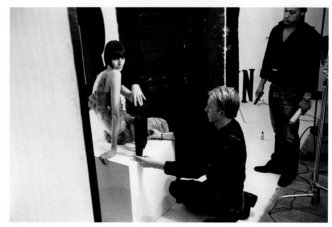

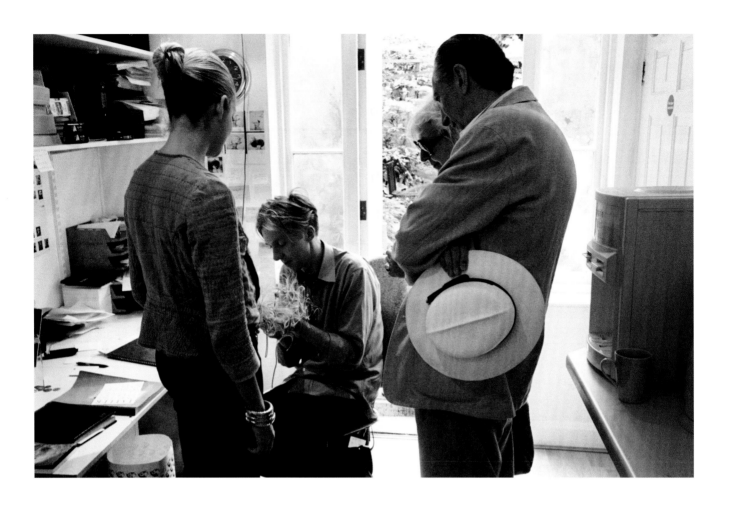

Kevin: I've always liked this particular photograph. There's something enjoyable in the idea that, for most people, there's only one hat in the image: a panama in the hands of the man in a suit. But the real subject is Philip, lost in concentration, working on his unique vision of what a hat could really be.

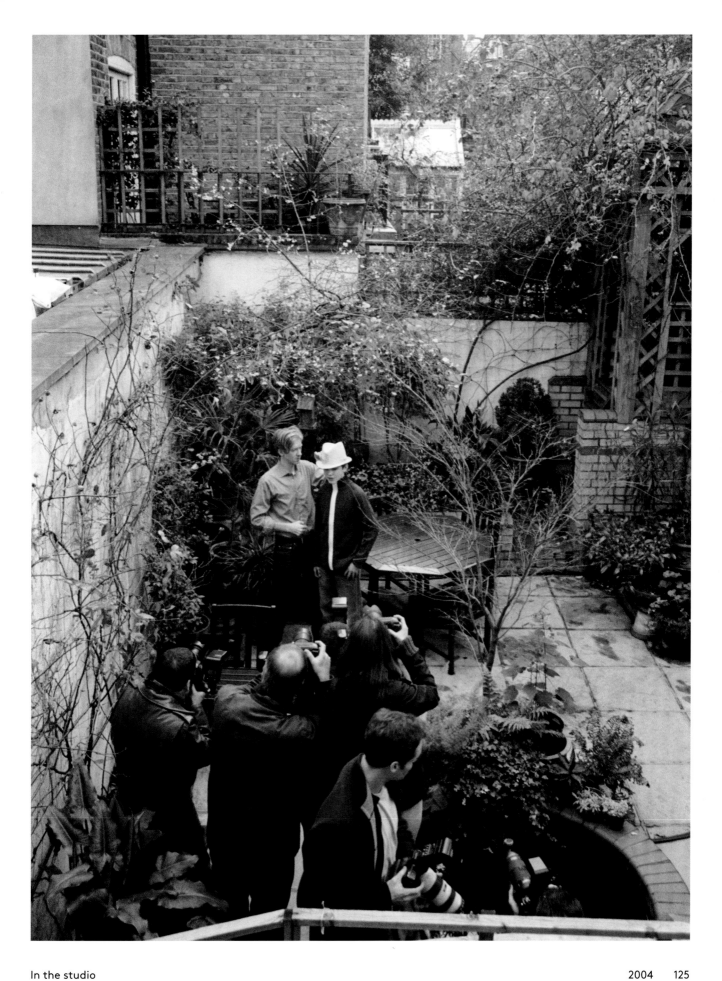

In the studio

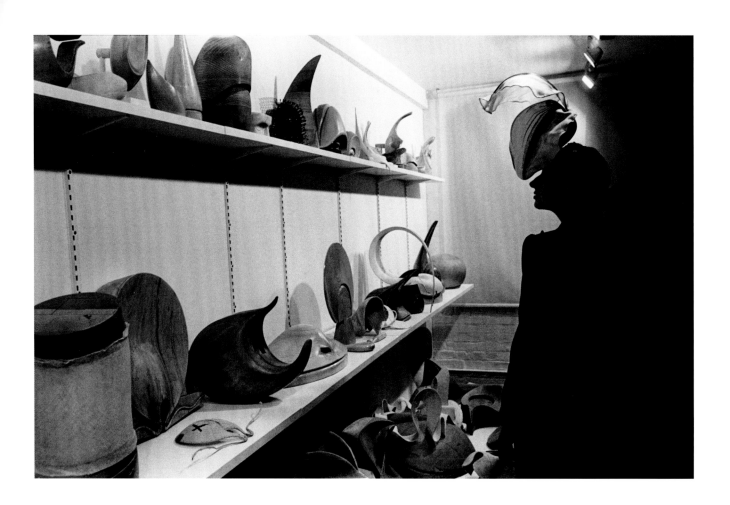

Philip: All my wooden hat shapes have been made by Monsieur Ré in Paris. He's the best in the world. Although sometimes I think that he's afraid to open the box to see what maquette I've sent him to replicate. I know I ask a lot of him. It's got to the point now where he tells me, 'Please, Philip, can you make smaller shapes?'

Iconic Hats

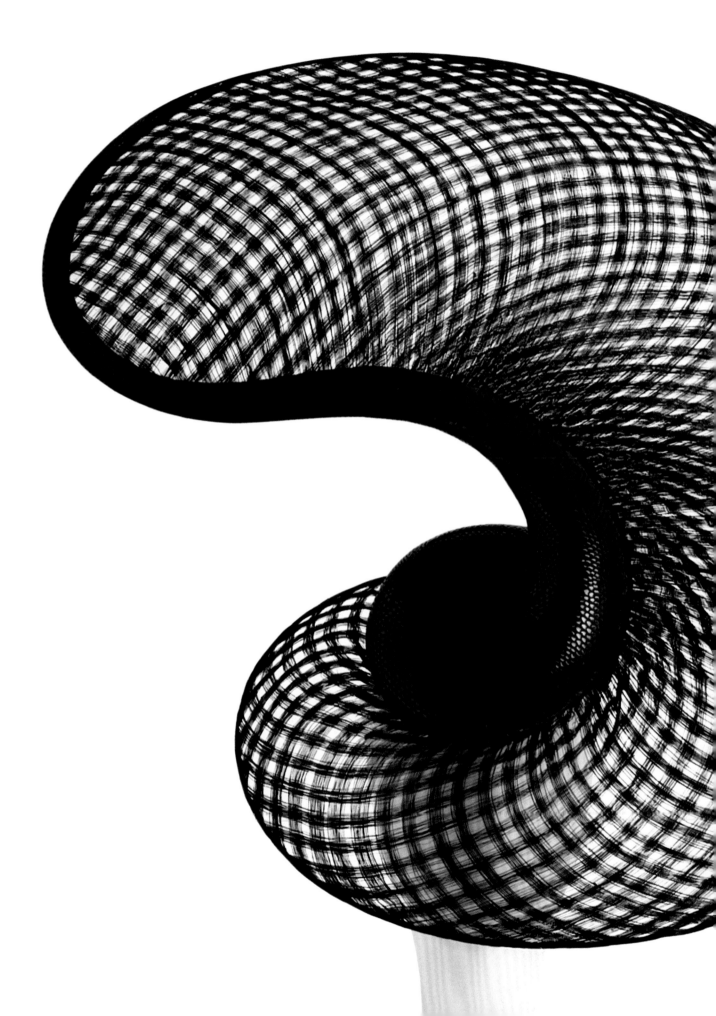

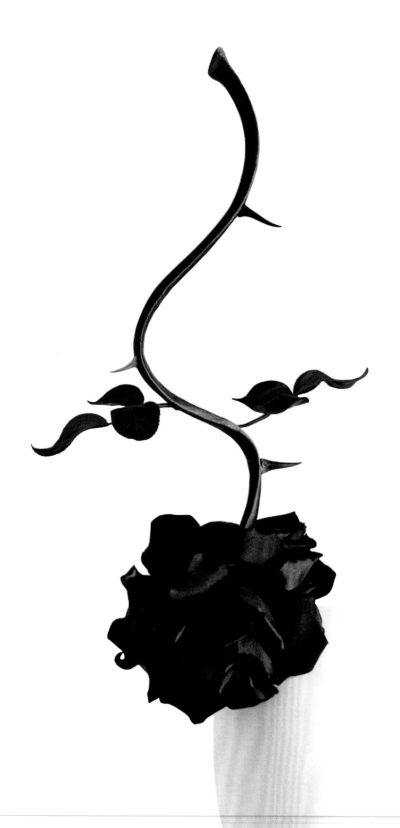

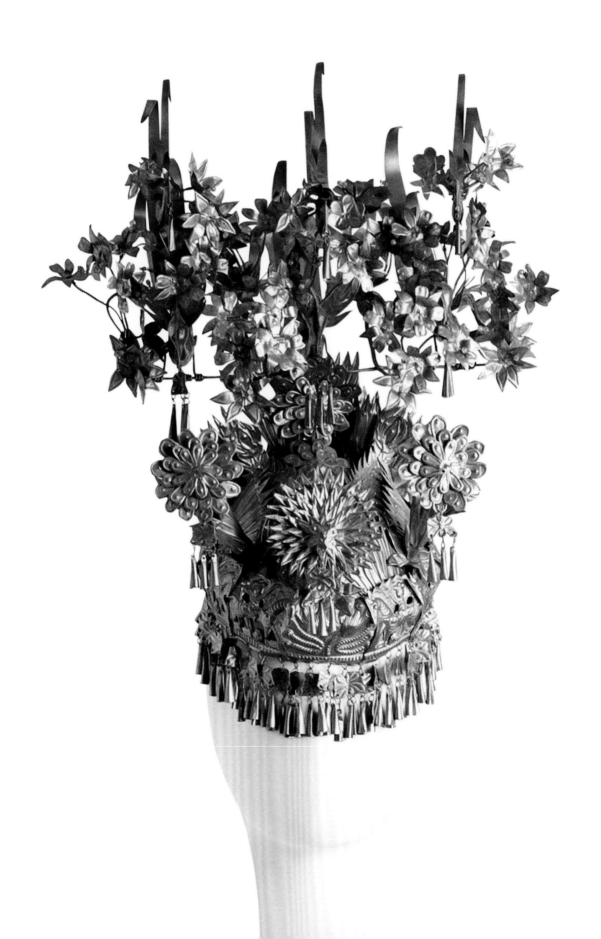

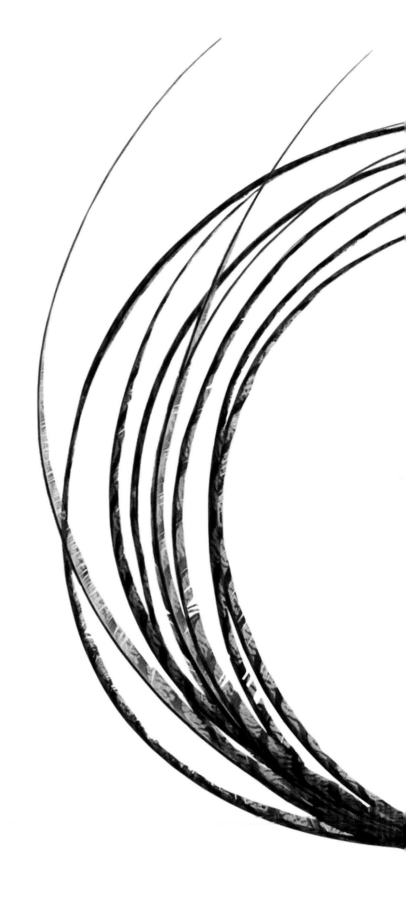

Fuchsia Swirl with Swarovski Crystal: New York & London, 1999

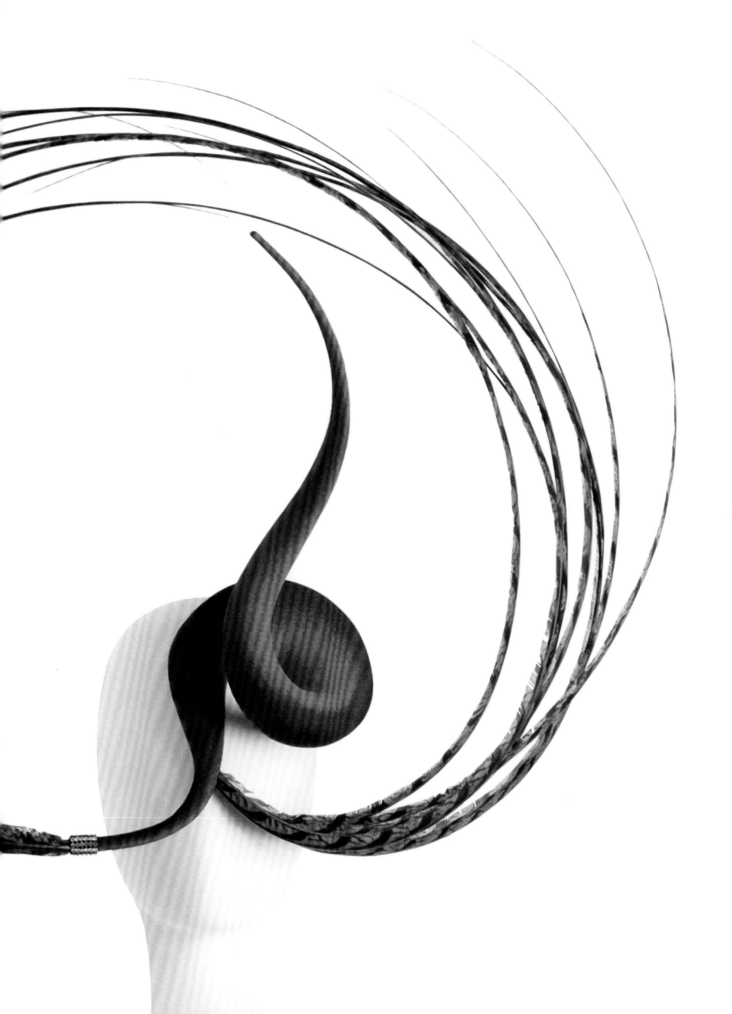

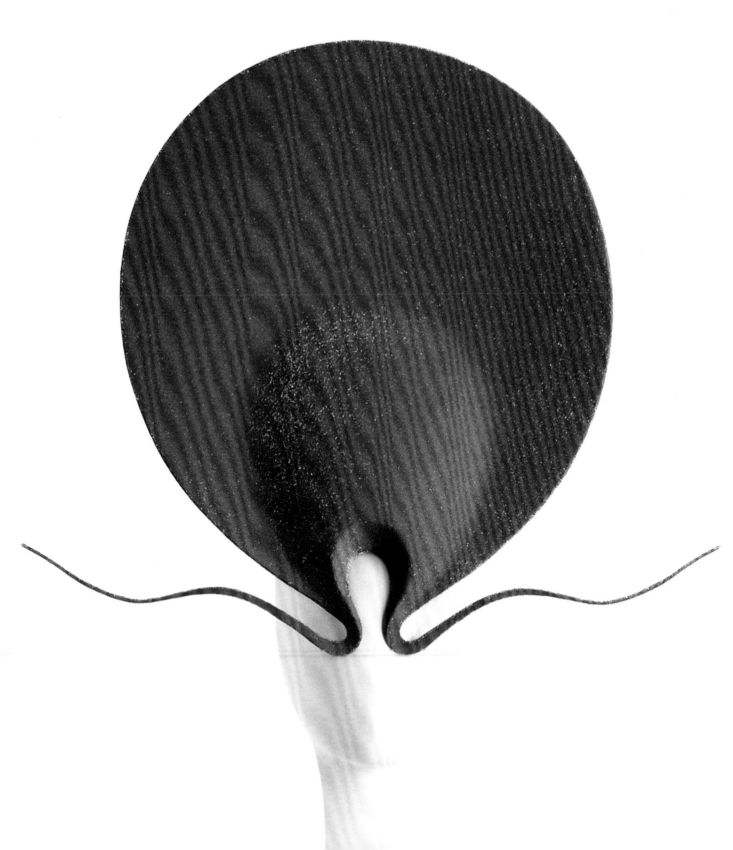

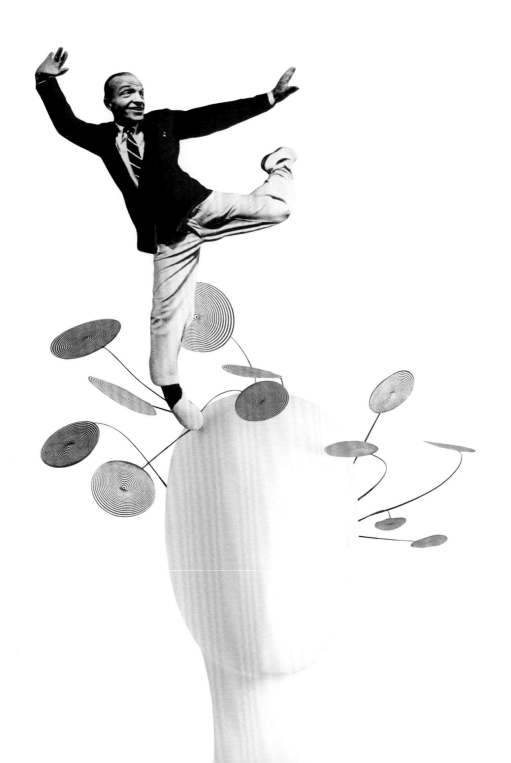

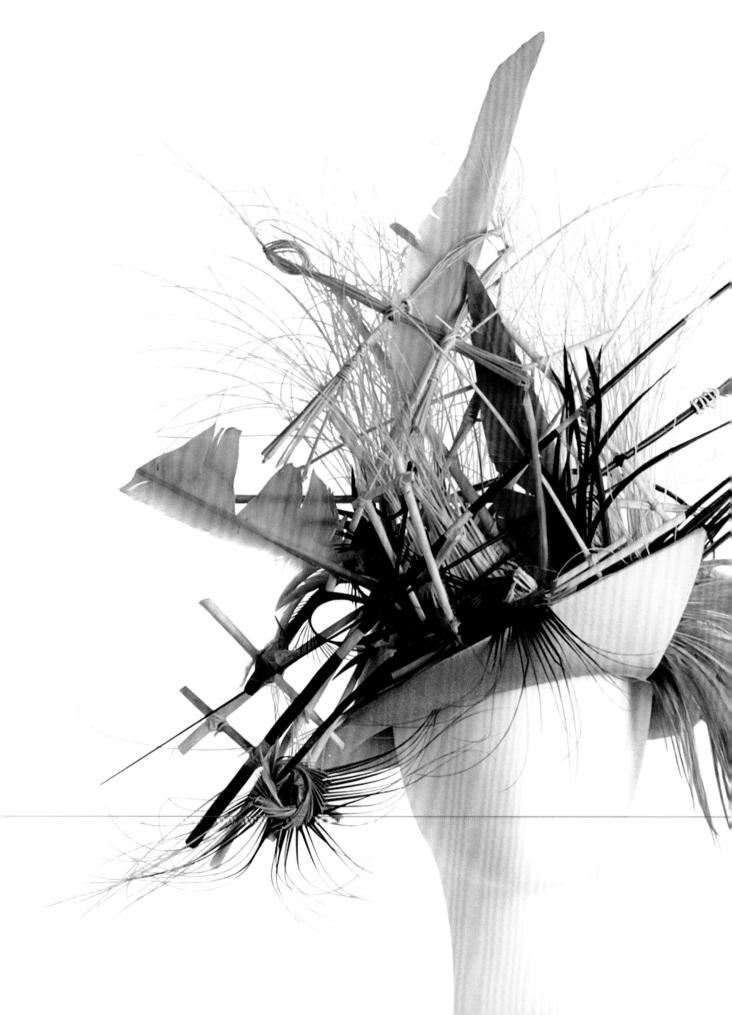

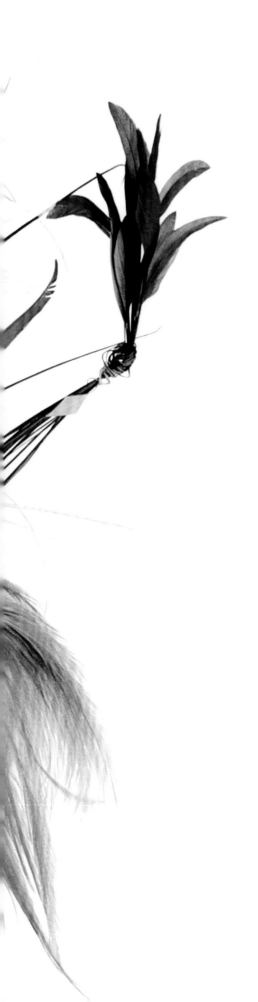

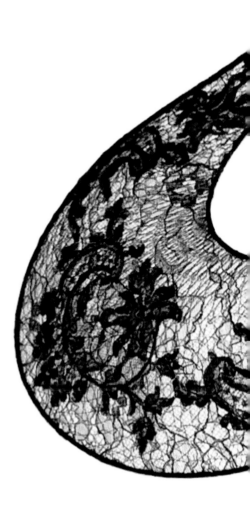

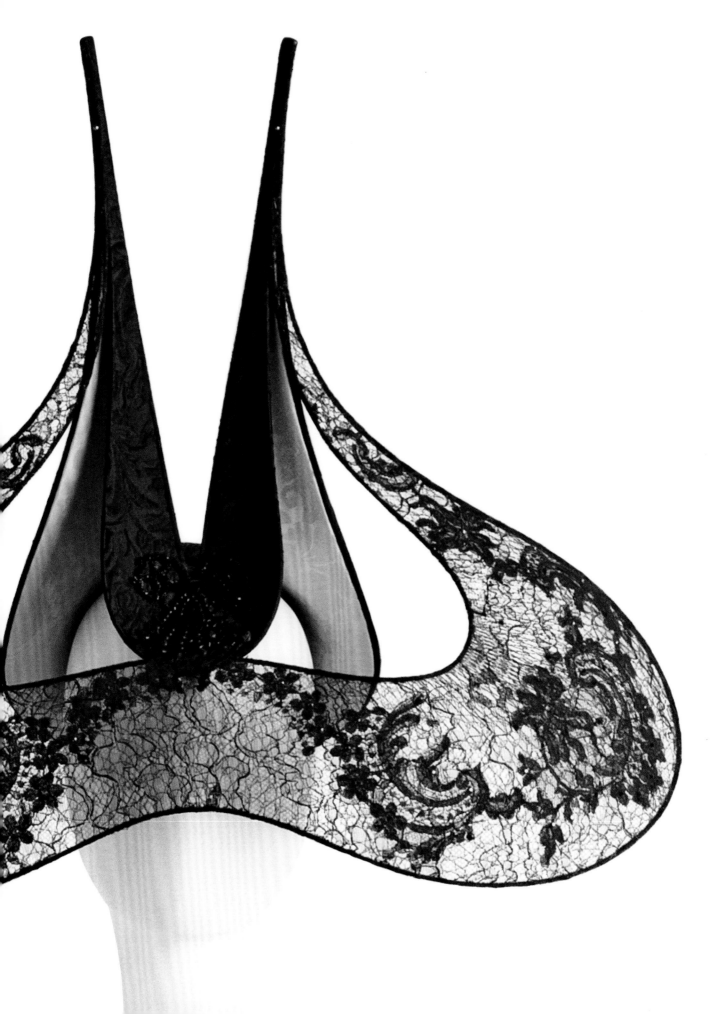

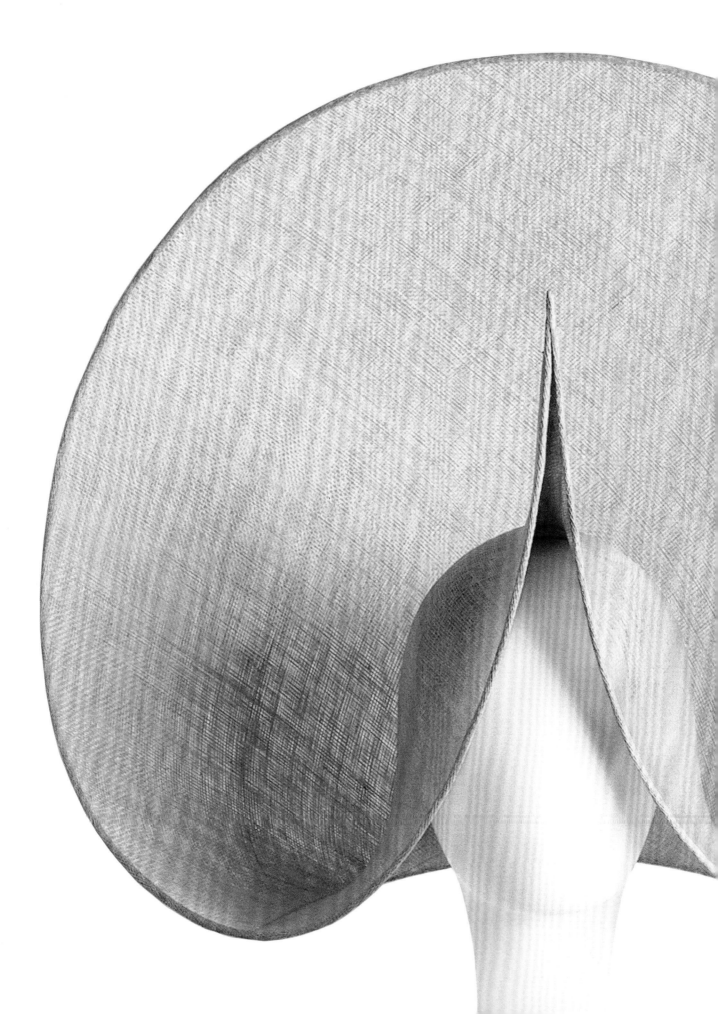

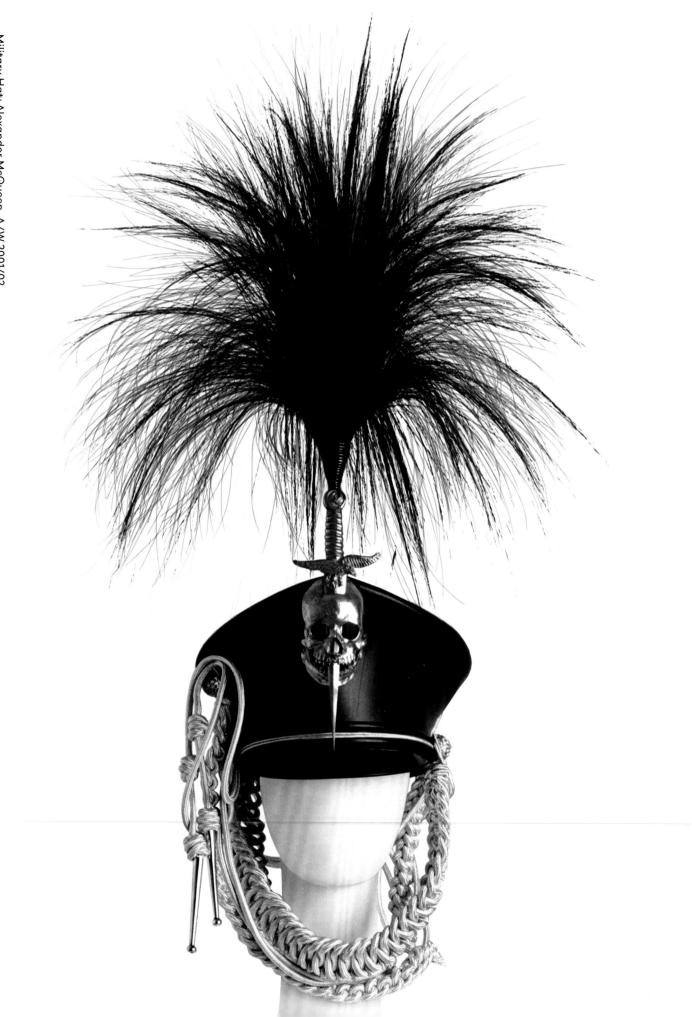

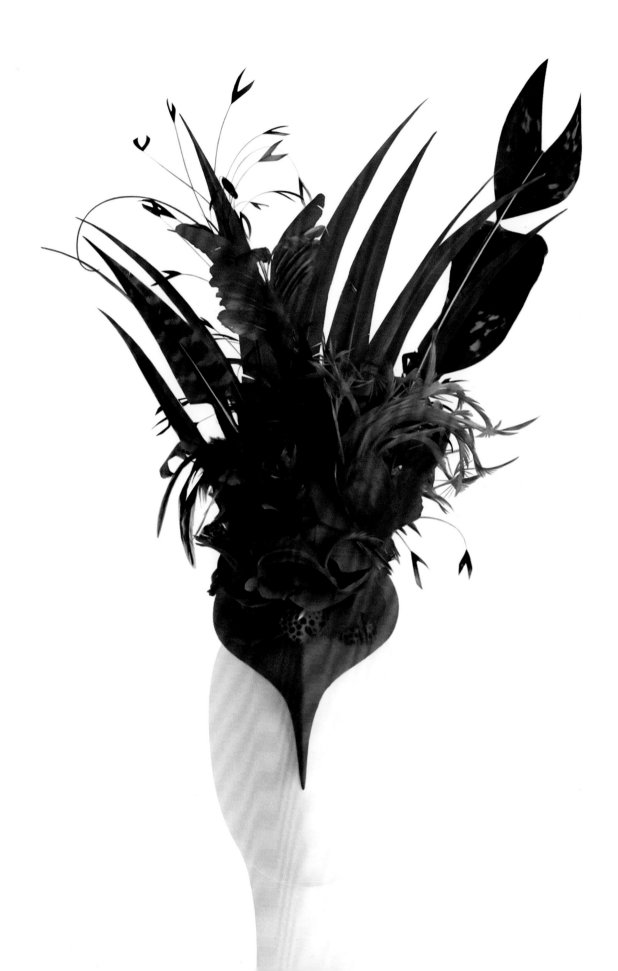

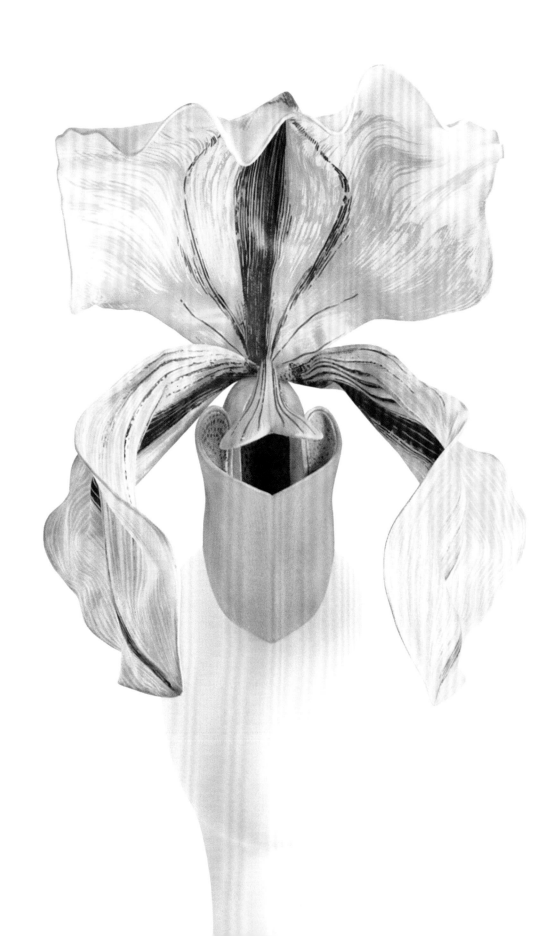

Battersea Studio
2004–

Philip's new studio in Battersea, which he moved to in 2004, stretched over three levels, with storage on the ground floor, a showroom on the first and a workshop and office on the second. Philip worked mainly from his desk in the top-floor workshop, but he also had a separate room that was more of a personal creative space, filled with mood boards, books and plants. It was well lit, with windows extending down both sides.

Of course, the atmosphere was still the same. I think it's something Philip creates within the space. It was still filled with the same kinds of things, with expansive shelves housing many of the wooden blocks, and every surface was covered in something: plants, books, busts, hats or photos.

When Philip moved to this new space I decided I wanted to describe different aspects and explore other ideas in his life and work. During this period there were fewer shows and, what with this, two children and other commitments, I had less time with Philip, so the opportunities I did have were all about capturing something I hadn't shown before. When I worked on a commissioned image with Philip we would discuss our preferred results using the contact sheets of the photographs I'd taken. Normally, I would mark the sheet with my choice and then allow Philip to do the same. However, what the contact sheets (such as the one shown overleaf of Philip's chair design for the furniture retailer Habitat) have also allowed me to do is to show the moments in between the final images. This is often when a subject is at their most natural, most relaxed and expressive. Being photographed is often an awkward experience, even a chore; it's something a subject is required to do, and even though I have known Philip a long time, it doesn't necessarily get any easier. I knew he was uncomfortable sitting for portraits and I was beginning to 'feel his pain.'

Philip was also being commissioned to do his own shoots, such as the one of Daphne Guinness for *Vogue* (p. 180–1). This provided a great opportunity to snap Philip and Daphne working together and capture quiet moments between takes.

Of course, the culmination of this period was the Royal Wedding of Prince William to Kate Middleton, and such a monumental occasion seemed to call for a different approach. Almost instinctively, it felt natural that shooting the Wedding would be less about the physicality of making the 36 hats, and more about the events around it: the preparation, film crews, interviews, fittings and photo shoots. Before I started shooting anything to do with the Wedding, Philip and I discussed the best approach to capturing it. We agreed it was better to shoot everything that was happening, and that's why I decided to shoot much of it digitally. When I shoot on film I tend to shoot less. An additional benefit this threw up was the extra anonymity a digital camera provides. Although I like the shutter sound of most of my film cameras, it does announce a picture being taken; sometimes it's useful to have a silent camera. Just like sometimes the digital flip-up screen can be useful, so that I don't need to keep climbing on chairs.

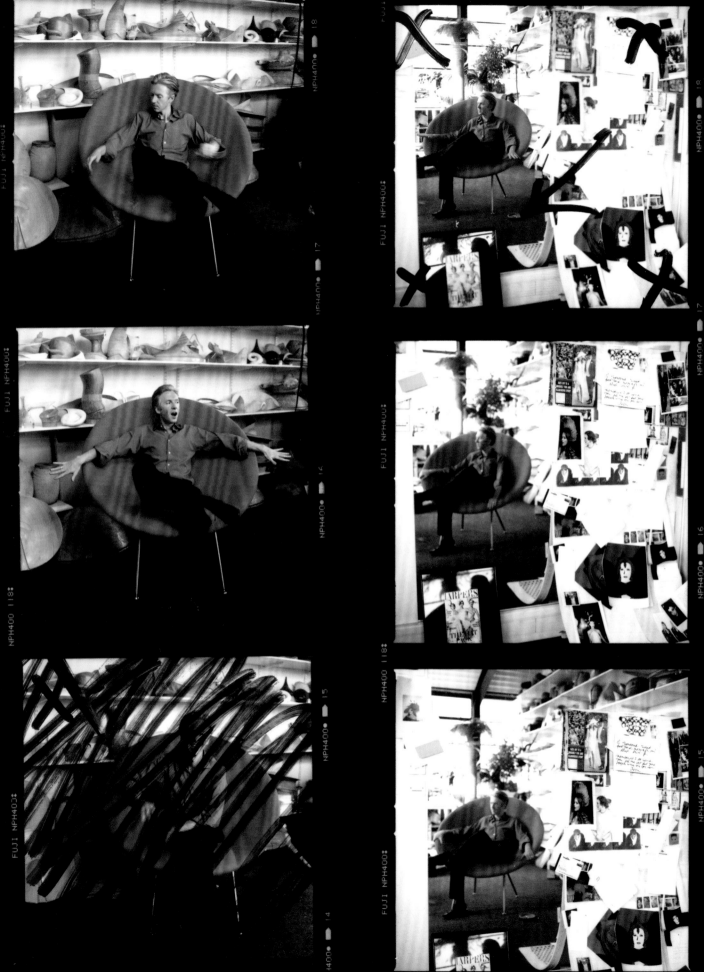

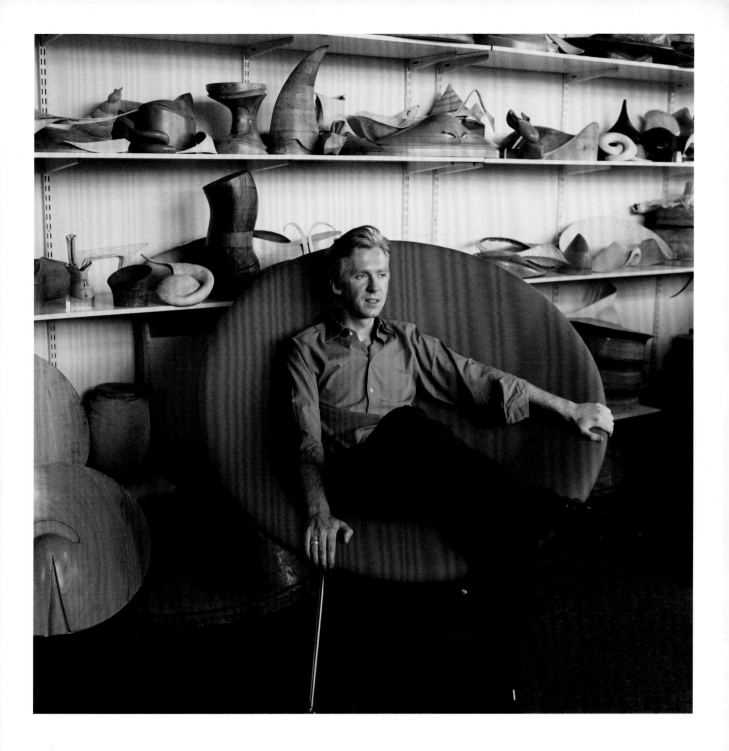

Philip Treacy for Habitat

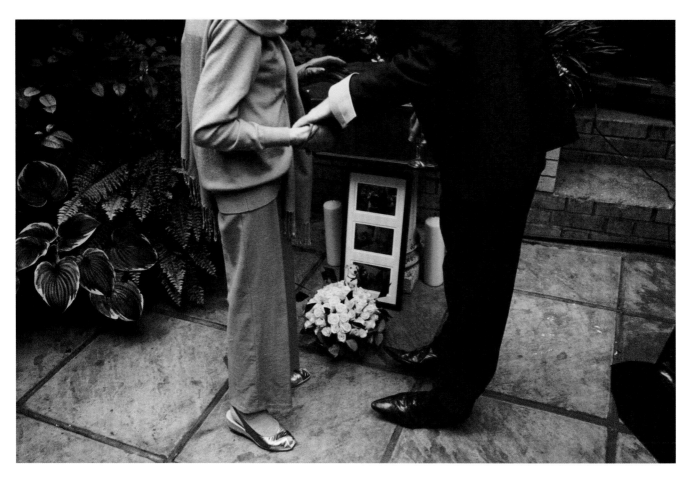

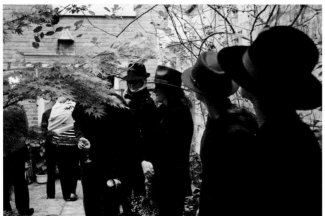

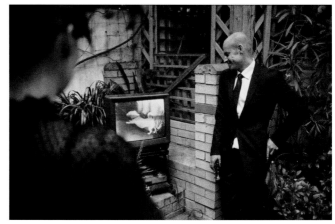

Kevin: I was invited to the funeral of Philip's Jack Russell terrier, Mr Pig. He had been a constant presence ever since I'd known Philip, and went everywhere with him. For the Moët Fashion Awards at the V&A, he was not only allowed inside the venue – not something that's ever been allowed before – but also had his very own laminated 'access-all-areas' pass made up. I asked Philip ahead of time if I should bring my camera. 'Absolutely,' he responded. I shouldn't have been surprised: as ever, Mr Pig was the centre of attention.

Philip: My neighbour, Luise Rainer (right), was the first to arrive for Mr Pig's funeral; she had no tolerance for lateness. Luise was born in Germany in 1910 and is the oldest living Oscar winner, having received two Academy Awards for Best Actress in 1936 and 1937. When I first knew her and spotted the statues on her shelf, I asked her, 'Who did you beat?' 'Greta Garbo,' she replied. Grace had composed a song especially for the service, but we were waiting for Isabella. Typically, she didn't arrive until after it was all over.

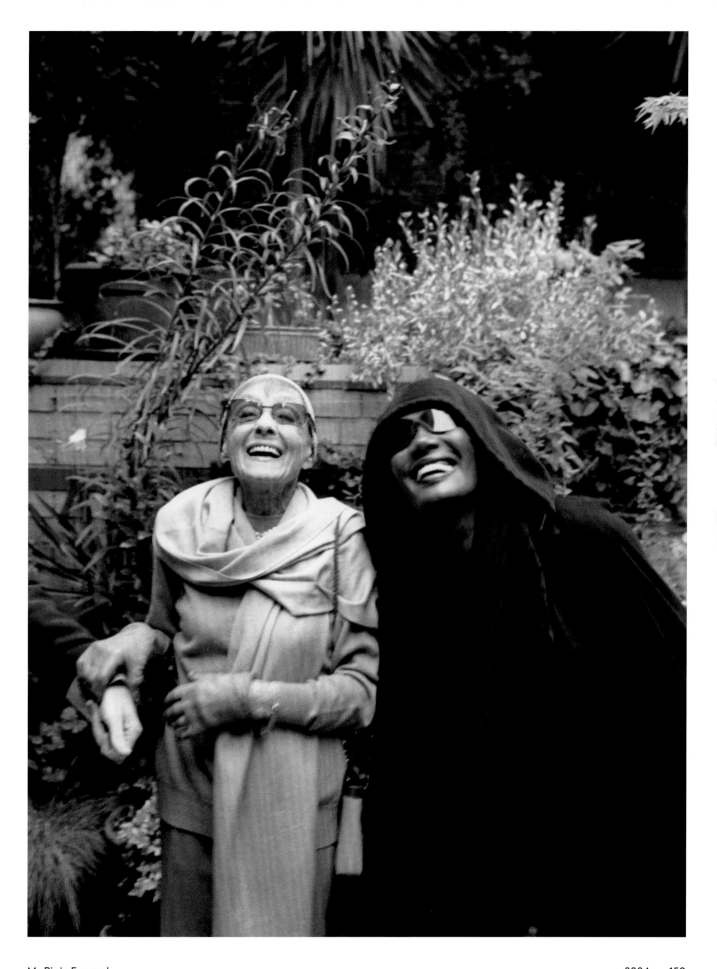

Mr Pig's Funeral

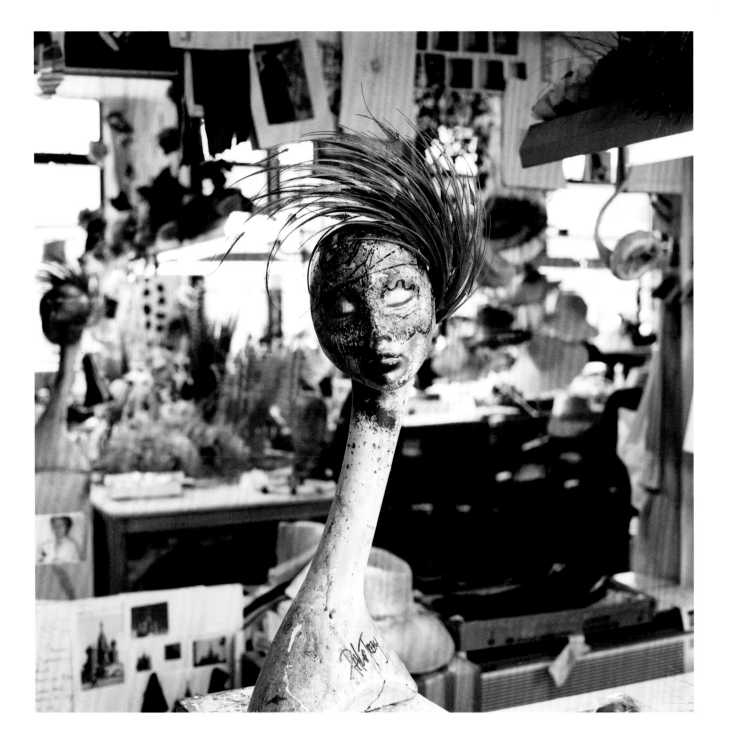

Kevin: This hat was made for Camilla Parker Bowles for her wedding to HRH The Prince of Wales. I had to shoot it quickly before it was packed away to be sent to Clarence House. For the final image it seemed perfect to shoot it in its box, still within the studio: a picture within a picture.

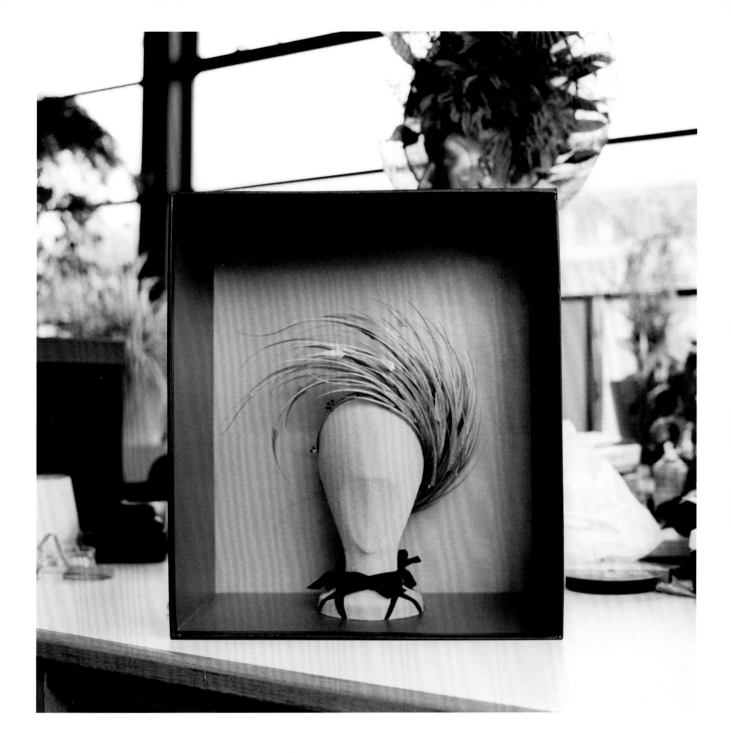

In the studio; Camilla's hat

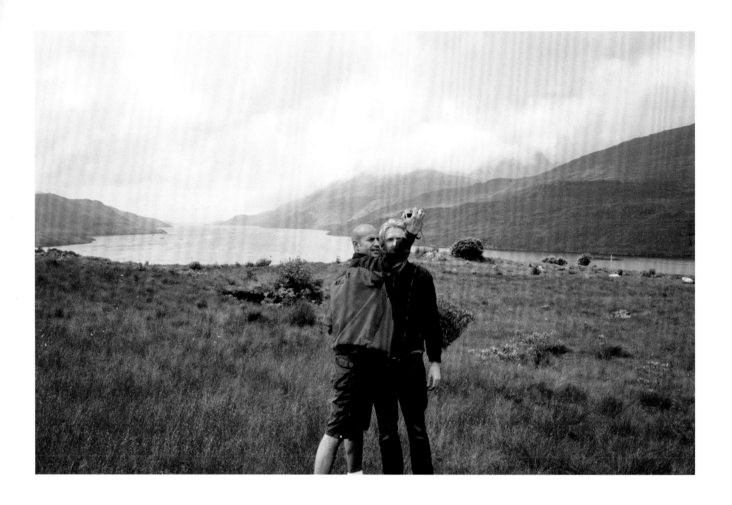

Kevin: Philip was born and grew up in County Galway in the west of Ireland before leaving to study in Dublin and then London.

In 2004, he was asked to design the interiors for Monogram Hotel's flagship property, The G, in the city of Galway. I travelled with Philip to cover the project for *Travel & Leisure* magazine, and since the hotel was still under construction at the time, I photographed some of the work in progress (p. 166–167) and also concentrated on the rugged landscape of Connemara, a

coastal area of cliffs, rivers and mountains.

For the shoot, we stopped at places we liked, and since the dogs were with us – Philip now had two Jack Russells for me to contend with, Archie and Harold – the beaches were a great place to take them for a walk. While walking across a field, Philip and Stefan stopped quickly and took a picture of themselves and the scenery. We were working, but it was something most people would do if they were on holiday: it was like a Kodak moment.

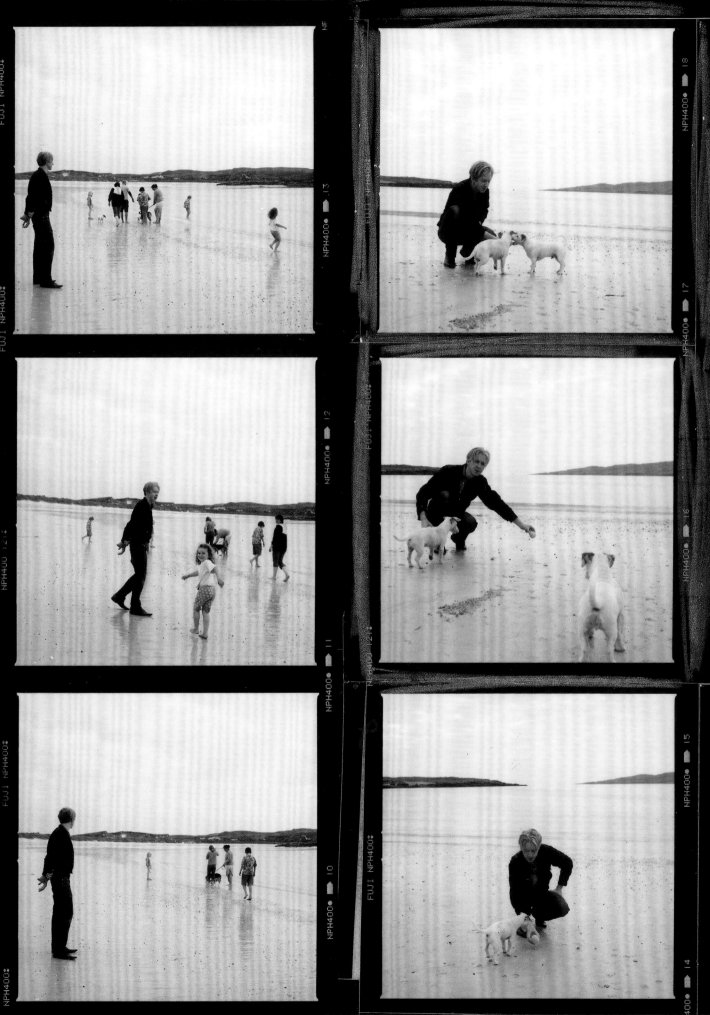

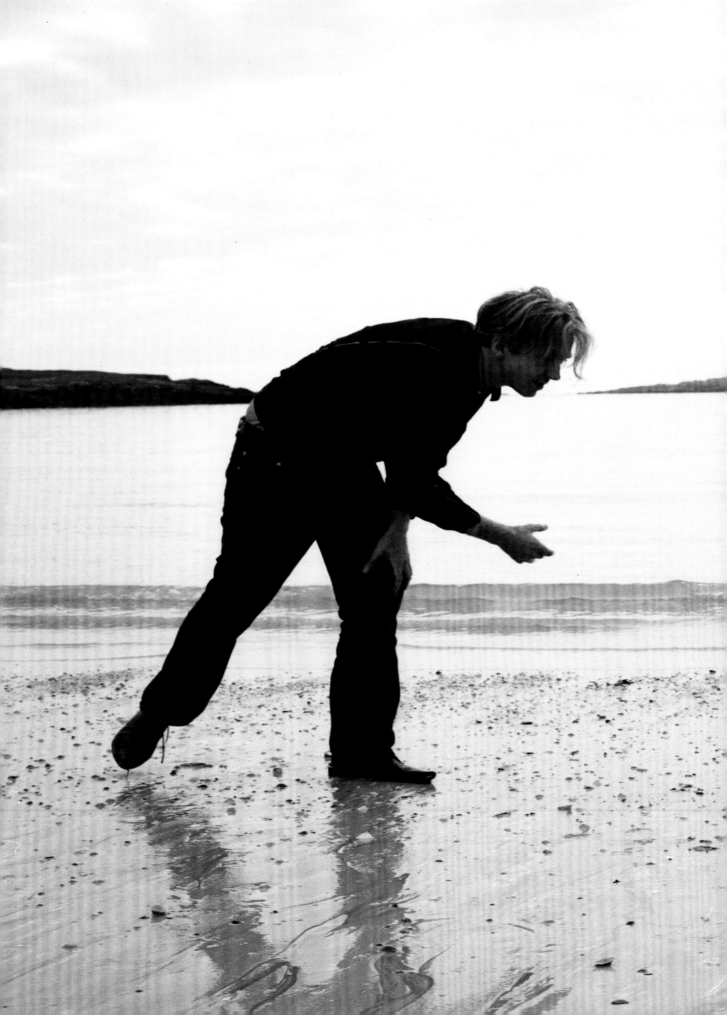

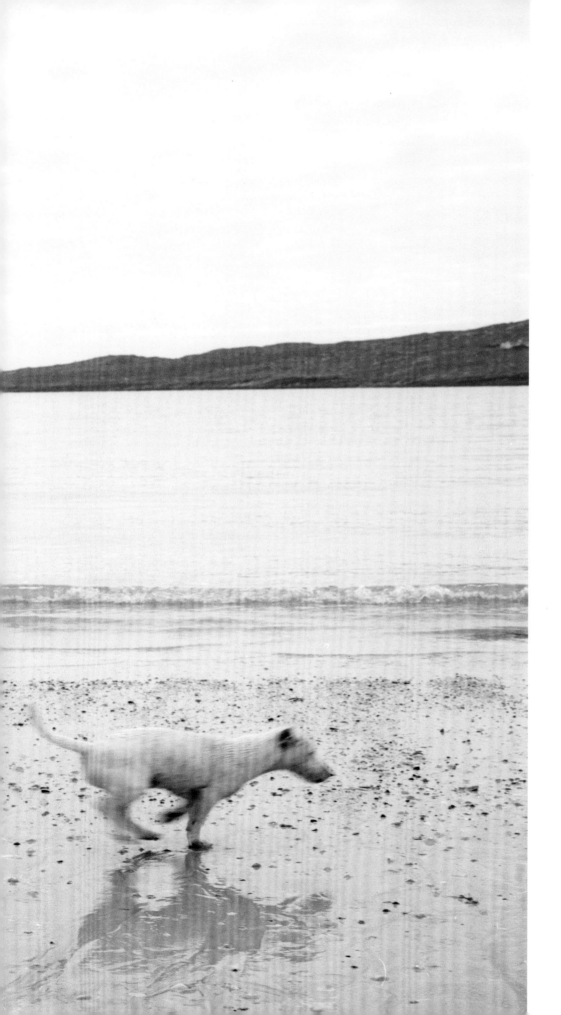

Kevin: The image of the finished interior of the hotel lobby (overleaf) was shot later, when I visited Galway for a family birthday. I am very fond of this picture; at the time, I was a father taking a photograph of his children having fun on holiday, but in retrospect I have increasingly seen that it was a way of capturing the hotel interior. The place was like an extension of Philip's own home but obviously on a much bigger scale. It was sophisticated and grown up, so I liked the idea of seeing two young girls messing about in there. The space has been brought to life by people, rather than left cold and uninhabited.

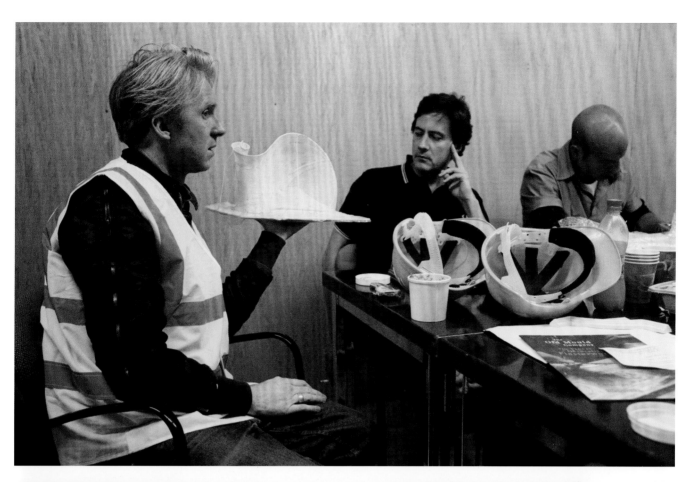

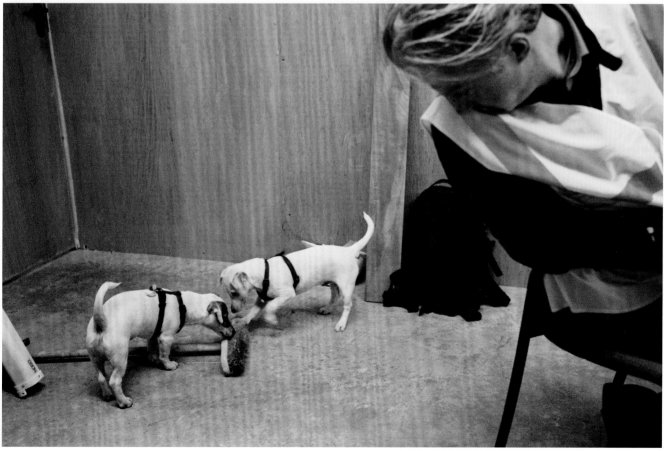

The G hotel, County Galway, Ireland

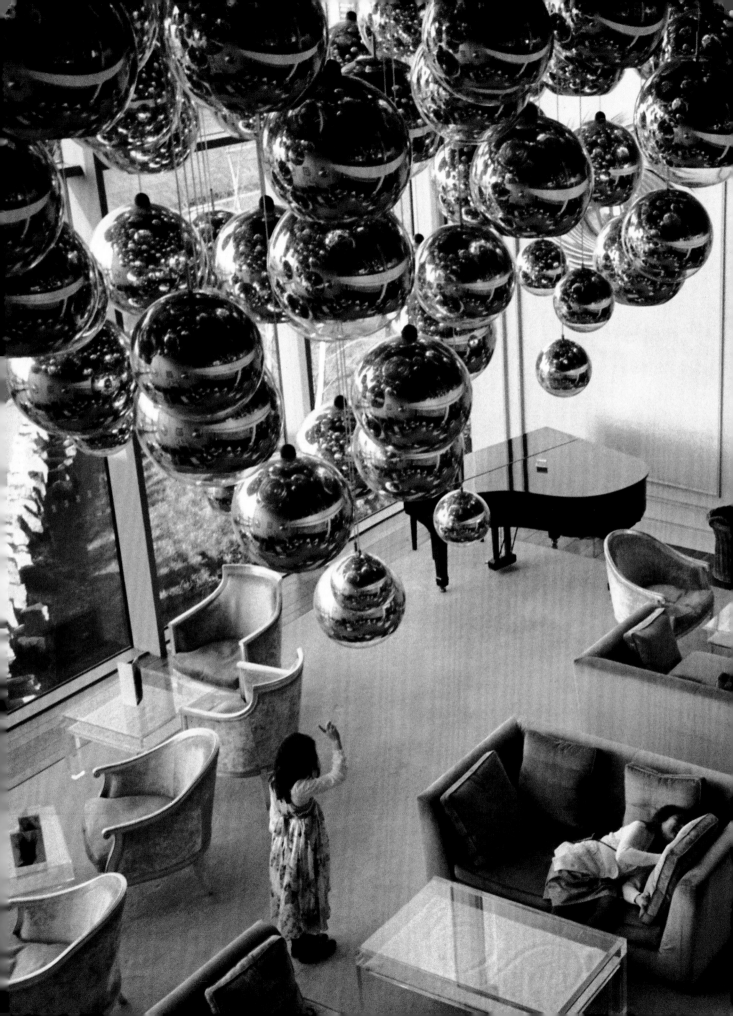

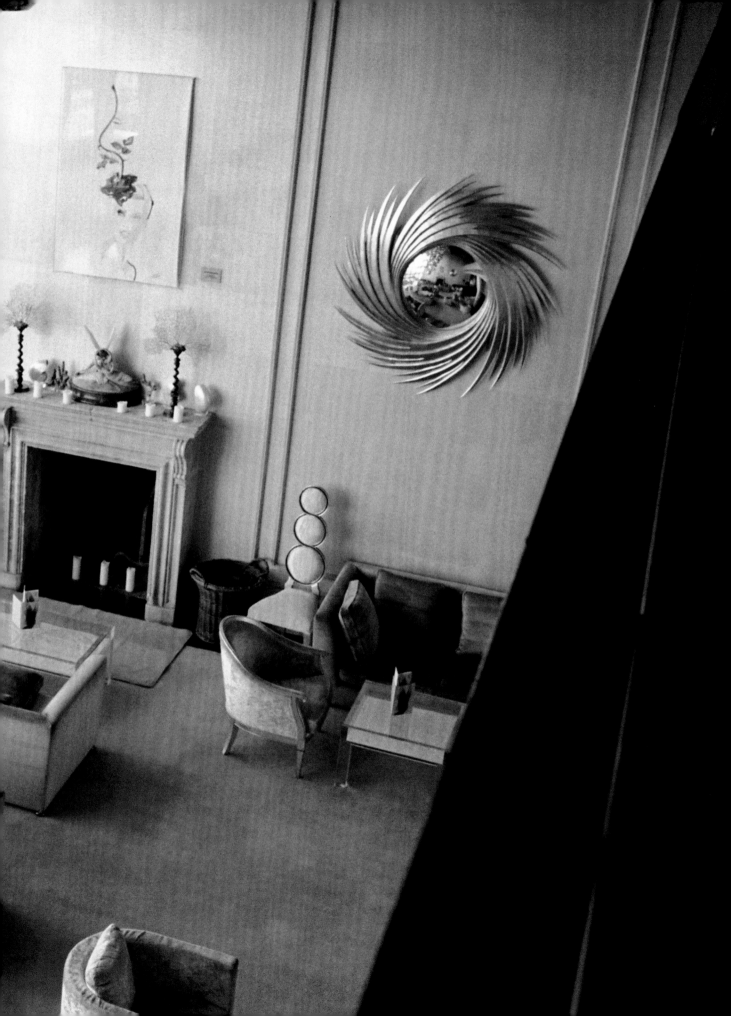

Kevin: In 2008, Grace Jones performed
her first concert in 20 years as part of the
Massive Attack Meltdown Festival at the
Royal Festival Hall in London. Grace had
asked Philip to design and art direct the
show as well as create her hats. Philip invited
me to come along – to see the show more
than anything else – but I couldn't resist
capturing a bit of the preparation, and
although 'live' photography had never really
appealed to me, while watching from the
wings, I created my own version of an on-
stage shot (overleaf).

Grace Jones; Meltdown Festival, Royal Festival Hall

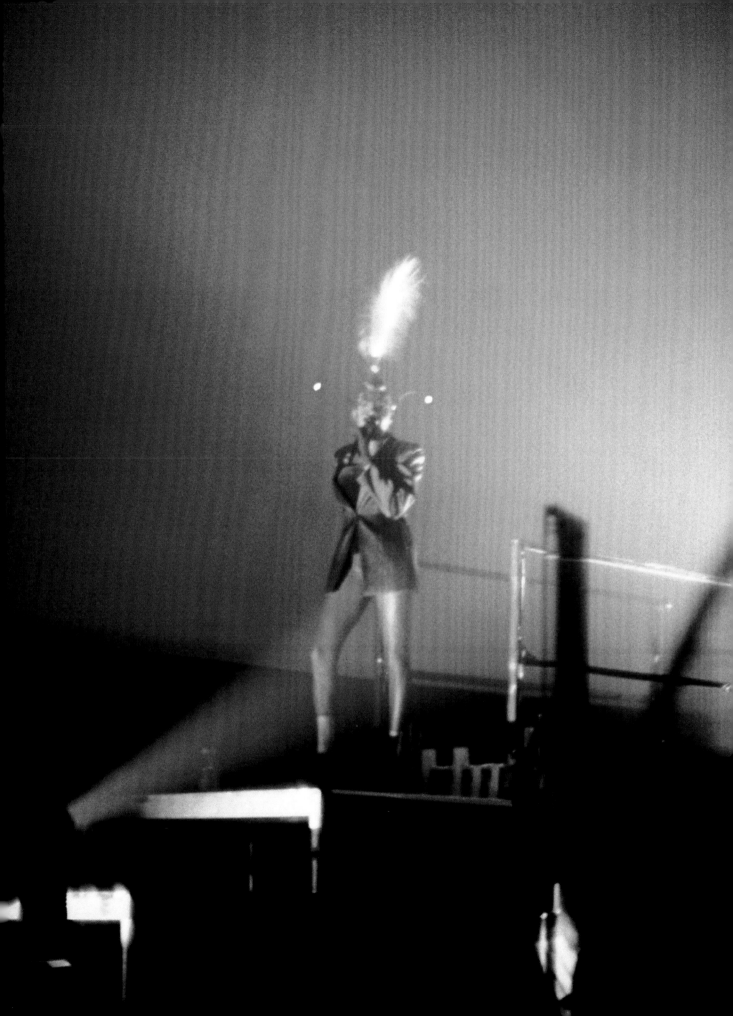

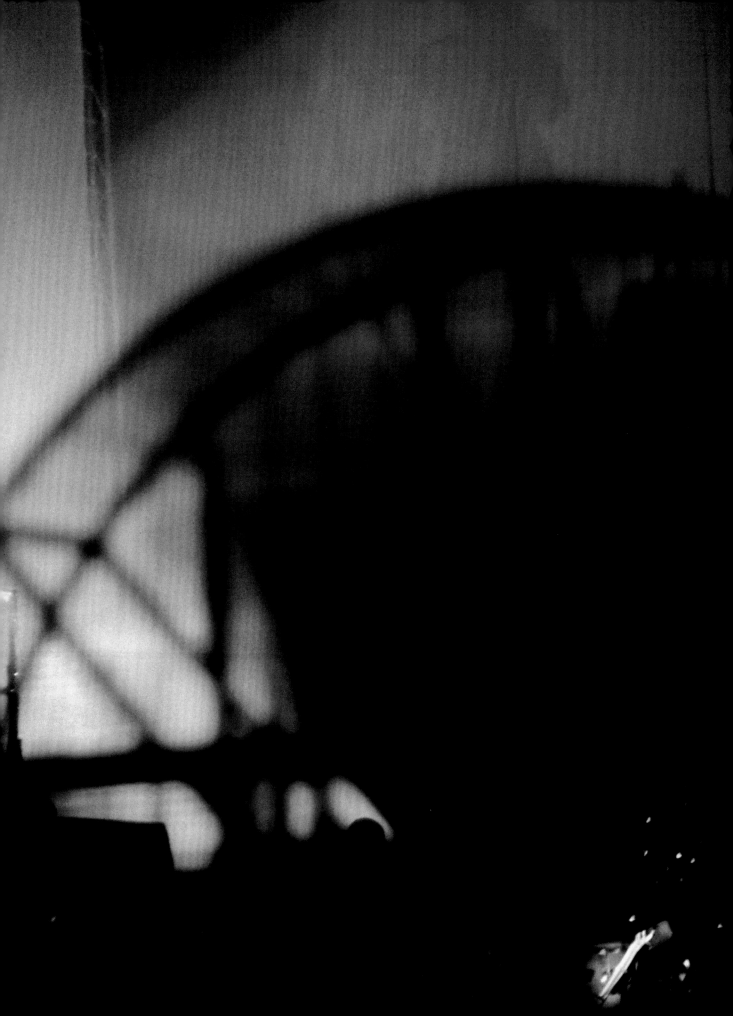

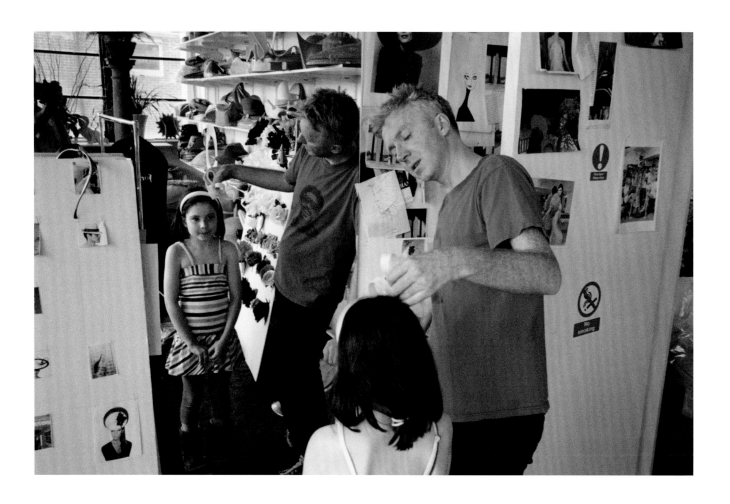

Kevin: As a father, I particularly enjoyed watching Philip giving my daughter Alice the full fitting treatment, trying on different styles and asking her opinion. She was not the sort of client I had been used to seeing.

The hat was to be for a special occasion, her first Holy Communion, and when it came to the event, photography was forbidden in the church during the ceremony. I placed my camera on my knee, pointed it roughly in the direction of Alice, guessed the exposure and distance, and clicked. It was a manual camera with no moveable screen for seeing round corners, but the picture was perfect ... sometimes you just get a stroke of luck.

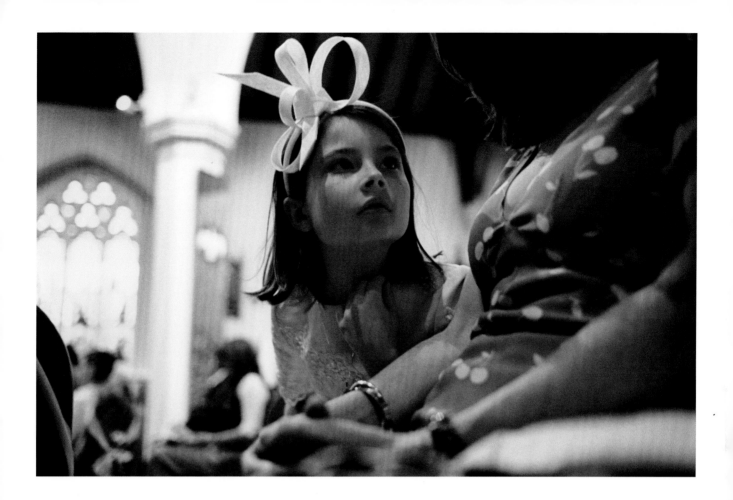

Alice, Holy Communion

Kevin: I must have passed the spray room every time I visited the studio, without taking a look inside. However, soon after I entered I was seduced by the abstract beauty of the colours scattered on the walls. Just like at Elizabeth Street, I wanted to show it as it was, letting the colours and shapes form their own beauty in the photographs.

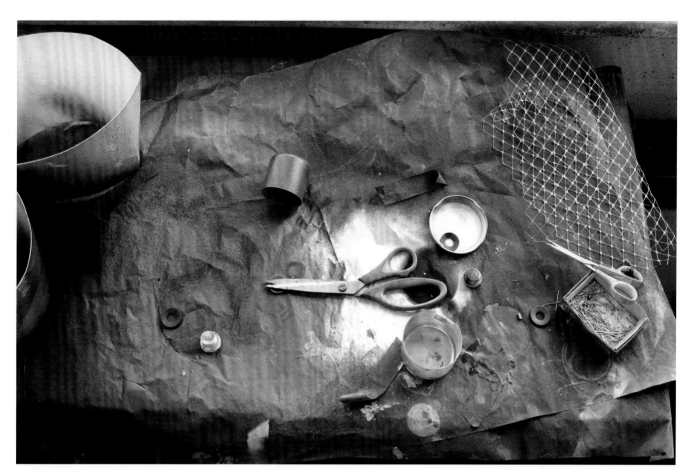

In the studio; spray room

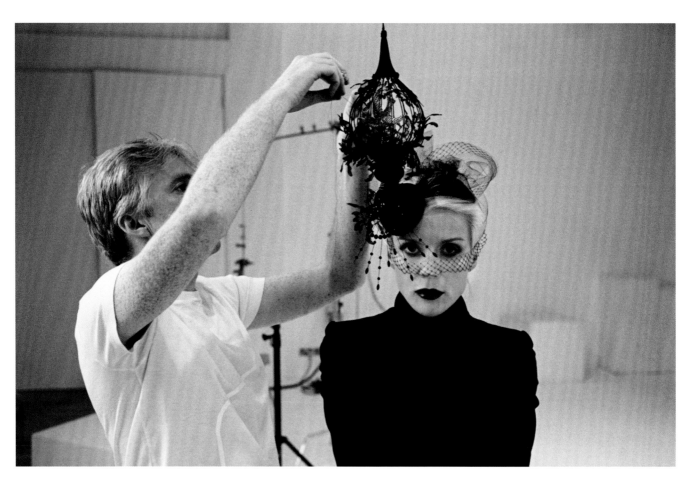

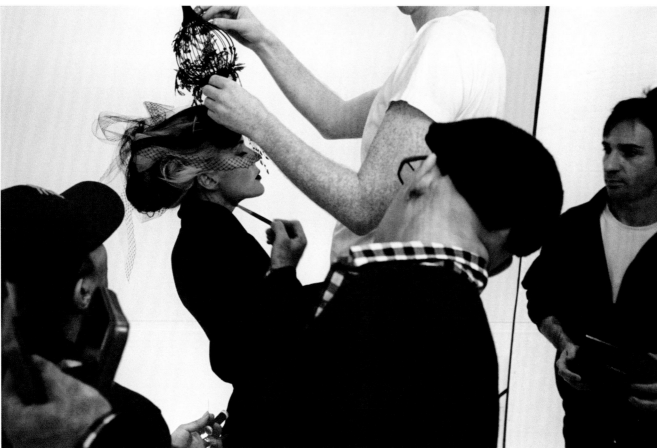

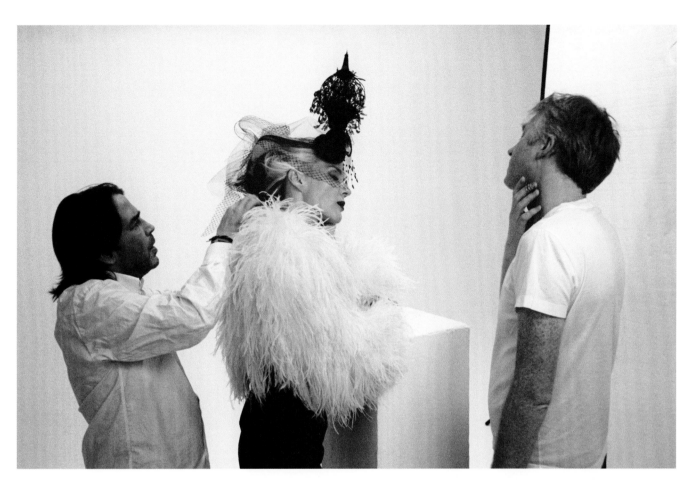

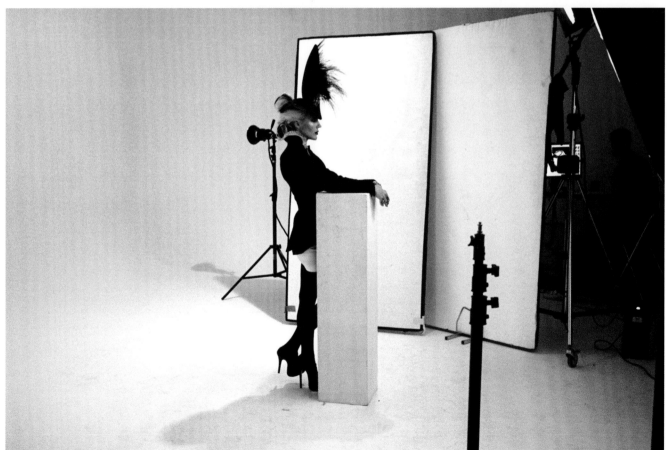

Kevin: I spent three days at Philip's studio immediately before the Royal Wedding of William and Kate in 2011. By the time I arrived the work was nearly completed.

I had seen lots of mood boards with fabric swatches, photos of clients, illustrations of dresses and images of lots and lots of hats. It was extraordinary, and the 'show' was enormous: television crews from America, hat fittings for royalty, interviews, photo sessions and everyone frantically finishing the 36 hats for the event. Even though it was manic throughout the building, the atmosphere appeared upbeat. It was difficult to keep up with Philip as he constantly moved from room to room – a hat fitting in one, a film crew in another – from his studio to the showroom, to the office, guests' hotels and even to an embassy. It was like a plate-spinning act.

I was keen to stand further back and show the wider picture, with the spaces filled with people as well as objects. It struck me how different this was from the basement atelier at Elizabeth Street, where everything had started in such a different type of chaos more than 20 years ago.

Philip: The Royal Wedding was one of the most exciting periods of my career. The enthusiasm and grand sense of occasion that everyone seemed to be feeling was equally infectious in the studio for weeks before the event.

The whole build-up was like working towards a single, monumental live show. The event itself felt like one of the biggest fashion shows on the planet, except it was all real. It reminded people all over the world that hats have always been, and still remain, an important part of our great historical occasions.

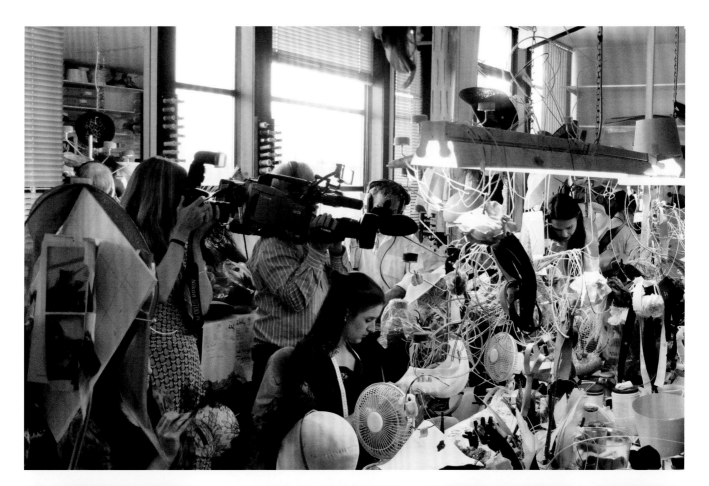

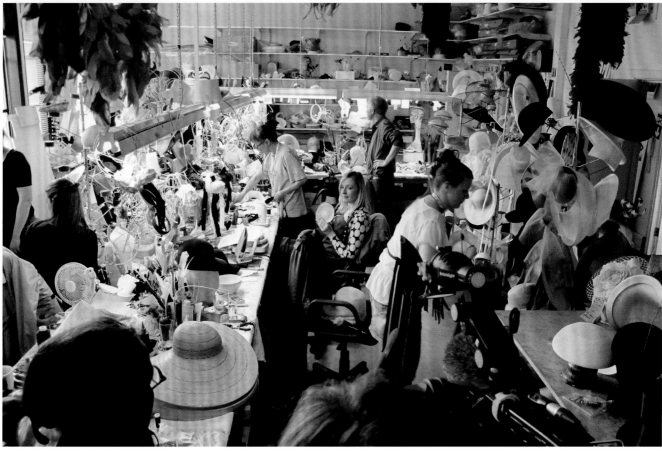

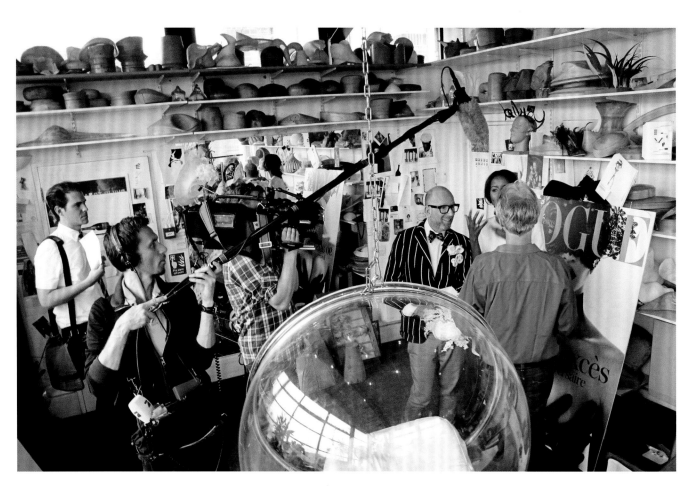

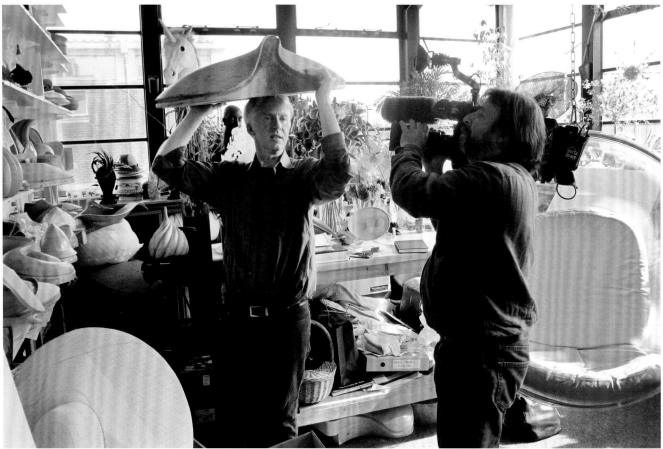

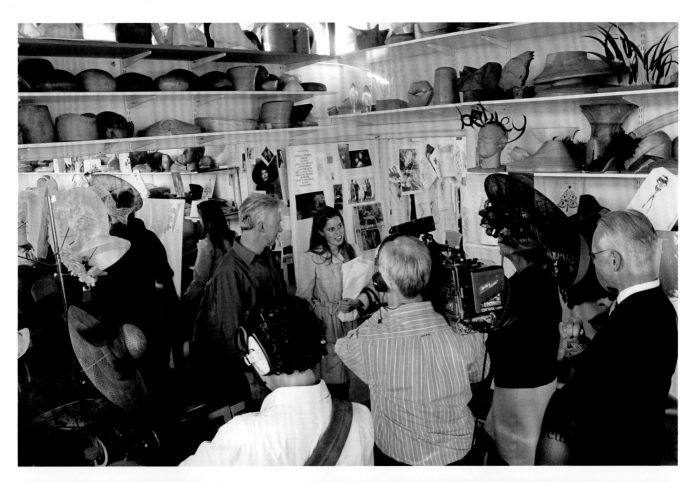

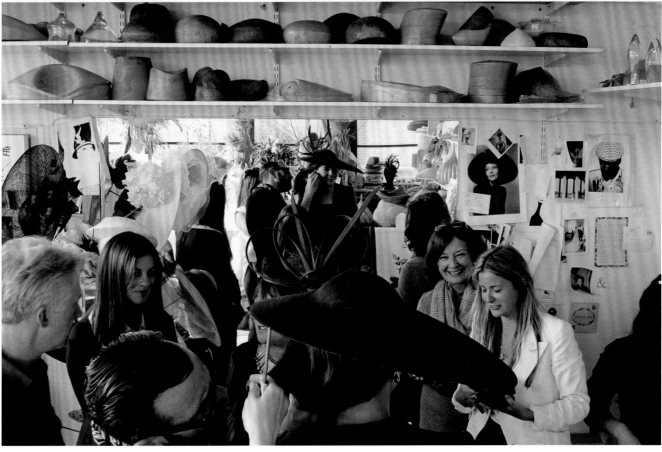

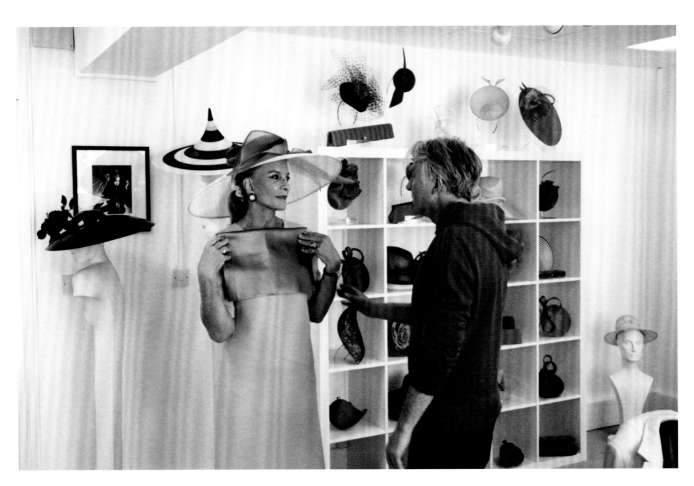

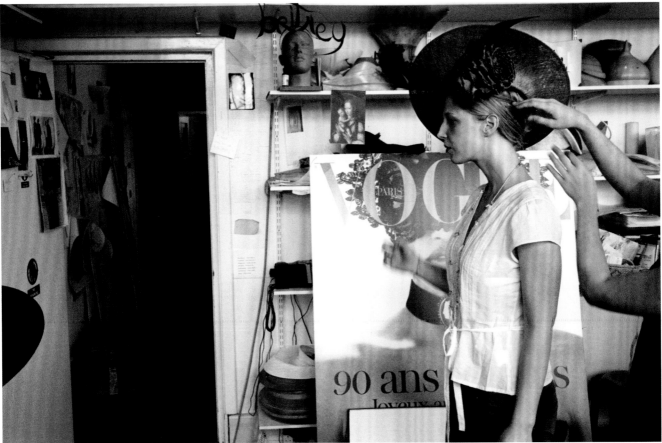

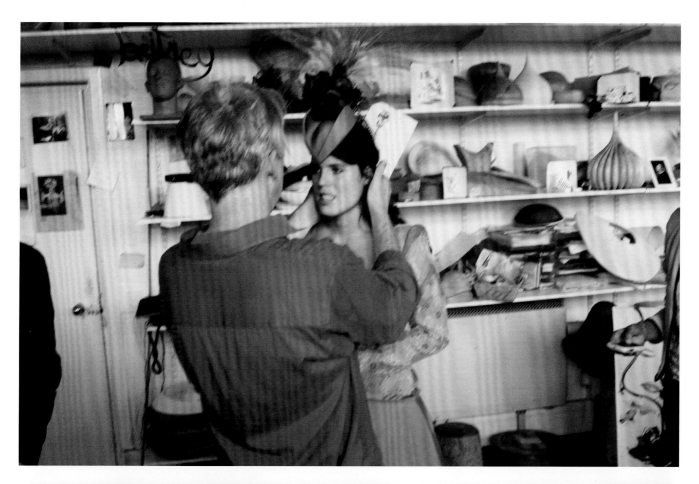

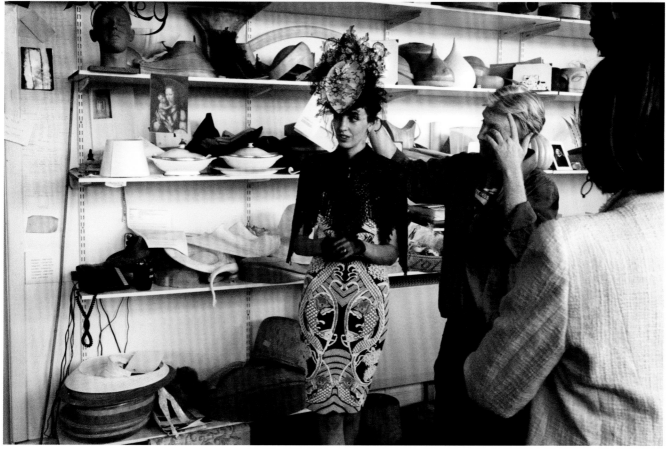

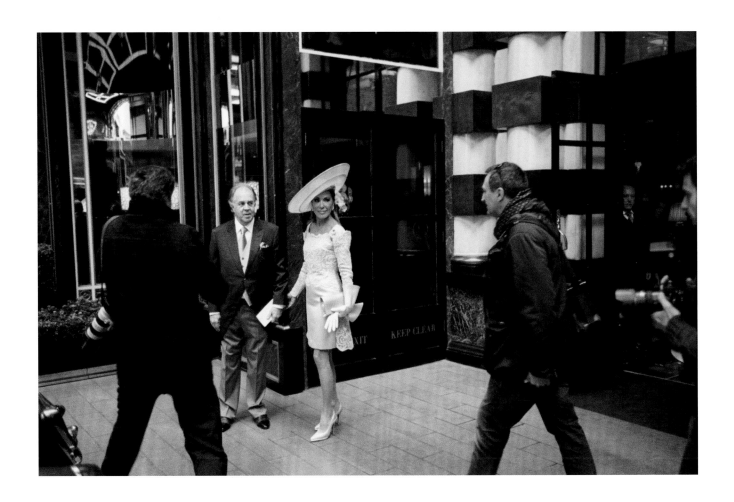

Kevin: On the morning of the wedding I accompanied Philip and Stefan to the Savoy Hotel for fittings. While waiting in one of the suites we gazed at an empty Westminster Abbey on a TV screen.

After a very intense three days, things seemed quite calm. I was hoping to shoot in a suite, but everything was running late. I hadn't envisaged shooting outside the entrance of the hotel, and fortunately there were only a few paparazzi. I was frustrated at not being able to get something more intimate, although the absence of Philip in the frame seems to work. Later that day we returned to Philip's house to watch the spectacle on TV. It was an incredible sight to see so many Treacy hats in one place all at the same time.

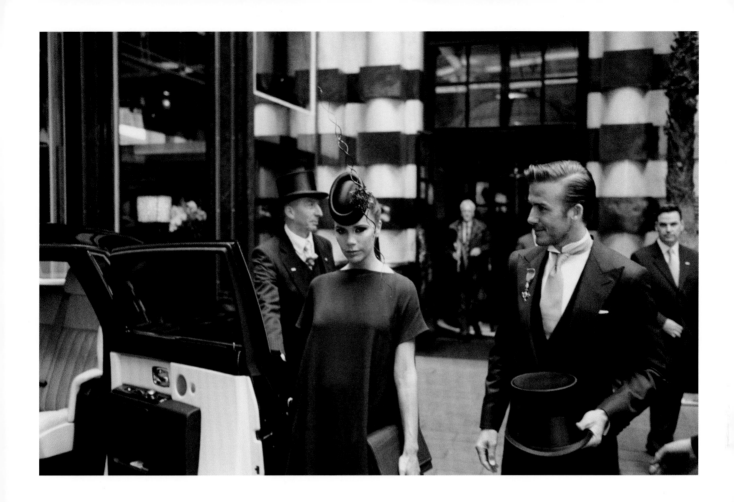

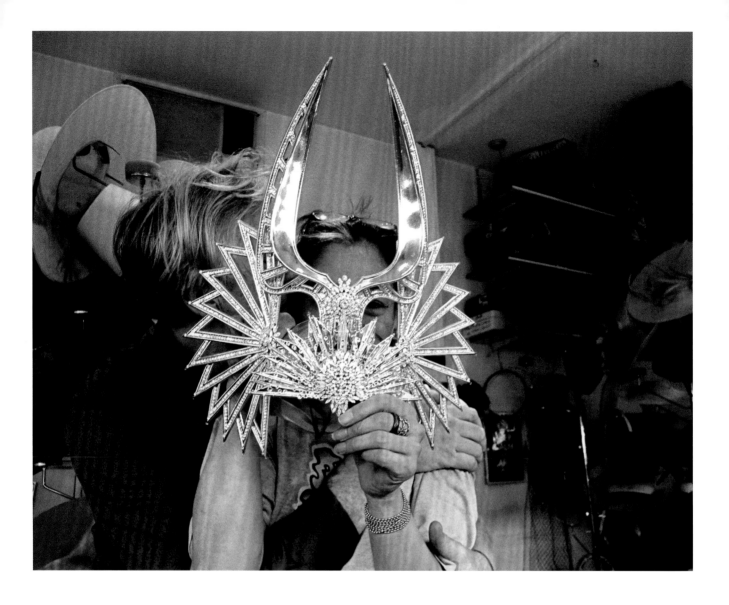

Kevin: Philip always seems to have a new commission that goes even further than the last one. After the Royal Wedding, it was Madonna and the halftime show at the Super Bowl XLVI final in February 2012 – not to mention a TV audience of 100 million people.

Chronology

Philip Treacy

1967
Born in Ahascragh, County Galway, in the west of Ireland. Lives with his parents, seven brothers and a sister

1985
Studies fashion at the National College of Art and Design in Dublin
Spends six weeks doing work experience with the hat designer Stephen Jones in London

1988
Awarded a place on the MA Fashion Design course at the Royal College of Art in London

1989
Shows his hats to Michael Roberts, fashion director of *Tatler* magazine, and his style editor, Isabella Blow
Blow later commissions him to design her headdress for her wedding

1990
Graduates from the Royal College of Art with first-class honours and sets up a workshop in the basement at 69 Elizabeth Street, Belgravia

1991
Invited to meet Karl Lagerfeld, chief designer at Chanel in Paris. The first hat he designed for Lagerfeld was the 'twisted birdcage', photographed by Patrick Demarchelier and worn on the cover of British *Vogue* by the model Linda Evangelista
Wins his first British Fashion Council award for British Accessory Designer of the Year
Meets photographer Kevin Davies at a shoot set up at Isabella Blow's house for American *Vogue*

1992
Wins his second British Accessory Designer of the Year award (he would go on to win a further three)
Begins designing hats for the high street
Is given a puppy, a Jack Russell terrier he names Mr Pig

1993
Stages his first fashion show, featuring all black hats, at the Harvey Nichols department store, as part of London Fashion Week: Naomi Campbell, Yasmin Le Bon, Kate Moss, Stella Tennant and Christy Turlington all model in the show
Begins designing a diffusion range of hats for the department store Debenhams

1994
Opens his own shop above the studio at 69 Elizabeth Street

1996
Exhibits in the Florence Biennale, Italy

1997
Launches an accessories collection of stingray bags and gloves, geometric lace and cut leather
Work included in the Cutting Edge exhibition at the Victoria & Albert Museum, London

1998
Exhibits in Addressing the Century at the Hayward Gallery and Satellites of Fashion at the Crafts Council, both in London

1999
Designs hats for Alexander McQueen's white *haute couture* collection at Givenchy in Paris: includes the gilded ram's horns, modelled on Isabella's own Soay sheep
Designs for Lagerfeld at Chanel
Stages a show at the Natural History Museum as part of London Fashion Week
Moves into his second, larger studio, also on Elizabeth Street in Belgravia

2000
Exhibits as part of the Victoria & Albert Museum's Fashion In Motion series
At the invitation of the Chamber Syndicale de la Haute Couture, stages the Orchid Collection: the first ever *haute couture* show in Paris devoted to hats
Philip's hat blocks are included in the Unlikely Sculpture exhibition, London

2001
Collaborates with artist Vanessa Beecroft at the Venice Biennale, Italy
Unlikely Sculpture exhibition shown at the Irish Museum of Modern Art, Dublin and Fondazione Nicola Trussardi, Milan, Italy

2002
Presented with the Moët & Chandon award for luxury
The book *Philip Treacy* is published as a catalogue for the upcoming exhibition When Philip Met Isabella: Philip Treacy's Hats For Isabella Blow at the Design Museum, London
Creates Naomi Campbell's hat for her first appearance at Royal Ascot

2003
Pays homage to Andy Warhol with his third *haute couture* show in Paris and launches the limited-edition Andy Warhol waterproof accessories range, available worldwide
When Philip Met Isabella begins its world tour, opening at the Melbourne Fashion Festival, then moving to the Power House Museum, Sydney, Australia
Presented with the Dream Weaver Award by the Fashion Group International alongside Jean Paul Gaultier, Dolce & Gabbana and Donna Karan
Commissioned by *Tatler* to shoot the cover of the magazine, featuring Erin O'Connor

2004
Moves to third studio, in Battersea, London
Begins designing glassware and furniture
Designs the Portrait Chair as part
 of furniture retailer Habitat's 40th
 Anniversary project
Presented with the International Designer
 of the Year award at the China Fashion
 Awards in Shanghai, followed by a *couture*
 show with Chinese supermodels and
 Sudanese-British model Alek Wek

2005
Appointed design director for the interiors of
 Monogram Hotel's flagship property The G
 in County Galway, Ireland
Creates the hats for the wedding of His
 Royal Highness The Prince of Wales and
 Camilla Parker Bowles

2006
Philip Treacy for Umbro launches at
 London Fashion Week
Awarded an Honorary Doctorate by the
 National University of Ireland
Contributes his *haute couture* Orchid
 Collection to the Anglomania exhibition
 at The Metropolitan Museum of Art in
 New York

2007
Isabella Blow passes away
Philip presents a fashion show within the
 Bessborough Restaurant during Royal Ascot
The exhibition When Philip Met Isabella
 travels to The Marble Palace in St Petersburg,
 Russia, and opens with a show in the
 Astoria Hotel
Collaborates with Ralph Lauren, Donna
 Karan, Alexander McQueen and Rifat
 Ozbek for their Spring/Summer 2008 shows
Presents his first-ever solo show in Ireland
 at The G hotel, County Galway
Philip is awarded an OBE by Her Majesty
 The Queen in recognition of his services
 to the British Fashion Industry

2008
Creates the Royal Ascot advertising and
 again presents his couture designs at
 Bessborough Restaurant
Commissioned by Italian *Vogue* to
 photograph specially designed hats and
 jewellery on Daphne Guinness
Designs and art directs Grace Jones's first
 concert in 20 years at the Royal Festival
 Hall, London, as part of the Massive Attack
 Meltdown Festival

2009
Designs and art directs the first leg of
 Grace Jones's Hurricane world tour,
 beginning in Australia, travelling through
 Europe and finishing in the UK
Collaborates with Valentino to design and
 produce his first ever shoe

2010
Collaborates with Valentino for Paris Fashion
 Week, designing all the eye masks worn on
 the catwalk
Designs the lace shoes for Valentino's
 Spring/Summer 2010 collection

2011
Designs a hat for Charlene Wittstock, the
 Princess of Monaco, for her first Royal
 engagement for Monaco National Day
Collaborates with Armani Privé for Paris
 Couture Fashion Week in January and July;
 designs the visor and dome hats made
 of Plexiglas and the crystal masks that
 were worn on the catwalk for the Spring/
 Summer 2011 collection; designs the
 feathered flowered headdresses and the
 structured bows for the Autumn/Winter
 2011 collection
Collaborates with Givenchy Couture,
 Givenchy Menswear and Givenchy
 Womenswear for their Autumn/Winter
 2011 collections
Designs 36 hats for the Royal Wedding of
 HRH Prince William and Kate Middleton
 on 29 April at Westminster Abbey, and for
 the Royal Wedding of Prince Albert II of
 Monaco and Charlene Wittstock on 2 July
Curates the Conversation Pieces exhibition
 at TATE Liverpool, showing his unique
 sculptural hat blocks
Collaborates with Gareth Pugh and Paco
 Rabanne for their Spring/Summer 2012
 fashion shows
Creates four large disc hats for Lady Gaga
 for the MTV European Music Awards
Nominated for Accessories Designer of the
 Year in America
Designs Madonna's hat for the Super
 Bowl half-time performance

2012
Collaborates with Armani Privé for their
 couture show, creating the snake
 headdresses and crystal flying masks
Designs 45 turbans for Didit Couture
Collaborates with Prabal Gurung in New
 York, designing black, hand-blocked peaks
Stages his Spring/Summer 2013 show at the
 Royal Courts of Justice as part of London
 Fashion Week

Acknowledgements

When I first entered 69 Elizabeth Street – and Philip Treacy's world – on a commission for American *Vogue* in 1991, I had no idea that it would lead to 20 years of friendship and a vast collection of photographs and experiences.

At that time, I wasn't aware of Philip's love of photography and how it relates to the shapes he creates. With hindsight, I am eternally grateful that he allowed me in and to work in my own way, even though it may have occasionally been at odds with his vision; thank you to Philip Treacy and Stefan Bartlett.

My printer Brian Dowling produced every image in this book and so much more besides. His unparalleled and unstinting eye – not to mention his patience – is unique and has always been an important part of my photography. Thank you also to R.J. Fernandez, Alan Beechy, Chris Clark and Paula Dowling at B.D. Images Ltd.

Thank you to my agent Ziggi Golding at Z Photographic for making this happen and for her continued support.

Thank you to editor Millie Simpson for her perspective and keen eye.

Thank you to the staff at Phaidon Press and in particular to Amanda Renshaw for her vision in shaping this book, to Tom Wright for his application as my editor, to Paul McGuinness and Vanessa Todd for their attention to detail in reproducing my images and to Mat Smith for his friendship and Ann's fish pie.

Thank you to Daniel Baer for all his input, art direction and elegant design.

Thank you to my friends – not an easy path – for their encouragement and long-standing loyalty: Balwant Ahira, Phil Bicker, Jamie Huckbody, Terry and Tricia Jones, Dylan Jones, Damian McFadden, Jonathan Phang, Greg Pond, Alan Searle, John Slattery, and the late but great Pamela Hunter.

To those united in following the unicorn, a warm thank you to Alla, Eloise Anson, Judy Blame, Juliette Botteril, Malinder Daamgard, Dan Donovan, Sam Dougal, Jutta Freedlander, Felix Forma, Fiona Graham, Ray Limburn, Deborah Milner, Shane Mitchell, Anthero Montenegro, Nicholas Kirkwood, Antony Price, Michael Roberts, Tracey Rumpley, Alison Russell, Jamie Russell, Nick and Tina Scott, Jessica Thinn, Topolino, Waka Uarai, Karen Walsh and Micheline Zacharov.

For stopping short of gilding any lily, thank you to everyone at Hempstead May.

Four legs good, two legs doing its best to keep up – thank you to the late Mr Pig and Harold, to the ever-present T.J. and pet Archie and, of course, to Coco.

Finally, more than any other people in the world, thank you to June, to my perfect and inspiring children Louise and Alice and to my invisible but very present wife ... thank you and guess what? I love you.

Kevin Davies

Phaidon Press Limited
Regent's Wharf
All Saints Street
London N1 9PA

Phaidon Press Inc.
180 Varick Street
New York, NY 10014

www.phaidon.com

First published 2013
© 2013 Phaidon Press Limited

ISBN 978 0 7148 6527 0

A CIP catalogue record for this book is
available from the British Library.

Designed by Daniel Baer

Printed in China